the big picture

LOU JACOBS JR.

WRITER'S DIGEST BOOKS
CINCINNATI, OHIO
www.writersdigest.com

Other fine Writer's Digest Books are available from your local bookstore or direct from the publisher.

Visit our Web site at www.writersdigest.com for information on more resources for writers.

04 03 02 01 00 5 4 3 2 1

Library of Congress Cataloging-in-Publication Data

Jacobs, Lou
 The big picture: the professional photographer's guide to rights, rates and negotiation / by Lou Jacobs Jr.—1st ed.
 p. cm.
 ISBN 0-89879-969-4 (alk. paper)
 1. Photography—Business methods. 2. Commercial photography. I. Title.

TR581.J34 2000
770'.68—dc21 00-025799
 CIP

Editor: Megan Lane
Production editor: Christine Doyle
Production coordinator: Mark Griffin
Cover designer: Stephanie Redman
Interior designer: Angela Lennert Wilcox

Dedication

To my loving wife, Kathy, who encourages me to write, photograph and make collages, each in its own time. Also dedicated to photographers everywhere, especially those who are getting started in business.

Acknowledgments

Thanks first to everyone who was kind and patient enough to be the subject of a Question & Answer session to enrich this book. Thanks to ASMP for which I've long worked and from which I have received endless information and education that is blended into these chapters. And thanks to EP, an influential group of Editorial Photographers, who are banded together to forge awareness and understanding of business ethics and techniques for the benefit of shooters, editors, art directors and bean counters alike.

Contents

BE PREPARED

Read the table of contents. Get acquainted with chapters that can illuminate the business techniques you want to refine, to help you make a better living and maintain your self respect. The book includes many familiar techniques and ideas, plus new ones, about business fundamentals in most photography categories.

Selling photography for publication or to individual clients is still a viable career in the twenty-first century. With this book and other resources I'll recommend, you'll have the information you need to take charge of your business future. The rewards are definitely worth the struggle.

CHAPTER ONE

Understanding Rights and Usage

RIGHTS ARE TO BE TREASURED

Charlie Chaplin was a rich and successful movie star in his lifetime for one significant reason. Not only was he talented, but he was an astute enough businessman to insist that after an agreed-upon rental period, sole ownership of his films would revert to him. Lots of big name stars in Chaplin's day were well paid, but most did not have his foresight. When other actors' films made lots of money, the profits went to studios and financiers, and the actor had to be satisfied with a salary. Charlie Chaplin arranged with movie studios to provide facilities and distribution, but he owned the negatives to his movies.

Today's smartest photographers, whether they work for magazines, the advertising industry or book publishers, follow Chaplin's example. The reason is clear: Sales from transparencies and negatives are the basis for future earnings. Since the accepted custom of media photographers is to lease, not sell, rights to their pictures, the legal use of their work is limited to the rights they specifically grant buyers. A client pays for the opportunity to reproduce images in various media. The photographers set the limits on those reproduction rights in the same manner used by writers, illustrators, composers, playwrights, actors and others to control their creative work. Rights are leased for specific purposes for a specific length of time.

Ideally, you and your client discuss and agree on what rights are to be sold, and you set fees based on that usage. (The idea of setting fees based on usage is covered in the next chapter.) In this way you retain control and ownership of your images, and the photographs are returned to you after they are published.

If you work for an employer who supplies film, equipment, benefits and a salary, the company is entitled to own the rights to your work. Self-employed photographers, however, live in what may be called permanent insecurity. They have varying incomes, no pension fund, no paid health insurance or sick leave, and they buy their own equipment. These are big reasons why it is essential that freelancers retain ownership of their work so they can continue to lease their images and earn income throughout their lifetimes. Stock photographs are also normally leased. So it is obvious that your career depends on business agreements that maintain your ownership of pictures from cameras,

computers or any other means. Giving up ownership rights—accidentally or intentionally—can undermine your professional future.

Warning to newcomers selling photography: Exploitive clients may find you. The promise of being published is seductive, and you may neglect to discuss rights when you talk about fees because you don't want to make waves. A memory of such an exploitation still haunts me. Decades ago on my first assignment for *Look* magazine, after publication the editor asked to "borrow" the negatives to syndicate the story. I was too dumb to say I'd *lend* the negatives, or to ask for additional payment. I never saw those negatives again. Now I regret that I threw away my resale opportunities, and the potential income. My early naive attitude exemplifies how eagerly brand-new photographers welcome sales. Think of guarding your rights as a necessity to your professional life.

TYPES OF RIGHTS
[Some definitions that follow are based on extensive work done by the ASMP over the years and are used with permission.]

First Rights
This is the most frequently used term in media and corporate photography. It covers rights leased for one edition of a publication only, though you may agree at the same time to lease first rights of images for specified related magazines, books, brochures, etc. For example, you may sell first rights to Magazine A plus use afterward in a sister publication, Magazine B, for an additional fee. Types of rights and photographic fees are always intertwined.

First rights are customary for many editorial jobs and are often granted with a time limit, such as ninety days beyond publication. This means that you agree not to sell the same or similar photographs to other publications, directly or through a stock agency, during that ninety-day embargo. The longer the time limit requested, the higher the fee you should charge. If the embargo expires, and the photographs have not been published, you are free to lease them again—without returning any money you've been paid. When you guarantee a client the right to publish an image first, the deal may be modified by geographic area. For instance, you negotiate sale of first rights in the U.S. and at the same time first rights in another country. The first rights principle applies to assignments, independently produced work and stock photographs and can extend to other categories.

In the advertising field, first rights may be granted to cover pictures reproduced in more than one publication or medium (magazine, billboard, etc.) for a specified amount of time. Fees should be increased in relation to the number of different publications involved as well as the length of the embargo (such as sixty days, six months, etc.). You are expected to agree not to lease the same or similar pictures to any other client, competitive or not, during the embargo period you agree to.

Onetime Rights

These rights cover pictures leased for one reproduction in one edition, in one language for a specific time. For example, you lease a scenic shot to a postcard publisher for onetime use in the U.S. and Canada for a year or more, and lease the same photo during that interval to a noncompetitive market, such as an encyclopedia or a bank check manufacturer. Onetime rights, which are most often applied to images sold as stock, are less restrictive than first rights.

Distribution Rights

These define where publications in which your pictures appear may be distributed, often limited by language or geographic area. Books, for instance, might be licensed for sale in English-speaking countries, or a poster may be licensed for distribution in the U.S. only.

Promotion Rights

These allow publishers to promote a book or magazine story by offering copies to reviewers or including a photo or book cover in an ad. When the book is your own, you don't charge for promotion rights, but you do charge for the use of your pictures to advertise someone else's book or to promote an issue of a magazine in which your photograph appears.

Electronic Reproduction Rights

These are for use of pictures on television shows, Web sites, CD-ROMs or videotapes. The specific electronic medium should be spelled out in a contract. A TV show used an enlargement of a friend's photograph to decorate the wall of a set without permission. He asked for and received a fee based on the number of viewers the show had and the length of time his photograph was visible in a scene. Evidently, the framed print belonged to a staff member who didn't know or didn't care that permission was needed to use it. Had my friend been contacted beforehand for permission, he would have charged less and the producer would have saved time, too.

All Rights or Buyouts

These terms signify a complete transfer of all photographic rights to the client, including copyright in some instances. Buyouts may also mean a transfer of specific rights only, like poster rights for specific images. In such a case, you would sell a good slide dupe, an excellent computer-generated print or a digital image on a disk, and keep the original in your files. All rights does *not* necessarily mean transfer of copyright. When you make an agreement that is sufficiently profitable to sell all rights (which is covered in chapter two), you may stipulate in your invoice or on a purchase order that you retain certain rights and/or copyright. An all rights arrangement for a photograph may also be granted for a certain time limit only. This gives the client a wide range of rights for the interval covered and reserves the copyright for you.

Caution 1: It is poor business practice to sell all rights to pictures unless the images will have little or no residual value for resale or exhibition, or unless payment is two or three times the normal rate. (See the section covering work for hire on page 9.) In the advertising field you may be asked for a buyout that could be called a "flat payment," which requires you turn over all transparencies or negatives to the buyer. This allows the client multiple usage of your photographs, and you must charge more than the usual fee to make up for the loss of future sales.

Advertising clients or agencies may claim to want all rights to prevent pictures they commission from being used in other ads, especially by competitors. You can give written assurance that you will file the images for a certain length of time to protect the client.

Caution 2: Photographers new to editorial, advertising and other publishing may be asked to sign agreements that give clients all rights, and they may do so out of ignorance or in an effort to please a buyer when business is slow. One photographer told me that a musical group offered her $150 for a slide they loved of a picture she shot of them in performance. "The phone bill was due, and I really needed the money," she said, "so I said okay." A few months later she saw her photo on a classy poster with no credit. "I don't know how many posters they printed," she said sadly. Nor does she know how else the photo was used. Economic desperation and naivete prevented her from negotiating for more money and limited rights.

Buying all rights for nominal fees that really only cover one time use is a scam against photographers and threatens their income. When you are faced with a buyout or a work-for-hire offer, point out that the client can avoid doubled or tripled fees by leasing more limited rights now and additional rights for added fees in the future if needed. This may save the buyer money and leave your creative work available for stock sales, books or sales to noncompetitive markets.

Beware that an all-rights arrangement may sneak up on you via the legend stamped on the back of a check, which is a dubious place to write a "contract." You may discover a rubber-stamped message such as "The undersigned warrants that the work paid for by this check is original, and that the buyer is hereby assigned full rights to the material described on the reverse of this check. Signature to this agreement is a condition of payment." When I have received such checks from magazine publishers, I've crossed out the offending words and cashed the check without repercussions.

The legend on a check is not a legal agreement since you were not a party to it. If you prefer, phone the editor, review your rights agreement and request another check without a legend. The editor may suggest crossing it out and cashing the check.

To avoid this problem, on a bill you may state, "For first rights only. All prints/slides are leased for a period of _____ months and must be returned to the photographer as a condition of this sale. Photo credit and copyright

notice must accompany reproduced photographs." Send two copies of the bill and ask that the buyer sign one and return it for your files. There is no reason to be victimized by a check legend, especially when you've already negotiated suitable terms. Forms and agreements are detailed in chapter five.

For additional rights information I recommend reading *ASMP Professional Business Practices in Photography* from Allworth Press.

WORK FOR HIRE

The work-for-hire (WFH) clause in copyright law states that if you take pictures as an employee, and are therefore receiving a salary and benefits, your employer owns the pictures and the copyright to them. An employer doesn't have to give you credit when pictures are published, though many staff photographers are credited. This clause was conceived mainly to cover employer-employee relationships.

Sometimes buyers of photography for advertising, corporate, editorial and other purposes may ask a self-employed photographer to sign a work-for-hire agreement to cover a job or period of time that the buyer defines. Why? This could be a scheme to obtain more rights without asking for all rights or a buyout. Signing a work-for-hire agreement could transfer copyright of your work to the buyer. You could lose ownership of your images, run the risk of not receiving a credit and lose the opportunity to sell further rights. When faced with a work-for-hire deal, discuss alternatives with the buyer and offer extended rights for extra money. You might choose to accept work-for-hire terms for a great deal more money than you would get for leasing limited rights. But you should remind a buyer that if you're considered an employee, in some states you would also be due health insurance and workman's compensation. These conditions result in red tape and paperwork for employers, which can help discourage work-for-hire requests.

Here is one photographer's reaction to an editor who requested work for hire: "It is bound to destroy relationships between creative professionals and their clients. It is insulting and exploitive. A lot of my sales come from leasing images from my stock files. Without the ability to own and resell our work, a majority of photographers will be restricted from making a living. I predict that you will spend a lot of time looking for photographers who are desperate enough to undermine their futures."

Work for Hire in Advertising

Though you may be told that an advertising job falls into the WFH category because it's a collective work or a compilation, this is not true. The decision to take on a WFH agreement is yours. Some photographers are offered photo assignments only if they agree to WFH terms because ad agencies feel they are protecting their clients. You are signing away your rights, but if you do, try to negotiate a fee that rewards your bank balance immediately to make up for the loss of future sales.

Transfer of copyright is not the same as work for hire. (In chapter three you'll read more about this.) In a WFH agreement you lose copyright permanently, but if you transfer copyright, you can get it back after thirty-five years. This may be small consolation, but you can bargain for the transfer of copyright instead of WFH, so you or your heirs will have eventual control over the work. If you do agree to WFH, the client might be persuaded to transfer the copyright back to you sooner when it has no further value to him.

CASE HISTORIES

Understand that rights and usage can have numerous twists and turns. Knowing the circumstances of an agreement enables you to tailor rights and fees to the needs of all parties.

Case History 1: Dale has been a successful professional photographer for a few years and is doing well. One day a friend who has written her first book calls. "Ann Author" asks Dale to take some portraits of her for the book jacket. They agree on a price for jacket usage plus expenses.

Ann loves Dale's pictures and asks for two prints each from four different color negatives. She pays Dale after receiving his bill, which states "Credit line with copyright symbol must accompany photograph on book jacket. Additional use of photographs may be negotiated." Dale stipulated the copyright notice because a book's copyright doesn't protect the jacket photograph. When published, the jacket photo was accompanied by a credit, copyright and date, and Dale received an autographed copy.

Two weeks later Dale sees a newspaper ad for Ann's book accompanied by another of his portraits of her carefully credited and copyrighted. He telephones Ann and explains that this use of his work was not included in his fee. Ann apologizes, adding, "When the publisher asked for another picture of me, I just sent it along. They said you'd be contacted about further payment. They may also have copied that photo to send to reviewers with the book."

Dale tells Ann she was responsible for additional payment because he had made the agreement with her, but he contacts the publisher to inform them that Ann didn't understand the extent of the rights she purchased. He discovered that the company never asked Ann about their rights agreement. Dale then negotiates a fee for ads and publicity that is triple the amount he charged Ann just for jacket usage. His bill states he must be notified if the publisher wants to make any further use of Ann's portrait.

Fortunately, the publisher is enlightened about rights. Ann was naive, but Dale was smart enough to spell out rights in his bill. Within three months of the book's publication Dale registers the copyright to his photographs of Ann for further protection (see chapter three for more information about registering your copyright).

This story underscores the careful attention you must give to details when specifying rights to ensure compensation for accidental or intentional misuse of your pictures. It is important to place a copyright symbol on your pictures

before delivery, and to specify that copyright be included with your credit line. By registering your pictures in a timely manner, you can collect monetary damages and fees for unauthorized usage. Experience will make you more mindful of tactfully educating clients with thorough paperwork. Clients are usually quite definite about what they expect from you. Your expectations of them should be equally clear.

Case History 2: Joanne is an advertising photographer. An ad agency hires her to photograph an experimental farm for a bank that lent money to the group that developed the farm. Joanne agrees to shoot enough situations to produce at least six horizontal pictures for ads in *Time, Newsweek, U.S. News and World Report* and *Forbes.*

"We may also want to convert one or two shots to black-and-white for trade magazines," the art buyer tells Joanne. "We'll discuss additional usage fees later." Joanne quotes a photography fee for six ads in four magazines and the agency okays it. *They seem enlightened about rights,* Joanne thinks. After nine months the agreement allows her to offer the color as stock to agricultural markets that do not conflict with the banking industry.

Before Joanne begins photography, the ad agency's standard purchase order arrives. It states the assignment is "a work made for hire." Joanne discovers the agency incorporates a WFH clause in all its purchase orders, whether or not that is actually the deal negotiated. Joanne tells the art buyer that the purchase order is clearly inconsistent with their agreement. He apologizes and tells her to strike the WFH stipulations. She does so and gets on with the job after receiving an up-front payment for film and lab charges. The final images are beautiful and the bank is happy with the magazine ads. Later Joanne delivers black-and-white prints for trade magazine usage, and points out to the art buyer that the agency paid less than it would have in a WFH deal.

This case history underscores the importance of reading agreements thoroughly. Photographers are also learning to present their own agreements, especially to editorial clients. One clause restricts use of the photographs until after payment is made—when time allows.

RIGHTS AND ETHICS

When I mention photographers' rights, I realize that clients have rights too. For instance, if you take a shot of a couple having a romantic candlelit dinner for an investment firm, you must inform your stock agency of this to prevent it from leasing the same or a similar image to a competing investment company. It is your responsibility to maintain ethical business practices. Photographers' mistakes encourage clients' desire to buy all rights.

Be aware that some clients expect exclusivity and are persuaded by lawyers to ask for all rights, which uninitiated art buyers may believe won't cost much more. By tactfully informing clients that their rights will be safeguarded, you'll make it easier to do business. And consider it enlightened self-interest to pass

ethical principles on to newcomers in the field. They need to realize their obligation to treat clients as fairly as they wish to be treated.

SUMMARY

Creative people in all fields expect to be compensated each time their work is used, but sometimes they must deal with clients who feel that one payment fits all uses. The American Society of Media Photographers (ASMP), the Advertising Photographers of America (APA) and other professional organizations try to educate creative people about their own worth. These groups also stress the good sense of written agreements.

But there will always be photographers who just don't get it and don't bother to consider the long-term consequences of their actions. They undercut professional rates and give away rights for a fast buck. Uninformed and insensitive people usually don't last long in business because their photographic skills may be as inferior as their business practices. If they are good photographers and bad business people, try to educate them. They need to realize that ownership of their copyrights can be the foundation of success.

Even if it hurts, it is sometimes good judgment to support your own reputation and self-respect by saying "no" to bad rights and/or fee arrangements you can't change. Try not to allow economic conditions to pressure you into deals that are counterproductive. Learn about all the ways you can conduct business successfully, about compromises you can make safely, and about building a worthy reputation. The business that will prosper through good practices is your own.

Q&A *with*
Bruce Blank

Bruce Blank attended RIT, then assisted a photographer in Philadelphia, ran his own commercial studio for eighteen years (concentrating on product illustration) and taught at the Art Institute of Philadelphia for eight years (mostly business classes). He was president of the Philadelphia ASMP chapter for eight years and a member of the national ASMP board for six years. He joined the national ASMP staff in 1993 and is currently director of education and director of member operations. He has been a valued advisor to me while writing this book.

Q What is the main reason clients say they want work-for-hire contracts?

A They claim that work for hire is the best way to prevent photographs from being used by a competitor. This can be a smokescreen for attempting to obtain all rights to photographs for future use without further payments. In response, agree to restrict resale of pictures so none are sold to any business that may be considered competitive. Help a client understand that your business depends on selling and reselling your images.

Q What if the client says, "I'm paying for the work, and I feel I'm entitled to use the pictures where and when I wish"?

A Explain that you consider this a work-for-hire deal and your higher fee may strain his budget. For example, a $1,000 job could easily become $3,000 or $4,000 for the same amount of work, plus expenses. Offer to license additional rights if and when they are needed for fees to be negotiated later. Remind the client that very extensive use of pictures is the only reason to own a copyright, and all rights associated with copyright ownership could be worth tens of thousands of dollars, depending on the images. Few clients will continue interest in work for hire. Assure a client that if you go out of business, you will arrange to transfer photographic rights to him for a reasonable fee.

Q What should you do if a client springs a work-for-hire deal on you in a purchase order, when you've already agreed on terms and fees for limited rights?

A Explain the economic consequences of work for hire as noted in the previous question, and emphasize the large additional fees. If you believe that the rights deal you've already negotiated should stand, and that the work-for-hire terms were added by over-eager attorneys, explain your views to the client and negotiate. Sign the original order and return it. If your sensible business views are shared, the client should be agreeable.

Q Where can one get a contract or agreement form for selling photographs?

A *ASMP Professional Business Practices in Photography* includes a form. [There's also one in chapter five of this book.] This form has space to type a description of the job, intended uses of the photos to be leased, fees and estimated expenses, date and time of the work, etc. Standard terms and conditions are on the back. The APA also provides confirmation forms for photography jobs. [The APA has chapters in New York and Los Angeles.]

Q Is an oral agreement with a client binding?

A In some states no oral agreement is binding. Check with an attorney in your area. In states where oral agreements are binding, they are difficult to enforce. Even if time is short, or you feel you can trust the client, it is always in your best interest to get it in writing. The effort you spend putting terms, fees, rights and other conditions on paper will pay off in peace of mind. Signed agreements reduce pressure on you and the client and increase good will.

Q What should you do if you have to shoot on short notice and "there's no time for paperwork"?

A It depends on the circumstances. If a client representative is at the shoot, write out, in long hand if necessary, a basic agreement about job specifications, time involved, estimated fees and expenses, and other specifics. Each party should sign it. If no representative of the client is on hand, and especially if the assignment was made over the phone, fax or E-mail a confirmation agreement (see chapter five for an example of a confirmation agreement) stating the figures and conditions listed above. Electronic communication is fast today and a client should understand why you are reluctant to begin

shooting until a mutually acceptable deal is signed by both parties. Find a way to quickly make the client quickly aware that he is bound to accept your interpretation of the assignment as it was agreed upon verbally.

Q If a client cannot or will not tell you where or how pictures will be used, how do you determine a price for the job?

A Try to get specifics. Explain your handicap in determining fees when you don't know what rights or media are involved. If no information is forthcoming, offer an estimate based on one-time use in one or more media possibilities. Explain that when the client decides on his complete needs, you will negotiate additional payment if necessary. An alternative is to quote only a production or creative fee plus expenses. Explain that a usage charge will be added when further decisions are made.

Q What do you tell a client who claims the concept for a photograph came from the company's art director and the company should share copyright of the images with you?

A Explain that you were hired primarily to shoot the image, and you are charging for your special skills. It is your *expression* of an idea that is covered by the copyright. Neither the idea for a photograph nor a layout is the photograph itself. The interpretation you make with the camera is the creative visualization that you own, though the client can take credit for describing what was wanted.

Q How do you respond to this question: "If the photographer doesn't have further work to do, why should he or she be paid more money when pictures are reproduced in more than one medium?"

A Explain that the more ways or times a photograph can be used to profit the client, the more valuable it becomes, and the more a photographer may charge for additional usage. For example, a photograph may be printed in an ad, a poster, a brochure and a book. Each case represents an additional reproduction right for which the photographer should be paid separately. Each printed form of the photograph benefits a client, and each should also benefit the photographer.

CHAPTER TWO

Understanding Copyright

CREATIVE INSURANCE

When you buy a home you get a title deed that guarantees ownership. A registration certificate proves you own your car. Copyright is the way to protect ownership of creative work. Until 1976, advertisers, magazines, corporations, publishers or individuals who purchased photography owned the negatives, prints or transparencies and thereby the copyrights to them. Amazingly, the old law said that by merely paying for a photograph, you owned its copyright, which meant you could sell it without sharing payment with the photographer. In those days, media photographers negotiated with clients to return their copyrights when possible, and clients used copyright as a bargaining chip for lower fees.

The current copyright law, effective January 1978, vests the ownership of photographs (and other creative work such as books and music) with their creators from the moment a shutter-release button is depressed. Unless there is an agreement to the contrary affecting copyright ownership, the pictures you shoot belong to you, and clients are required to lease or buy usage rights from you. Of course, it's not an ideal world and complications you may face are covered in this chapter.

The Copyright Symbol©

Copyright is granted to you by law so you can control the reproduction, copying, distribution, derivative use and public display of your photographs. Copyright of literary, musical or artistic work helps you prove and maintain your ownership of it. The copyright symbol (©) or notice on a photograph warns others that they may not reproduce or exhibit that work without first getting permission from the copyright owner. Buyers learn that it is customary to pay for this privilege. If a slide or print has no copyright notice on it, someone may not bother to contact the photographer about reproduction rights. Even today, people who should know better than to use an image without permission claim they assumed pictures were available. That's a pretty dumb assumption, but there are people who choose not to understand copyright law. It is clear that putting a copyright notice on all the photographs you create is a good business practice, comparable to putting a patent notice on a product or using a trademark to guard a company name.

Work For Hire

The main exception to automatic ownership of rights by the photographer is the sometimes onerous category of the law called work for hire (WFH), discussed in chapter one. The work-for-hire principle covers salaried photographers or photographers who sign on as temporary employees with a WFH contract. This means your employer owns the pictures you shoot and the copyright to them. Clients may request or require freelance photographers to sign a WFH agreement covering one or more assignments. In most states, by signing you become a temporary employee, and as a consequence you should receive worker's compensation, health coverage and all benefits regular employees receive. If the client is unwilling to grant you those benefits, and won't pay you at least twice what you'd charge for onetime rights, it is likely the WFH request is the client's way of pressuring you to relinquish your resale rights and copyright. Think very carefully about what owning rights might mean to your income. However, if pictures have only minimum future value, work for hire may be worthwhile if the fees are profitable enough.

COPYRIGHT NOTICE

Professional organizations like the ASMP recommend that all photographs carry a copyright notice, even though it is not required by law. A slide or print without a notice in the hands of an ignorant or dishonest user could allow that party to use the defense of "innocent infringement." If a judge or jury believes that someone who used the picture without your permission did so because "they didn't realize it was copyrighted," your recovery of damages in an infringement (the term for using pictures without permission) claim could be seriously limited.

A copyright notice on a print or slide announces that "This is my work, and you may not use it for any purpose without asking my consent." A copyright notice emphasizes the value of your work and alerts everyone that you will take action to protect your rights. Here are three ways to display a copyright notice:

> ©2000, Your Name
> Copyright 2000, Your Name
> Copr. 2000, Your Name

Although all three forms do the same job, it's probable that © *2000, Your Name* is most effective because the copyright symbol is so widely recognized. I use a small rubber stamp along the narrow edge of a slide mount to show my name and copyright notice. The same stamp is used on the back of a print accompanied by another stamp with my name, address and telephone number.

ASMP Professional Business Practices in Photography offers a word of caution about typing *(c)* as a substitute for © if your word processing program doesn't offer the © symbol. The ASMP says there is no record of copyright

rejection with (c) used as a copyright symbol, but there is no guarantee that a court would uphold it as proper notice. The law calls for a © or the word *Copyright* or *Copr.*

WHY REGISTER A COPYRIGHT?

You own the copyrights to your images, published or not, whether or not you register them with the U.S. Copyright Office. But there are excellent reasons for registering copyrights, the main one being the option to sue for higher damages in case of infringement. The defendant will also be required to pay attorney costs if you win.

Published Work

Under copyright law, the word *published* means distribution of copies of a work to the public by sale, other transfer of ownership, rental, lease or lending. By copyright standards, pictures are also considered published when they are exhibited through another party, such as a gallery, which offers them for sale. When you send images to a stock agency, which will lease them to publications or display them in a catalog, your work is legally published, and each slide or print should have a copyright notice. Exhibiting your work in your home does not constitute publication.

You can sue an infringer if you registered your pictures with the U.S. Copyright Office within five years after you shot them and before the infringement occurred, or within three months after an infringement occurs. Because you registered, if you win, you may be awarded attorney fees as well as statutory damages. You may register a copyright at any time after shooting a picture that has not been published, but registration within five years makes it easier to prove you own the copyright. Keep in mind that infringers realize that photographers may hesitate to sue them because of the expenses involved. If your pictures are registered, it can be easier to negotiate a settlement without filing suit because infringers wish to avoid paying your attorney costs and higher damages.

Unpublished Work

The law treats published and unpublished work differently in relation to registration being a prerequisite for infringement remedies. The law prohibits awards of statutory damages or attorney's fees for infringement of an *unpublished* work that occurs before the date a copyright is registered. To say it another way, unpublished, unregistered work is protected, but the amount you may collect in case of infringement is limited to damages up to $10,000, and no attorney fees. The same restriction applies after the *first publication* of a work and before the effective date of its registration, *unless* the registration is made within three months after first publication.

SUMMARY

To restate and augment the above, register your photographs in a timely fashion that is within the limits of the law. If your copyright is infringed, the maximum allowable damages for willful infringements, increased in 1999, is now $150,000. In cases of a repeated pattern of infringement, statutory damages could be as much as $250,000 per infringed work. Keep in mind that these monetary limits are available only if your copyright was registered prior to, or within three months of, first publication. Infringers are apt to settle suits knowing your work was registered because if the judgment is in your favor, they might have to pay attorney fees as well as damages.

If you do not register work within three months after infringement, you can still sue, but there's a $10,000 maximum and no recovery of attorney fees. The ASMP has found that few unpublished works are infringed, and that most infringements of published works occur six months to a year or longer after first publication of a photograph. This leads to an obvious conclusion: Protect your images by copyright, registering them before publication or immediately after.

A survey of infringement cases in the 1990s shows that the amount of awards for damages depends on factors such as willfulness of the defendant, extent of unauthorized use and the commercial value of the unauthorized use. An award may be for less than $150,000 depending on court findings. Still, timely registration is worthwhile since your attorney fees are covered if you win, and whatever you are awarded may at least cover your costs.

The copyright law doesn't require a photographer to register works in order to retain copyright to them. However, timely registration will serve your interests if somebody uses your images without proper permission. The "bad guys" may figure that you'll settle for a lot less money, if an infringed work is unregistered because attorney fees can be greater than the $10,000 damages limit. In addition, attorneys are much more likely to take a case on a contingency fee basis when the images involved are registered.

CASE HISTORIES

Case History 1: You photograph a man's portrait for use in a magazine ad that is published on April 1. You register copyright of the portrait on June 15 (2½ months later) and afterward discover that on June 1, the company *reused* the picture without your agreement. You tell the company your usual fee for reuse may be tripled because there was no license for additional reproduction. If the company does not agree to pay you, since you registered for copyright within three months of first publication, you can sue with the expectation of being awarded your attorney fees and statutory damages—even though the infringement began two weeks before the date of registration.

Case History 2: You shoot a scene with models for an ad first published April 1. You register copyright of the images on September 1 and later discover the photograph was reused on July 15. You are not fully protected because

you registered five months after first publication, rather than within the three months required. You may negotiate for a larger fee for the additional use, but the company may not be concerned about a lawsuit because your attorney fees can't be recovered.

HOW TO REGISTER FOR COPYRIGHT

To register you must send copies of the photographs, along with an accurate and complete registration form, to:

Register of Copyrights
Library of Congress
Washington, DC 20559
(202) 707-3000

Form VA is used for registration of published or unpublished works "of the visual arts," which includes original photographic prints, photographs used primarily or exclusively in books, advertising materials, most single contributions to periodicals, CD-ROMs and a slide show. When your photo is published in a separately copyrighted work such as a magazine, you can still register copyright of your photos involved on form VA as a contribution to a collective work. This allows for statutory damages and legal fees in an infringement case, and is safer than just relying on the registration of the magazine or other collective work.

Form VA can be requested by mail from the Copyright Office, or by calling a 24-hour hotline number for forms at (202) 707-9100. The Library of Congress has a large Web site, http://www.loc.gov, which includes a long series of frequently asked questions that is almost guaranteed to have the information you want.

There is a $30 fee for registering for copyright. When you think of how many images you shoot, it's obvious that registration can be very costly unless it's done in a bulk fashion. Fortunately, you may register photographs in groups using form VA. Include two copies of a published work or one copy of an unpublished work, plus the $30 filing fee. These copies are called a deposit.

GROUP REGISTRATION

The larger the group of photographs, the more complicated group registration is. Your options depend on whether the work is published or unpublished. Published photographs will be accepted by the copyright office in groups (or bulk) only under these conditions:

1. All photographs in the group were first published as a contribution to a single collective work (such as a magazine) within a twelve-month period.

2. The author is an individual photographer, not an employer or other party for whom the photographs were taken as work for hire.
3. If published before May 1, 1989, each photograph when first published contained a separate copyright notice naming the applicant as the copyright owner.
4. Copies of the collective work in which the photographs appeared must be filed with the registration.

As you may note, only certain published images meet these conditions, so it seems that group registration is not a very practical way to protect your rights. Group registration, however, is good for unpublished images because regulations are much broader. Here are the conditions:

1. All the images must have been taken by the same photographer.
2. They cannot have been published, as defined on page 19.
3. Copies of the photographs must be in an acceptable form of deposit, as described below.
4. Each collection must be given an identifying title. Any title will do, such as *Photographs by J.P. Photographer, 1999*.
5. The complete subject matter in each photograph to be copyrighted has to be visible, that is, full frame.

Those rules are quite liberal. There is no time limit, so pictures could have been taken yesterday or years ago, and they can be images of any subject. The deposit can be made in any one of several forms:

1. Individual slides in protective plastic pages. These should be dupe slides, or prints from negatives or slides.
2. A group of color or black and white contact sheets.
3. A group of slides placed in plastic pages and contact printed by conventional means or by a color photocopier. This may be the most efficient and economical way to group twenty images in a recognizable form.
4. A videotape in VHS format (containing up to the number of images the tape can hold). Visibility of each image must be held for at least two seconds. This means a 120-minute tape could hold thirty images per minute for a total of 3,600 images per tape. The full frame of the originals must be visible, and each should have a copyright symbol. When you have thousands of unpublished works, copy them over a period of time on one tape. Each tape requires its own Form VA and $30 registration fee.

REGISTRATION TECHNIQUES

Here are some pointers to help make copyright registration clearer and easier:

• When slide dupes are not available and a color photocopying service isn't handy, place a page of twenty slides on a light table or against a

bright window and photograph them on a color negative, after making correction filter tests. Submit an enlarged print of each plastic page for your registration deposit.

- File number your slides and prints, or contact prints. Then you'll have printed lists of photographs for which you have registered copyright without having to look at numbers on countless images. Your lists are an index that is easy to reference.

- To make collections of photographs easier to remember, give titles such as "Opening of restaurant, 1997," to those with a unified theme of photographs. You can always title a collection "Work by (Your Name), January to August, 1998." Dates are required by the copyright office and help you access copyrighted materials.

- It is unacceptable to send a very similar transparency in a deposit to serve as a dupe of the shot you want to copyright. Avoid unexpected complications that an "almost-like" picture could cause.

- When you create in-camera duplicates that are exactly alike, only one of them needs to be registered to protect all that are identical. However, similar images that are alike but not identical should be registered individually.

- A collection sent for bulk copyright must be organized so it can be examined without difficulty or confusion. If you have a question, call the copyright office. You could also write, but that would take longer.

- Divide your unpublished work into four categories: 1) Images unlikely to be published later (or rejects). 2) Images likely to be sent to your stock agency. It is good practice to apply for registration before sending submissions to agencies. 3) Assignment photographs which will be sent to the client. 4) Assignment photographs which will become outtake inventory.

 You may decide not to register category 1, but the other three categories are more important.

- Time for creating the deposit is limited for images waiting to be sent to a client. Deposits of black and white or color contact sheets are routine, but the job of grouping slides for deposit takes more preparation and could cost more than contact sheets. Whether you use an inexpensive individual slide copying setup, close-up copying of twenty slides at a time to make one print, or videotaping, your choice will be influenced by how many pictures you have for registry over a specific period.

- Edit and copy the selected assignment photographs, when there is time, before delivery to the client. These could be sent for copyright when they are returned. If you have a setup for a video camera, it may be a quick way to collect a number of images on tape and send them for copyright deposit later. After you photograph images selected for the client, send them off and then copy other shots that seem to have value.

COPYRIGHT INFRINGEMENT

The most frequent problem you'll face is unauthorized use of pictures by clients who happen to have slides, prints or disk copies of your pictures on hand. I call this photo-in-hand syndrome, and if the pictures have your copyright on them, you can claim infringement.

Consider this scenario: You shoot pictures for a brochure and your delivery memo specifically spells out that you are leasing onetime rights or limited rights that are defined. Before the images are returned to you, an eager person at the agency hands a few to a colleague who is laying out a poster. Neither individual bothers to contact you to negotiate a fee and rights for the additional use. After all, they think, the pictures belong to the company don't they? Some users of photographs don't bother to consider the creator's rights. Some may assume that rights for additional use have been paid for, or that they are doing you a favor by giving your work extra exposure. Many people who claim to be professionals are influenced by the fact that they buy film for $4 a roll and get it processed for another $6, so pictures are cheap and reuse is no big deal.

In the scenario above, had you been contacted, you probably would have been happy to lease additional rights and negotiate payment. But in this story you are not aware of the infringement until you see your work reproduced in a way you did not agree to. The company had no legal right to use the pictures, whether or not they are marked with a copyright symbol, if specific limiting rights were previously stated in writing.

Contact the company and keep your cool. Negotiate for payment, which should be at least twice as much as you would have charged had they consulted you first. If the client is honorable, and realizes an error was made, you will reach an agreement. If not, and the company claims the right to use the pictures again without payment, you might ask an attorney to write them about the consequences of infringement. Having marked each of your pictures with a copyright notice will strengthen your case, and previous registration will be added ammunition. Here are more guidelines:

- Smart clients educate their personnel about respecting photographers' rights, but there are always new employees who don't get the word. *Someone* should have the responsibility to check your rights agreement.
- Copyright also protects you if someone copies a picture of yours, whether photographically, with a scanner or duplicating machine, or by drawing or painting. A friend of mine shot a row of six puppies, and later, without his knowledge, a well-known artist made a five-foot sculpture of them and didn't bother to hide the infringement. In court the sculptor claimed that by changing the medium he had a right to work from the photo he found in a magazine. The judge thought otherwise, but because the puppy photograph was not registered, there was an out-of-court settlement. The sculptor paid the photographer an amount that would have been charged to copy the photograph into the medium of sculpture. Had the photo

been registered in time, the sculptor would have had to pay more in damages.

- Copyright infringement covers intentional imitation of a picture, unless it is meant as a parody. Even when somebody tries to disguise the similarity by using a different model or by changing minor details, infringement may be proven.

- You may file for copyright registration after an infringement takes place, providing the photographs involved had copyright notices on them. However, you must file within three months after the first publication of a work to be eligible for attorney fees and damages higher than $10,000.

- You may sue for statutory damages only in a federal court. If you win, the court may award you between $250 and $10,000 per infringement if registration was not timely. That amount can be increased to $50,000 for "willful" infringement, or reduced to as little as $100 for "innocent" infringement. You can also sue for actual damages, which requires finding out how much profit an infringer made at your expense. This is worthwhile when the stakes are high enough, but it's often more practical to accept statutory damages.

- Many suits for unauthorized use of photographs brought in state courts are not based on copyright infringement but on breach of contract and other legal grounds. If you have a problem, get an attorney's advice about whether you have a base for a copyright infringement suit. Gather all the facts, keep good records, and help prevent a judge from deciding the infringers were unaware of their offense, which could result in little or no award for you.

FAIR USE

Under copyright law the doctrine of fair use allows someone to copy a work without permission or notice. To qualify, the photograph must have been copied for classroom teaching, news reporting, book reviews, or other public interest purposes. There are four standards for evaluating fair use:

- If the use of the work is not for profit, such as in educational television, fair use may be granted.

- The nature of the work itself influences fair-use application, such as a photo distributed for a charity, publication of which would benefit the charity.

- If using the work or a portion of it can harm its future sales as a copyrighted work, fair use can be limited or denied.

- The amount of the work used in relation to the whole copyrighted work, such as one chapter from a book, is also considered.

Fair use interpretation can be complex. A public library may permit duplicating and distributing one or two copies of your photograph from a magazine,

but adequate monitoring of fair use abuse is impossible. The copyright law established a five-member Royalty Tribunal to oversee royalty distribution for fair use of photographs on public television. These royalty rates are very low and a coalition of visual artists organizations has been trying to get them raised.

Artists creating collages or manipulating photographs by computer may be inclined to incorporate one or more of your pictures from a magazine or book into their work. First you have to discover this usage, then you need to determine whether combining it into another visual image has harmed your reputation or future sales of your work. If so, discuss the situation with an attorney. (Christine Valada discusses this in the accompanying Q&A on p. 29.)

DEFINITION OF TERMS

- A *collective work*, such as a magazine, anthology, book or encyclopedia, is one in which a number of separate images, perhaps of varying themes and subjects, by various people are assembled into a collective whole. A photograph used in a collective work can itself be copyrighted.
- A *joint work* is one prepared by two or more authors or photographers with the intention of merging their efforts into a single whole. With a joint work, copyright is applied for under two or more names. Each joint copyright holder can grant nonexclusive licenses to third parties, with the obligation to account to the other joint owners regarding their share of the profits.
- A *compilation* is a work formed by the collection and assembly of pre-existing materials, such as photographs, that are related in theme or subject and edited and arranged to result in a whole that constitutes an original work. The term compilation includes collective works.
- An *audio visual work* consists of a series of related images together with sound, intended to be viewed or projected. These may be made on videotape, movie film or other means that combine sight and sound.

ADDITIONAL COPYRIGHT POINTERS

- *Copyright notice:* Make an effort to require use of your copyright notice with your photo as part of an agreement when you lease pictures to clients. Your written request on a bill for a copyright notice, for instance, protects you if it is omitted and an infringement occurs in the future. Let clients know that using a copyright notice on printed materials is protection for them as well.
- *Effective date of copyright:* The date a copyright is registered is the day on which an acceptable application, samples of the work and the fee are received by the copyright office. It may take a while for your copy of the copyright form to be returned to you, but you are protected upon delivery of your application.
- *Term of copyright:* The lifespan of a copyright begins with registration.

Pictures copyrighted after January 1, 1978, are now protected for seventy years beyond the artist's lifetime. Photographs copyrighted before January 1, 1978, are now protected for a total of ninety-five years from the original copyright date. For example, a photographically illustrated children's book I did was copyrighted in 1968 and is now protected until 2063. Copyright terms apply to all visual arts creations.

- *Transfer of copyright:* Copyright, like any asset, can be bought and sold. The law requires that a transfer of copyright ownership be in writing and be signed by the copyright owner. Copyright law does not say you have to transfer copyright to a client, even if the client originates the concept or idea. *Caution:* Look carefully at purchase orders and contracts because it isn't unheard of for a copyright transfer to be embedded in the terms and conditions in small print on the back of a form. If you don't read it thoroughly, you sign such a document at your own risk.

 There is no specific form for transferring a copyright, though the copyright office will send you Circular 12 with information on expediting and recording a copyright transfer. You'll need to create a document that covers these details: the date of transfer, description of the copyrighted work, date of original copyright, name of copyright holder, name and address of the copyright recipient, length of time the transfer applies, and the fee charged. The copyright holder *must* sign the document.

- *Copyright and payments:* Some photographers invoice a client with terms stating that rights to use the photograph are not granted until the bill is paid in full. Situations such as shooting for a weekly magazine may require that you adjust the time limit or operate on good faith, but this stipulation can help pressure slow-to-pay clients. Legal questions may arise because under this provision, nonpayment may be both a breach of contractual obligation and infringement of copyright. When you need help distinguishing between the two, consult an attorney.

- *Titles and ideas:* Neither of these can be copyrighted. Copying someone's work too closely, however, can cause problems as mentioned previously. Using the title of an existing book for your competitive book can generate a suit for damages under the law of unfair competition. If you think up a catchy title for a book that sounds original to you, the publisher should check it out—it may already belong to a book that's out of print.

THE PROFESSIONAL TOUCH

Copyrighting your images is the foundation for successful business practice. Photographers who undercharge for their work may be indifferent to protecting their rights and may ignore using copyright symbols. Such individuals are asking to be exploited. A copyright symbol on your work gives it a professional touch. It is enlightened self-interest to encourage other photographers to copyright their work in addition to charging suitable fees.

Q&A *with*
Christine Valada

Christine Valada had a fifteen-year career as a freelance commercial photographer prior to becoming an attorney. She began shooting as a staffer for the *Stanford Daily*, then the *Washington Post*, consumer and trade magazines, ad agencies and corporations. She photographed over four hundred science fiction writers, artists and editors for a solo exhibit that traveled the United States. Her career as a creator's rights activist began in the 1980s when she served on the ASMP board of directors and lobbied Congress for changes in the work for hire provisions of the Copyright Act of 1976. She was president of the Washington-Mid-Atlantic Chapter of the ASMP from 1983 to 1986. In 1989, Valada's photography took a back seat to law school. Since 1993 she has practiced in entertainment, copyright, art and publishing law, a career that has involved her in topics affecting writers, artists and photographers. Her clients include television and film writers, photographers, novelists, playrights, songwriters and illustrators. Her office is in Encino, California.

Q Photographers and their clients have had more than twenty years to familiarize themselves with the Copyright Act of 1976. Are there continuous conflicts and infringements because entry-level photographers are unaware of the law and clients are reluctant to abide by it?

A I would like to think that organizations like the ASMP and APA have done a good job of educating young photographers so they have some idea of the state of the law when they start in business. Unfortunately, supply and demand have a lot more to do with photographers being willing to work with clients who intentionally ignore the law. While there are legal ways to deal with wrongful exploitation of rights, litigation is too expensive for the average photographer. In addition, the value of owning copyrights is widely recognized, and corporations have the money to buy them up—and they do.

Q Have advertising and editorial clients continued to ask for or demand work-for-hire agreements? What techniques should photographers use to resist work for hire and how might they offer to lease rights instead?

A I often see contracts which use WFH language for situations that the U.S. Supreme Court in *Community for Creative Nonviolence (CCNV) v. James Earle Reid* held were not appropriate. [Reid was a sculptor who agreed to create a modern nativity scene for the CCNV for public display in the mid-1980s. He was an independent contractor who volunteered his services, but was supposed to be paid for expenses. He marked the statue with his copyright before delivery. The CCNV wanted to create copies and produce greeting cards for sale. Thus a dispute began over whether Reid was an employee under WFH. The U.S. Supreme Court decided he was not because the situation did not fit into any of the nine work-for-hire categories.]

What happens even more these days are outright demands for all rights, in all media, for the same single-use payment we got in past decades, because of the Internet and electronic media markets: As an example, the Tasini [trial court] decision really hit creative people. Briefly, the *New York Times,* without previous agreement covering electronic rights, made electronic use of articles by several journalists [including Tasini] without paying any additional fees. A suit was filed, and the publisher alleged that under the copyright law further electronic use of words or photos was legally presumed by publishers by virtue of a right to republish "revisions" of collective works, which include newspapers and magazines. The judge agreed.

This decision was reversed in the fall of 1999. Luckily, publishers will not be able to reissue whole publications without reuse fees. The appeal panel held that "the privilege afforded authors of collective works [such as magazines and newspapers] ... does not permit the publishers to license individually copyrighted works for inclusion in the electronic databases." Photographers who worked without written agreements thought they were granting onetime rights, and though the reversal affirms this, it truly emphasizes that one should state specific rights in writing and reserve all other rights. Otherwise, you may find your work exploited without permission or payment. The most potent weapon any photographer has in dealing with clients is the willingness to say no.

Q We were once told that a copyright notice with only a symbol and name was not valid unless the year also appeared. Is that true? Are many copyright notices I see ineffective?

A Copyright notice used to require the copyright symbol, the word *copyright* or the abbreviation *copr.* plus the copyright holder's name and the year of first publication. Adherence to the Berne convention, which provides copyright recognition in all signatory countries, and implementation of the Visual Artists Rights Act made this identification optional since about 1988. However, one should use a copyright notice to short-circuit a defense of "innocent infringement" when work is published without your permission.

Editorial content in an editorial publication has always been entitled to rely

on the overall copyright notice of the publication, which is why you might only see the photographer's name and not the copyright symbol or year next to a picture in a magazine or newspaper. If you specify in your agreements that the symbol must appear and it isn't followed, you have a defense if an infringer says the work wasn't properly copyright noticed or was in the public domain. It is virtually impossible for a work created after 1977 to fall into public domain by accident. Advertisments required full adjacent notice prior to 1988, and that's no longer required either.

Q Is it easier to register photographs in groups now than in the past? Is the best way a loose-leaf notebook with clippings and/or dupe slides? Do you have to do it all in duplicate? Do you advocate photographing or color photocopying groups of twenty slides in a sheet as the best way?

A Group registration is still a little tricky, but technology certainly has made the physical act a lot easier. It's easiest with unpublished work because you only need one copy. I recommend contact sheets of slides or negatives in loose-leaf notebooks. Scanners and color printers have also made getting contacts or prints of transparencies easier. The images should have some coherent and reasonable title, such as *Portraits 1999*. I strongly recommend individual registration of potentially valuable images, promotion sheets and any work that is used on the cover of a magazine or other work. There is some question about what damages you'll be entitled to if one or several images from a group registration are infringed by the same party at the same time, perhaps a fraction of the total statutory or a multiple of the statutory.

If you register an image as part of an unpublished group, I strongly recommend re-registering it when it is published (assuming a cost-benefit analysis makes it worthwhile). It now costs $30 for a registration, but a published image is more likely to be infringed, and it is preferable to have the full measure of statutory damages if you're looking for a lawyer. Registration prior to an infringement (or within ninety days of first publication if the infringment takes place prior to the expiration of those same ninety days) is essential if you want to ask for attorney's fees and statutory damages in federal court.

Q Please give readers one or two case histories of infringements that were successfully contested in the print medium, and maybe one suit or effort that failed.

A One of my favorite photographic infringement cases, because it came out so well for the photographer, is *Art Rogers v. Jeff Koons*, a well-known artist. He saw a photo greeting card by Rogers, an ASMP member, tore off the copyright notice, and sent it to artisans in Italy to reproduce as a sculpture grouping of two people holding about nine puppies. Koons placed his own

name on the piece as artist. Art Rogers found out about it when a friend saw a photograph of the sculpture grouping in a Los Angeles publication. Koons got nailed by both the trial and appellate court in New York for infringing a photograph. His argument that his "transformation" was somehow fair use didn't hold a drop of water.

Recently, a court in Florida ruled in favor of a photographer whose work was used as reference by a *National Geographic* illustrator who may have been sent the photographer's book as a reference by an editor. The illustrator did tracings of the photographs and then painted them. The infringement was blatant and, fortunately for the photographer, there was plenty of evidence to support the copying.

Proving copyright infringment requires establishing access and substantial similarity. It's easy to prove that a photograph was copied if the photographer has the negative or original transparency on file. In those cases, the infringer is likely to pay up rather than deal with a law suit. When the photograph is used as basis for another work, the situation can be tricky. Is it the idea or expression which has been taken? Or is it that the infringer just didn't want to pay the photographer's price or to work with that photographer? In several such cases, the photographer has won.

On the other hand, Annie Leibovitz lost a very public case in which her famous nude photograph of the pregnant Demi Moore was, according to the court, parodied and not copied, in an ad for a Leslie Nielsen movie. Parody is a defense to infringement, coming from the fair use balancing act, but I'm not sure the court was right in its analysis of this case.

Q I am not very familiar with the nature of infringement on the Internet, except that images can be downloaded and used illegally. Is that the main difficulty photographers face? If not, please elaborate briefly.

A Policing the Internet for infringed photographs is a headache for photographers. I've run searches under my name and the names of some of my famous portrait subjects to see what's going on. Using Lexis-Nexis, if you've got access, is really useful because credit lines are listed with the articles, though perhaps not with the photographs. When I opened the *Los Angeles Times* a few years ago I found one of my registered photographs, one of an author with whom I had a restricted release. It was badly reproduced without credit. The photo had been scanned from a book jacket, placed on a Web site, removed from the Web site and downloaded by an unidentified person. That explains the poor image quality. I was assured that unauthorized use was not the policy of the *Los Angeles Times*, but I wonder how many publishers educate their employees that just because it's on the Internet doesn't mean it can be used without permission or payment.

The Digital Millenium Copyright Act, which was signed into law in 1998,

is quite the buzz in legal circles. It's too early to say what effect it will really have on individual photographers who want to enforce their copyrights. It does make it easier to get a subpoena to serve on infringers, but it also cushions Internet Service Providers (IPSs) from lawsuits so long as they cooperate after they've received notice of potential infringements on their sites. This law counteracts the "deep pockets" theory behind some lawsuits: America Online makes a much more wealthy defendant than Joe Photo who may operate his Web site with infringed photographs, but AOL can get off scott-free, and copyright holders are unlikely to recover their losses from Joe Photo who may be in a distant state.

The other interesting thing about the Digital Millenium Copyright Act has to do with liability even though there is no outright economic damage. That's pretty exciting because the whine I frequently hear from infringers is "Well, I didn't make any money—I gave it away" or "It was meant as a compliment" or "It gave exposure to the photographer."

Q What about montages of photographs from newspapers and magazines that are framed and exhibited as artworks? Fair use or infringements?

A There is a "first sale" doctrine that governs what I can do with a copyrighted work I buy. I can read it, cut it up (though this is not recommended for original, one-of-a-kind art work) or frame it. What I can't do is reproduce it. So a montage of cut-up photographs (given proper credit) might be a fair use so long as we don't factor in moral rights, but the collagist wouldn't be able to make multiples (like prints) or otherwise license the work for reproduction without securing rights to its pieces. [Moral rights give a photographer the option to ask for removal of his image or images from a montage especially if he objected to the context.]

Q What general problems arise from the doctrine of fair use? How do people try to exploit it? Do you have an anecdote or case history?

A Fair use limits the exclusive rights of the copyright holder and requires a balance of these factors: the purpose and character of the use, the nature of the copyrighted work, the amount and substantiality of the portion used in relation to the copyrighted work as a whole, and the effect of the use upon the potential market for the value of the copyrighted work. The parody of the Leibovitz photograph was determined to be a fair use even though it copied everything except Demi Moore's face. This is about the only way the First Amendment will trump a copyright holder's rights. On the other hand, a recent case in New York said that the use of one still frame from an entire motion picture without license from the owner of the film in a special supplement of a trade publication was an infringement, not a fair use.

CHAPTER THREE

Basics of Pricing Photography

THE COST OF DOING BUSINESS

The puzzle of pricing photography has numerous explanations and solutions. This chapter deals with pricing for media, commercial and wedding photography. Pricing stock images requires its own techniques, which are covered in chapter eight.

Bruce Blank (whose Q&A is in chapter one) is director of education at ASMP's national office. He conducts seminars about photography business issues, including setting fees and protecting rights. Blank gets to the point: "To put a price on anything, you need to know how much the product or service costs to make or create, and you need a sense of its value to the client. I meet photographers who don't know the costs of opening their studio or office every day. That means paying rent and salaries, including their own, plus buying equipment, supplies, services, insurance, and lots of miscellanea. Even people who work alone may be in the dark about the cost of doing business. That's the basis for establishing a price for your work when combined with the client's plans to use the image."

To begin, Blank says to add up your fixed business expense figures for a year and divide by twelve to get an average figure for the money you spend monthly to keep your business running smoothly. Compile another set of figures for personal expenses, such as mortgage, food, clothing, transportation, child care, insurance, etc. Divide the total by twelve to realize the average "salary" you need to live for a month.

When you come up with these numbers, it's a good time to plan ahead for how you'd *like* to live. In a separate column add items like payments on a new car or money to remodel your home to accommodate a growing family for future reference. Include a plan for savings, both business and personal, because you'll need to buy new equipment and someday you want to retire. Setting aside money for taxes, usually paid quarterly, is another important consideration.

Add the business and personal average monthly totals, and you'll come up with the approximate amount of money you need to bill each month in order to maintain your business and your lifestyle. That's your gross income, also known as revenue. Subtract your business expenses to get your net income or profit. A trip to Hawaii will be a lot more fun when you know it is paid for from business profits.

Now comes the hard part. You have to estimate how many assignments or jobs you expect to complete in a month. Let's assume that you need $2,000 a month to maintain your business overhead, and you'd like to earn another $2,500 a month to cover living expenses. That's $4,500 a month. You expect to do two assignments a week for half the month and three a week for the rest of the month. That's ten assignments in a typical month. (This is hypothetical. Decide what's realistic for you.) Divide the $4,500 you need to live and work by the ten projected jobs and you'll find you have to charge at least $450 per assignment to make ends meet. Charging a smaller assignment fee will leave you short, unable to pay some bills. The solution: Charge more than $450 for some jobs that take more time or require a higher fee, and in theory you could do okay. You might make more money than you actually need! On the other hand, if you only shoot eight assignments in a given month, you might have to hustle to do twelve the next month to make up the difference.

EVALUATING USAGE

There is another element to charge for besides business overhead and personal living expenses. This element is *usage*, which results in a fee based on what your client will do with the image, or the value of the client's benefit from the image. This is a very important concept in pricing. Remember, media and some commercial photographers don't *sell* pictures. Instead they rent or license rights to permit the use of images in ads, brochures, magazines, books, on billboards, etc. (More in-depth information about portrait and wedding photography is covered in chapter twelve.)

Usage may not be hard to calculate if you think of it as a dollar amount determined by how many people will see the image and, therefore, how much value the client receives. Magazines base their advertising rates (the amount paid for space on a page) on their circulation. The larger the circulation, the more advertising space costs. An 8½″ × 11″ ad in *People* magazine is much more expensive than the same-size ad in *Farmer's Weekly* (*FW*) because *People*'s circulation is in the millions and *FW*'s circulation is in the low thousands. So it follows that the more people who see the image you lease, wherever it appears, the more the client should pay to use it. Clearly, photographs in ads or editorial stories are what attract readers.

Let's follow that analogy to editorial photographs. The larger a publication's circulation, the more you can charge for usage of a picture. That means charging a higher creative rate (the modern equivalent of *day rate*) per day or job for *People* than for *FW*. In addition, if the publication wishes to use your pictures on a Web site, or is selling reprints of your story to a business, the rate for usage grows. (A reprint is a magazine article reprinted separately from the issue in which it appeared and sold to the subject of the article for promotional use.) The basic theory of usage is *the more value a photograph has to a client, the more he should expect to pay for it.* When in doubt about setting usage fees, ask around among colleagues. You'll find that one theory

is to base usage on advertising space rates. The higher the price of an ad page, the more a publication or advertiser can be charged for editorial or advertising images. Find the Standard Directory book of *Advertising Agencies* in the library for current ad page rates. There are more details about editorial pricing in chapter six and ad photography pricing in chapter seven.

PRICING FOUNDATION

Think of the $450 average charge per assignment in the theoretical formula above as a base fee for production and creativity, to which, in media photography, you'll be adding charge for usage. Those calculations become the foundation for deciding how to price your photography. The confidence to set photography prices results from realistic figures, business experience and perhaps some business seminars. Ask yourself these questions: Are you making a profit now? Can you plan when you'll be able to afford new equipment or an assistant? Are you concentrating so completely on making outstanding images and finding clients that you don't give proper attention to whether you're charging enough? If you are not yet comfortable with pricing your work, when you are better able to determine business costs, and realize whether you're actually making a profit, you'll be better able to price your photography. Assurance comes from sales plus understanding your economic situation. To help put yourself over the top, consider carefully the value of your images to clients. The more extensive, or expensive, the usage, the more the client benefits, and the more your images should cost.

EXPENSES AND OVERHEAD

Photographers' expenses fall into two categories. The first is expenses that accrue from the operation of your business, commonly called *overhead*. These costs continue even when you are not shooting. The other category is billable expenses resulting from assignments. Only the first category needs to be considered in deciding how to price a photographic job. It is standard practice to add assignment-related billable expenses to the base fee and usage charge for editorial, advertising, commercial, portrait and wedding work. Techniques for doing this differ slightly and a schedule of billable expenses is included and further explained on the forms for Assignment Estimate and Estimate of Photography Fees and Expenses in chapter five.

Below are typical fixed expenses for a fictional small business without full-time employees. Notice that the list does not include costs of equipment such as cameras, lenses and computers. These are *capital costs*, and are the ones you depreciate. This means an expensive lens, camera or computer must be written off in stages as business expenses on income tax reports. An accountant can help determine depreciation rates for you. The figures below do not represent a specific photographer. They are estimates to help you understand the basics of business costs and pricing photography.

FIXED EXPENSES
Annual management and overhead costs

Studio or office rent or mortgage	$7,200
Utilities, electricity, heat, water	1,500
Telephone and Internet service	1,800
Office supplies	720
Postage and delivery services	500
Stationery	300
Liability, equipment and other insurance	1,500
Promotion	1,000
Accounting and legal fees	500
Subtotal of overhead	$15,020

Depreciation costs

Office Equipment	$500
Computer equipment	1,500
Camera equipment	1,500
Subtotal depreciation	$3,500

Personnel expenses

Owner's salary	$42,000
Part-time help	3,600
Employee benefits and taxes	350
Subtotal personnel expenses	$45,950

Total basic expenses $64,470

This theoretical list will vary depending on business and living costs in your location, the volume of your business, whether you have business loans to pay off, how much salary you want or need to cover general living expenses, and other factors. It may seem odd to pay yourself a salary, but it is essential to knowing how much it costs to operate a business, and helps give you financial consistency.

Make a list of your expenses modeled on the one above. Add or subtract categories to fit your needs. Your bills should offer a realistic picture of what it costs to do business, whether you shoot every day or once a week. Direct assignment expenses are not included in basic costs because these are billed to clients, and are marked up enough to cover time and overhead costs. Income taxes are also not listed because they are predictably paid quarterly.

Markup Factor
It is usual for photographers to charge a client more for goods and services than their actual cost; this is called *markup*. This applies to film you buy and test, professional help you hire such as a makeup artist or an assistant, time

needed to take film to a processor and other items you need to complete an assignment. It is standard practice to add at least a 10 percent markup to these items.

Some clients may think of markup as an unfair expense but it is not. Don't announce that you're marking up items, but if you are asked for receipts, avoid supplying them. Explain that markups are a service charge, which is common in all businesses. On many medium-size and smaller assignments, ranging from under $500 to around $1,000, clients tend not to challenge expense statements if your markups are not exorbitant.

BASIC COSTS AFFECT FEES

Regarding the hypothetical list of expenses above, when you have data to estimate your own overhead, consider the number of assignments or shooting sessions in a studio that you might undertake in a year. Base this on prior experience, or if you're just getting starting, make some realistic estimates. Let's assume that you expect to shoot about forty to fifty jobs a year. Some assignments can be done in a day and others may take two, three or more days. For this example, let's say those jobs take about eighty days a year. Adjust your number of shooting days according to your type of photography. If you use a day rate, let's say those eighty shooting days plus pre-production and post-production time will come to 120 billable days.

If you were our fictional photographer, your expenses came to $64,470 including salary. Divide that figure by 120 days and the answer shows you have to bill $537 a day for 120 days you'd have to bill $500 a day for 129 days, and so on. Keep in mind that you may adjust the formula to fit the type of photography you do in terms of client and income potential. Avoid thinking of these figures as establishing a day rate. Think of pricing as satisfying your money needs by the time you spend working, the rights you lease and your experience and skills. After being in business awhile, you should be charging more for your photography than when you were a newcomer. In turn, your expenses will be higher.

CALCULATING ASSIGNMENT FEES

Photography is a service business, and whether you go on location to shoot or work in a studio doing portraits or products, providing service is time-intensive. Your income comes from prices you charge based on assignment fees, creative fees or day rates. Here are some factors to consider.

Creative factor: This is the fee for photographic services. It will vary depending on your talent. If you are a specialist at shooting still lifes, for instance, you can charge a fee to match your expertise. Following our fictional photographer, let's suppose that others in his field charge a $500 a day production and creative fee for certain types of usage. Because our photographer has a reputation for artistic still life pictures, however, he asks a fee of $1,000 a day. Different disciplines in photography generate different levels of

talent with fees to match. You should charge what the market will bear, according to capitalist economic theory, which means you should consider your special skills, your client's specific needs, his desire for your services and his ability to pay. A specialist charges more than a general practitioner.

Usage factor. You should apply this kind of fee when you license usage rights. It multiplies your creative fee on the basis that the more a client uses pictures (or pays for space to use them), the higher the factor. For example, if the client wants onetime rights, the factor might be zero. For first rights you might multiply your creative fee by 1.5, while exclusive three-year usage may call for a factor of 3 or more. A transfer of copyright might be worth a factor of 5. The theoretical $500 a day multiplied by these factors comes to $500 a day for onetime rights, $750 a day for first rights, $1,500 for a three-year exclusive, and $2,500 for a copyright transfer. These figures are symbolic.

There are no hard and fast rules for these fee variations because business involves judgment calls. The usage factor may include limiting or extending leased rights to the work for a period of time, which is part of the potential value a client receives for the fee you charge. When professional photographers discuss pricing, their first question is, "What are the pictures going to be used for, and where?"

A valuable software resource to help price photography, including the usage factor, is fotoQuote. This software guides you through the process of marketing stock photos and pricing assignment work. Available for Windows and Macintosh systems, fotoQuote is updated on a regular basis. Call (800) 679-0202 for information.

Get an advance. When expenses for planned jobs increase, and you need to buy plane tickets or rent hotel rooms and cars, ask the client to advance you an amount to cover these expenses. That way, you won't be using your own money while waiting for reimbursment. No business code requires that the photographer must act as a banker for the client, loaning him money without interest. I've asked for advances to cover extensive travel on an assignment, but on local jobs of a day or two, I usually put out my own funds and remain patient. I use a charge card for most expenses and often receive payment about the time the statement arrives.

FEES AND EXPENSES TO REMEMBER

In summary, here is a list of expenses which you may augment or adapt.

Photography: This appears as a creative fee charged by the job, the day, or by the shot in some photographic categories.

Pre-production work: Your fee for time plus costs of labor to get ready for a job. An hourly rate may be charged by ad or editorial photographers for preparations, for location hunting or special arrangement time. Ad photography bids include pre-production requirements.

Casting: Time spent choosing models for a job.

Travel: The cost of air fare or automobile transportation (at IRS milage

allowance or higher), hotels, car rentals, cabs, meals, tips, etc., plus at least half the day rate for time spent.

Weather delays: A fee per day for time spent away from your studio or office when it isn't feasible to work until the weather clears.

Assistants: Photography assistants and others you may hire such as stylists or animal trainers.

Film and lab charges: All types of film used on a job plus processing, printing and postproduction costs.

Props: Everything you and the client decide is necessary, such as wardrobe, furniture or food. These items may be rented or purchased.

Insurance: A portion of the liability, equipment, studio or other insurance you must carry to have peace of mind. Add your insurance costs and divide them by the maximum number of jobs you might do. According to one insurance service the value of your equipment should be multiplied by .0175, which comes to $87.50 for $5,000 worth of insurance, but the minimum premium is $250 and the deductible is also $250. Rates for liability, fire, theft, etc., vary depending on what you are insuring. If your insurance totals $1,500 and you do sixty jobs a year, insurance costs per job would be $25.

Location: When you do assignments that require scouting for locations, expenses involved are billable.

Rentals: For a special camera, lens or for lighting equipment, or a truck to haul equipment to a location, the cost is billable.

Sets: At some point in your career you may have to build a set or have one built as part of a photograph, or as a background for pictures of products. Even if you build sets yourself, the time becomes part of the job fee plus materials and other expenses.

Models and clothes: Model fees and special clothes required for pictures are all billed to the client. When model fees are high, which may be often, have models or the modeling agency bill the client directly.

Shipping: This includes messengers and all methods of delivering your work or supplies you need.

Make a list of all billable expenses as a reminder when you prepare bills. There's a fees and expenses form in chapter five that you can modify. When you include all assignment expenses and whatever overhead items apply, you will feel comfortable that you haven't lost money by negligence. Keep your own salary in mind as you calculate business costs and income. With careful and intelligent business practices you will eventually enjoy a system behind your inspiration to make impressive photographic images.

SOME SPECIAL BUSINESS TERMS

These terms apply to pricing photography and to the art of negotiation covered in the next chapter. Understanding these terms will help you feel more secure in setting fees for editorial, advertising and corporate assignments, or portrait and wedding jobs, whether based in your studio or out of your home.

Style

Personal style is an intangible, involving a photographer's artistic talent, reputation and personality, together with his or her experience, marketing skills and what is called "the look" of the work. Visual style helps give images distinction. Well-known photographers like Richard Avedon or Monte Zucker, who command high fees, have taste and talent that are marketed as their personal style, even though these qualities don't appear in invoices.

Assignment

An assignment is a business commitment that entails an order or request for photographs for specific purposes to satisfy one or more of the many ways that photography is integrated into business. An assignment explicitly involves delivery of images and a responsibility to pay for them and any expenses. The client states what is expected photographically, and the photographer estimates how much time a job will take and what the expenses will be. The photographer and client then negotiate a fee based on time, the rights being leased, and the photographer's experience and reputation. The client agrees to pay the photographer within a specific time, such as thirty days. The photographer agrees to be conscientious, imaginative, efficient, ethical and sensitive to the practical requirements of the job. The photographer also agrees to shoot on a reasonable deadline and deliver the pictures. Reliability is part of good business practice.

If an assignment comes to you by telephone, ask that it be sent to you by E-mail, fax or Federal Express so that you will have it on paper. The client may send you a purchase order and you may send him an assignment confirmation form. An example is shown in chapter five. This form, which both you and the client should sign, reiterates the terms of the assignment. Terms of an assignment, however, may also be adequately listed in a letter signed by the client or his authorized agent, which serves as a contract. All important conditions must be included.

Photographers learn to trust assignments by phone from clients they have worked with, but it is prudent to ask for a summary of the job on paper, or to send your own summary letter or form to the client immediately. Your fee should be included in that paperwork. Ask the client to make a copy of the agreement, sign it, and return it to you. That way you have started a paper trail to protect all parties.

Contracts and Agreements

Unless you are comfortably familiar with a client (a good relationship can develop after a year or two), beware of oral assignments and loosely defined requirements. If a client says you're being paranoid, mention that editors and art directors tend to play musical chairs, and you don't want to be left hanging if a new editor or art director refuses to accept your work or bill. Many clients will accept an assignment confirmation form though they may prefer to give

somewhat vague specifications and rates. At the end of the 1990s many magazines and some ad agencies are issuing their own contracts, which often include inadequate rates and little or no payment for additional use on Web sites, reprints or foreign editions. Photographers are crossing out objectionable conditions, which usually results in verbal negotiations. Some magazine publishers are obstinate, some more flexible. Reasonable photographers try to be adaptable, but many end up saying no. Communication between editorial photographers, especially, has been helping many understand that publications that try to dictate all terms are out of line.

The mantra of good business practice is "get it in writing." Don't rely on oral agreements alone. Expect the unexpected. Be prepared to negotiate rates and rights. There are a lot of potential pitfalls between a friendly arrangement and a successful job paid for in a timely manner.

A note about relatives. This may be controversial, but one should be especially wary of unwritten photographic job arrangements with relatives when much time and money are involved. Hopefully, you have good reasons to trust a relative, and you get paid and they get top notch photographs. If the other party has honorable intentions, however, and feels you do, too, each of you should not balk at signing a simple agreement that includes what you promise to deliver and the amount of payment you expect, plus expenses. The relative (or close friend) who says indignantly, "Don't you trust me?" is the one to be worried about. Those you can trust will not object to a simple agreement on paper.

Speculation

This is a dirty word among creative people. Speculation means that you work without a promise of payment unless the potential client finds your work acceptable and agrees to buy it, perhaps at a price dictated to you. Speculation is unfairly weighted in the buyer's favor. The photographer invests time and expenses and the buyer risks little or nothing. You may be offered limited expenses plus a credit line to do a job, with payment only when your pictures are accepted. The client's enthusiasm about such a project may be enticing, but unless someone puts a commitment to pay and predictions of possible usage in a negotiated written agreement, you face a serious risk. Avoid blue sky dreams. It's too easy for someone to tell you later, "Sorry it didn't work out."

Photographers speculate because they need the income, and perhaps for the exposure of publication and a credit line. Speculation can seem like a sure thing but it's too often an absurd gamble that twists what looks like a legitimate business arrangement into a game of craps.

Speculation is less prevalent in advertising where tightly planned campaigns are common. If you were foolish enough to shoot an advertising "job" without a signed agreement including details of payment and the pictures were rejected or the campaign was cancelled, what could you do with them?

As for low-paying magazines that offer five to twenty-five dollars per photo, it is wise to sell rights only to images that have no other market prospects. Just being published in an obscure periodical may generate hope, but your reputation is unlikely to grow and it's a form of exploitation.

Independent Production

When you have an idea for a photo or project and shoot it without contacting prospective buyers, you may be speculating that your idea will sell, but you are not following someone else's directions. Doing the photography, or getting it started, for a possible magazine story, book or market such as greeting cards, where, when and how you please, is called independent production. Time and money risks are your choice and you own the photographs. Independent productions offer experience and they can be an outlet for strong convictions about controversial subjects that may not sell easily. It is common to begin on your own with an idea and try to sell it *before* you've finished shooting, because of your enthusiasm and to stimulate financial support. Many fine stories, projects and pictures are launched as independent productions and later become part of proposals that segue into assignments. Some photographers do independent productions to satisfy inner urges, and to avoid client involvement until they are ready for it.

Minimum Guarantee

In the editorial field particularly, a potential buyer may offer a minimum guarantee in order to encourage a photographer to work on a story, or even a book project. This may apply to projects that could be lengthy, expensive or uncertain. The photographer agrees to begin making pictures, and the possible client agrees to pay for a specific amount of time and expenses so both can sample the worthiness of the idea. Magazine or book editors get an impression of the photographer's work and can better determine the value of the material. In some cases you can charge a higher fee for completing the assignment because its value is more readily apparent.

A minimum guarantee payment may be a flat fee or a day rate for a certain number of days, plus expenses. The client gets first refusal rights to the project and the photographer is subsidized for a limited time. You shoot all or part of a project, and if the buyer likes what you've done, you lease it at a prearranged rate and go on to complete the work and get paid. If the project doesn't meet the client's needs, the pictures and the idea belong to you. A minimum guarantee is a down payment against a job rate or page rate (the price per photo based on its size on the printed page), which are balanced against a magazine's page rate. If you are guaranteed $750, and the work is used on four pages at $300 a page, you will bill an extra $450 before or on publication. (For more information about editorial pricing, see chapter six.)

In the case of a book, you and the publisher may decide to negotiate a contract based on the preliminary images you've shot. On a book project the

minimum guarantee fee may or may not be incorporated into your advance against royalties. This should be decided ahead of time, when all minimum guarantee arrangements are spelled out in a written agreement. The good faith of both parties can result in a profitable mutual investment. (For more information about royalties and book publishing, see chapter ten.)

OTHER BUSINESS PRACTICES

Postponements: A purchase order or assignment confirmation should define what happens when a job has to be rescheduled for specific, defined reasons. Postponements are usually limited to a thirty-day period.

Cancellations: This fee covers time and effort the photographer spends preparing for a shoot, plus future shooting time lost, in case of cancellation. The number of days notice for cancellation should be negotiated in terms of compensation.

Reshoots: Responsibility for reshoots needs to be outlined in an agreement. Photographers usually want the right to reshoot without a fee when they are not satisfied with their images. They may also reshoot without fee when equipment failures, or other problems, are their fault. When a change of concept is involved after the original pictures were executed satisfactorily, the client should be responsible for a full fee, but not an additional usage fee. You and the client should stipulate ahead of time where responsibilities lie. Special reshoot insurance is available.

FUNDAMENTALS OF ESTIMATING

Estimating the fees for editorial and advertising work is both an art and a science. Calculating with some accuracy what to charge and how much your expenses will run can mean the difference between getting the job and making a profit, or going broke. The material in this section applies especially to advertising and corporate photography as well as larger editorial and commercial jobs. For smaller jobs, estimates of time and expense costs are less complex, so you can put them in a letter or on a listed estimate form.

An *estimate* is a prediction of the cost of a photography assignment including fees for shooting and preparation, travel time, casting, usage of the images, and all related expenses.

A *quote* is a current price a photographer gives a client to do a specific job.

A *bid* is a competitive quote compiled on the assumption that other photographers are also bidding on a job that may go to the lowest bidder.

All three terms include photography fees and expenses. The difference is in final cost flexibility and making an estimate gives you the most leeway for many jobs. Clients may feel there should be no variation between a quote and a firm bid. Following are considerations in the estimation process.

Ask Questions

Talk first with the creative decision maker, such as the art director, whose concepts you must understand in order to make the images he or she fancies.

Answers are usually based on a layout, so ask to see one. Essential questions to ask are listed in chapter seven under *Budgets, Estimates and Bids*.

Usually you will speak to an art buyer, an account executive or a client representative who has responsibility for budgeting the job. You should also speak to someone who can make budget decisions unless the art director can also discuss photographic fees and expenses. Chapter seven also includes a list of usage questions that need to be answered in order to come up with a suitable price for an advertising job. In chapter nine another series of questions enables you to better estimate photography for an annual report, brochure or corporate magazine.

Additional Questions to Ask
- What other photographers have been asked to estimate the job? Often your most important source of information for estimating jobs is another professional photographer, especially one who has more experience than you in estimating the type of job at hand. Sharing information helps prevent further reduction in fees by photographers who "lowball" (underbid). There is nothing illegal or unethical about discussing price estimating with other members of your profession as long as there is no attempt to fix prices.
- Does the client, the ad agency or a design firm issue purchase orders and pay bills?
- Will the client or ad agencies negotiate terms with and make payment directly to models?
- What agency and client representatives will be at the shoot? What expenses for these people should be included in your estimate?
- If the buyer says that the client has a low budget, ask "Is the job going to be awarded on a creative basis or is the the financial factor the deciding issue?" You have to decide whether it's worth taking the time to make an estimate under some circumstances.

Get It in Writing
Use forms or letters to show a client what you will charge, what expenses you expect to have and the conditions of the assignment. Address your estimate to the person who will approve it and issue the purchase order. Give your estimate a time limit such as fifteen, thirty or sixty days. Use the job estimate forms in chapter five to detail what rights the client has to your photographs as well as to give clear estimate figures and usage information.

Time and Rights
Let it be known that you will negotiate to contract for additional publication time if needed. If you are asked to sell all rights to the work with no limits on time or usage, instead try to negotiate an offer that guarantees payment for future usage that the client can buy if necessary.

THERE ARE NO "ASMP RATES"

The ASMP has been on the forefront of helping editorial, advertising and corporate photographers understand most of the topics covered in this book. You may hear the terms *ASMP rates*, *ASMP day rates* or *ASMP guidelines*. None of these terms actually represents ASMP policies. The ASMP does not, and legally cannot, set, fix, establish or otherwise create or impose photographic rates because it is a trade association, not a union. Surveys of ASMP members in the 1970s and 1980s revealed a range of day rate fees. The ASMP points out, however, that referring to those figures as ASMP rates "compounds the inaccuracy" because the amounts are antiquated and incorrect.

Q&A *with*
Suzenna Kredenser

Suzenna and Peter Kredenser of Los Angeles specialize in photographing celebrities. They also shoot advertising and promotion for TV shows and networks, and sell their own stock through sub-agents abroad. Peter was originally a fine artist in painting and sculpture. He came to California in the 1970s and moved into fashion photography. Shortly after, he began shooting *TV Guide* covers, other editorial work and then advertising. Suzenna used to shoot album covers, was in the music business and worked in film. She designed and manufactured sportswear under her own label and owned a boutique until she married Peter. She then switched careers and has been running their photography business for almost twenty years. Here is an interview was Suzenna.

Q You told me in a previous conversation that photographers are often their own worst enemies when it comes to pricing their work. Please elaborate.

A Most photographers don't know their markets. They don't know the value of their own work. I find that a lot of them seem afraid they might not get a job. They don't know the actual cost of doing a shoot and do not figure all of their expenses. They just put in a figure they think will get them the job. At the end, they find they're not making very much or they're even losing money. They don't know how to negotiate and don't know how to say no. I'm not referring only to entry level photographers, because some experienced enough to know better do the same thing. They'll undercut their own prices. Sometimes I feel that a lot of photographers have an air of desperation about them. They will do things people in other professions wouldn't dream of doing. I know this from the number of calls I get from photographers asking for help after getting into trouble.

Q What kind of help can you give them after the fact?

A Well, I know one man who sent out photographs in a promotional mailer, and later discovered someone had used one of them in a magazine ad. He called to tell the people they had used his copyrighted picture, and I

was shocked to hear he was willing to settle for a couple hundred dollars. When we discussed his overhead, etc., it became clear that even without infringement, the price should have been at least $1,000. I suggested he aggressively go after the infringer with the legal tools available to us all. Eventually, he was able to negotiate, from a position of knowledge and strength, a fee of $3,600.

Photographers do not understand what infringement entails. We hear in the news about designer luggage being copied illegally, and how the police and even the FBI go after the infringers. There's no difference between stealing a luggage design and stealing intellectual property such as a photograph, but people seem to think a photograph has less value. It has more value. It is an artistic creation, always one of a kind.

Q On what basis do you lease your work to television networks and shows?

A We do a lot of photography for advertising and promotion of television shows, and while many photographers turn over the rights to their pictures through a buyout or work-for-hire deal, we refuse to do that. We license the images for a set number of years and ownership always remains with us. If they wish to use them for a longer period, we negotiate additional payment. Thus, people who pick up a publicity still that is sent out by the networks can't legally reproduce it without first obtaining our permission. Photographers who work with celebrities have a bigger problem with infringement than most. This is because celebrities are becoming less accessible and stock agencies may rip off photographs that the studios send out as publicity stills. These agencies are under the mistaken belief that either the photographs are in the public domain, or that the studios own them, and that no one will go after them anyway. Individual photographers don't prosecute because of fear, lack of knowledge of copyright laws and how the legal system works, or because of improper legal advice.

Television studios as well as magazines resist working with us because we don't let go of our copyrights. We get hired mostly when a celebrity insists that we do the photos. Peter has long term relationships with many celebrities and they trust him. We negotiate with the producers, who want everything for nothing, so it's a struggle. We want to accommodate celebrities when we set prices, because we know the rights will come back to us and have further value. We emphasize that buyers can do well with limited rights, and that way they don't have to pay more for unnecessary rights. Often they understand. In some cases when producers don't want to pay enough for celebrity pictures we take, we try to negotiate for European sales, which sometimes will help sell a show worldwide. We try to find creative ways to make a deal.

Q On the Los Angeles ASMP E-mail network, you advised a member who had trouble with billing. This is what you said: "If we give permission for onetime use, that's what it means. If it's used again without permission, it's a copyright infringement. I always triple the normal rate for each unauthorized use, which is the industry standard. Our invoice states that we expect payment in ten days, and we charge 1.5 percent per month on the unpaid balance. I send a statement every two weeks with a reminder that until it's paid in full, no permission to reproduce is granted. Because our photographs are registered, the buyer is subject to statutory damages as well as attorney fees if we have to file in federal court. I usually give a two-month time limit, and then send a strong letter reiterating all of the above, with a copy to an attorney. If this produces no results for amounts less than $5,000, we file an action in small claims court, and have the marshall serve the buyer. Most often that does it."

A It's clear that if someone uses a copyrighted photograph without payment, they are in breach of contract. The more paperwork you have, the better your case if it goes to court.

Q When you triple the bill for additional use, do you get understanding or hassles?

A Defensiveness. One of the things we reward is when people seem to take responsibility and try to correct the problem. Sometimes it's just ignorance about their legal rights and obligations. One person in the company will deal with licensing photographs, and someone else in another department will just take a photograph and use it without thinking. Recently a television show used some of our photographs they licensed from a stock agency, which had obtained and distributed our photographs illegally. The production company assumed they had the rights to use the pictures. Most production companies and magazines, I find, do not ask stock agencies if they have the legal right to lease photographs. They just assume. I tape all the biography television shows so we can monitor them for our work, and that's how we found that infringement.

The production company balked at paying triple. In discussing the situation with their attorney, they showed a willingness to change how they do business: They promised to take time to check copyrights, and would research what rights they had. We liked their attitude and charged them half the triple rate. In the months following, they did ask questions, and showed they were sincere in sorting out photographic rights. That helps everyone in the business, and we continue to work with them.

Q Following a system in *ASMP Business Practices in Photography*, in this chapter I suggest that readers figure how much income they need to work and live, and to

determine fees accordingly. Does this seem a good way of pricing?

A Absolutely. But one has to be flexible. We've worked out a minimum editorial rate based on rates magazines will pay, which is difficult to control. The editorial field is not where you make the money. You do get access to good subjects from the shoot, and resale adds value, which is why it's so important to hold onto rights. Advertising is a different story. You have to determine charges case by case.

Q How are your stock and advertising fees based?

A We have minimum rates for stock, plus the value of the photo based on how exclusive and/or expensive it was to produce. We also take into consideration how it is to be used. Advertising fees are negotiated and they depend on the difficulty of the job and the rights they require. We try to stay within their budget if it's someone we work with on a regular basis.

Q Are you able to maintain fees because you are well known and have a track record? When clients try to chisel your prices, what kind of arguments do you use?

A We say "no" a lot. We're fortunate enough to be able to do that now. We are backed up by stock income when assignment work may slow down, and we have invested some of our income through the years. We try to think of each job as creating other income opportunities in the future. We did an ad shoot in Hawaii, and added a lifestyle editorial shoot for a magazine that did very well to supplement income on that trip. When we do celebrity shoots, we'll do more than the client requests so we'll have stock to sell.

Q What advice do you give entry level photographers who ask you about using forms for estimating, billing, etc.? Do you use such forms?

A Absolutely. All our assistants have to learn the business that surrounds photography. We explain the forms we use and we emphasize how important copyright and leasing rights are.

CHAPTER FOUR

The Art of Negotiation

THE BASICS

A perceptive daily newspaper comic strip called "Mister Boffo" recently showed two men talking at a desk. The visitor says, "I have a degree in business with a masters in looking busy, and I wrote my doctoral thesis on kissing up." The cartoonist, Joe Martin, commented, "The world the way it would be if colleges and universities offered more practical courses with no-nonsense realistic applications."

In the real world, valid business negotiation doesn't include "kissing up." Of course, negotiating agreements about fees and rights goes more smoothly if you and the client like each other, but don't think of negotiating as a popularity contest. You are making an agreement to support your legitimate position regarding rights, money and ownership. The other side operates from its viewpoint about the same topics, with different interests at stake.

Favorable negotiations are carried on in personal and practical ways. For example, the chairman and CEO of a high-tech company had to cut a production and distribution deal with a successful movie company. The CEO was asked how he was able to negotiate a fifty-fifty split of profits after only one successful film collaboration with the studio moguls. He responded: "We really like working with the studio. We wanted things like an improved income and greater name recognition for our company. They wanted to extend our relationship over a longer period of time. So we were able to accommodate each other." What resulted was a win-win situation which you'll read more about in this chapter.

GUIDELINES FOR NEGOTIATION SKILLS

Ideal negotiations about money, rights, scheduling and other business issues consider the interests of the parties involved in such a way that everyone finds the outcome acceptable. Is that possible? Well, photographers and their clients actually have many things in common. They share the same interests in achieving pictures they can be proud of and use effectively. They should also share a desire for fair payment for the lease of reasonable reproduction rights. Usually the areas of compensation and rights are where difficulties arise, and ideally, disagreements should be ironed out through compromise. When you face a dispute, keep in mind it's often more expensive, time consuming and emotionally draining to find a new client than to negotiate wisely and retain an existing one. Preserve client relationships by settling differences to your mutual satisfaction whenever possible, because the end of a photographer-

client relationship can be disappointing and costly to both parties.

Negotiation solves differences through reasonable communication. Reaching an agreement helps to eliminate areas where you've been adversaries and improves your chances for future business. Worthy negotiating skills for a photography business are similar to those necessary to get along with difficult relatives you nonetheless like and respect. See if you agree as you study this list of helpful characteristics:

- *A good self-image is helpful.* Confident negotiators are able to communicate in more persuasive ways than negotiators with low self-confidence. They organize their thoughts more positively and visualize consequences, both pro and con. Photographers ordinarily have to make mental predictions about how pictures will come out, so thinking ahead about negotiations, how your views might be received, and what the desired outcome may be should seem familiar.
- *Important decisions need to be made.* Like photographic decisions, business negotiations make similar demands on your imagination and nerves. Thinking about money can cause anxiety, so be as informed as possible in negotiations about rates and rights. Talk to knowledgeable people for advice. As you gather information, trust your instincts and prepare to live with your decisions. Even with the best intentions you may sometimes negotiate inadequately, but stand by your agreement in order to maintain your reputation as a business person. Your word has value even if you have agreed to terms you later find unfavorable.
- *Try to preserve harmony.* Before you start a job, begin negotiating agreements about rates and rights in a friendly atmosphere. Resolving a disagreement after the shoot is more likely to become rancorous. Lay the groundwork by doing your part to create a good, harmonious atmosphere for discussing problems. A positive outlook and confidence in your position help a lot.
- *Be intentionally reflective.* As you think about the issues being discussed, analyze them thoroughly. What you think you hear at first may not be correct. Ask in a friendly way for clarifications. Explore the "iffy" possibilities and consider the consequences. If you ask for a concession, what is the client likely to say? What might he or she ask for in return? Anticipate the alternatives so they don't pop up to surprise and disturb you.
- *Good negotiators are flexible.* There will be times when you can shift your position on issues to some degree without undermining your principles. Plan ahead, before you begin formal negotiating, about the areas where you can give if you get something in return. Topics where flexibility may be most valuable are fees, the range of rights, scheduling the shoot and expenses. Flexibility doesn't mean giving away the store. You should not have to compromise professional standards or ethics during negotiations. Knowing your costs and the consequences of going below or above

certain numbers will help you make sensible judgments You can't afford to undermine wise business practices or you'll risk losing your financial security.

- *Be empathetic.* It's amazing how effective your negotiations can be when you not only try to anticipate how the other side may respond, but what they are feeling about the issues at hand. When you are aware of the client's problems, even in general, show that you recognize them while negotiating from your own viewpoint. Try to imagine how a worthy client will respond to what you say and you may come close.
- *Be fair-minded and option-oriented.* If you are determined to "get the best" of every deal, eventually clients will abandon you because they may feel beaten down. Negotiating is like a careful ball game, but instead of hurling a ball back and forth, each side presents options to the other. When there are enough options on the table an issue or disagreement can be resolved using the best ones.
- *Be a conscientious listener.* Good negotiators have to be persuasive speakers, and they also need to be good listeners. Careful attention to the other party's positions helps you devise options to settle an impasse. Along with accomplished listening comes relevant questions. When you hear their answers and pay attention to the client's tone of voice, you can use your insight to develop options to solve the disagreement.
- *Believe in the value of your business and your photography skills.* I am talking about the importance of self-image and sincere convictions about the value of your own work. You must believe that the pictures you take will benefit the buyers and your negotiations should reflect this.

Photographs are valuable links in the world's commerce and communications, but if all photographers rejected exploitive deals, would clients stop buying pictures? It's very unlikely. Clients often realize how important good photography is to them, and therein can lie a special strength for you. Consider that some major magazines charge more than $150,000 for a four-color advertising page. Even with discounts for insertion frequency, the price of an ad page is staggering compared with the fees photographers charge to shoot images for those pages. If you are asked to quote a price for a magazine ad photo, or for other usage you know will be expensive, consider the client's other costs. You'll feel more confident in negotiating higher fees than you may have otherwise.

NECESSITIES, STAGES AND METHODS OF NEGOTIATION

Some time ago I read about the negotiating techniques of several members of congress. One leader, it was said, "Listens to everybody's points of view, and appears to be interested in what they're saying. But in the back of his mind he has a gyroscope going that keeps him on track to get him where he hopes to go." This leader has perseverance, the report continued. "He's a man with steel in his spine, despite his reasonable and modest demeanor. He sounds out

his opponents. If he finds his ideas aren't working, he drops them. If they are good, he moves his negotiations to the most senior congressional members. He has been seen under heavy pressure, but when his policies don't prevail and too many views could fracture agreement on a bill, he tries to find an alternative approach." This congressman knows how to lead and work with a team at the same time.

Negotiation Necessities

A basic necessity of negotiating about rates, rights and other photographic conditions is that you and the other side be ready and able to negotiate. Some people are inept, some lack convictions and some seem to feel negotiation is unnecessary. Often you cannot negotiate with such individuals. Think whether you fit any of these descriptions. If you do, ask someone to negotiate for you.

In a business environment you have to be something of a salesperson. Sales are important to your company, even if it's a one-person operation. Negotiations are an extension of your sales efforts. Salesmanship, or call it skillful persuasion, is a key to business success. If you can agree with a client on basic topics like fees and rights, you can help cement your relationship, and your income is boosted. Disagreement results from having different prerequisites or priorities, and sincere negotiations can resolve such differences.

Recognize that there is a spread between wants and needs. What you want may be a price higher than you've ever charged, but what you need may be somewhat less. Imagine your lowest price from which you will not move. A client may want more rights for less money than you're willing to lease, but could be satisfied with either fewer rights or an increased fee. The spread between wants and needs creates a negotiable range. By negotiation you can maneuver wants and needs closer together until you reach an agreement.

The Stages of Negotiation

1. The analytical or requirement stage when you review details of the problem or disagreement. For example, the client wants to use your pictures for a Web site as well as a magazine story, without extra payment.
2. The alternative stage, when you devise and present alternatives to solve the problem. For example, after asking questions, you determine that the magazine wants to use two or three pictures from your take for the Web site. You quote a fee.
3. In the acceptance stage the client considers your fee, and may suggest a twist of his own that you can live with. Together you discover what is acceptable to satisfy each side.
4. At this point you reach agreement and may sign a note, contract or agreement that incorporates the conditions you have negotiated.

Though you may not be aware of it, even in a short telephone negotiation,

all the above may happen. But you are more likely to see these steps on more complex negotiations, and after you have gone through the routine more often.

Aspects of Negotiation

- Who will do the negotiation? Yourself? A representative or partner? And who may be on the other side? An editor, art director, art buyer? Are you sure the person is authorized to negotiate with you, or are they sounding you out for someone else who makes the decisions?
- When will the negotiations take place? Often they may seem appropriate after creative discussions planning the job. Your enthusiasm is high and you may be unguarded. Actually, this may not be the time to discuss money and rights, because you might need time to think about the assignment and what it entails. It's too easy to be lenient immediately after a creative session. Unless it's a simple job, make the effort to postpone rights and money negotiations until you've had time to do some figuring.

 Convert to negotiation mode after a suitable interval. Determine what you want and what you find reasonable to give, and during this time you should feel the satisfaction of knowing you are maintaining your integrity and self-respect. You know that becoming belligerent will be counterproductive.
- Where will you negotiate? Many negotiations take place on the phone, one-to-one, where you can resolve things quickly. If you're meeting in an office, try to remove the client from distractions. Interruptions can have unfortunate consequences and affect a client's mood. If you want an atmosphere for selling yourself and your work, try to isolate your client, maybe in a conference room. A restaurant in mid-afternoon might be quiet, or go to a pleasant nearby park. Find a setting where interruptions will be avoided.

MORE NEGOTIATION TACTICS

Here are some additional aspects of negotiation:

- Go into negotiation with a mental image of what you want to accomplish. Besides your photographic fee, you may negotiate about time, advances and additional rights. Write down your goals and keep them where you can see them easily, but the client can't.
- Talk to colleagues who have worked for the client and find out if the company is a reasonable outfit. Inquire about the reputation of the art director or account executive or whoever you'll work with. Find out about their work style and personality.
- If you'll be talking money, discover as much as possible about the client's budget. When the subject comes up, you might ask, "What kind of money are you projecting for photography costs on this project?" Keep notes, especially on jobs that will cover a number of days.

- Imagine the worst-case scenario. What's the awful consequence if you don't get this job? You probably won't be out of business, and you can find other work. That attitude can help shield you from accepting deals you'll regret.
- Try not to ask a question that can be easily answered with a "no." For instance, don't ask whether you've got the job, but do ask how many photographs they'd like to see from each location or setup.
- Accentuate the positive. Establish some "yes" thinking by reminding them how reliable you've been in the past, or how well you have worked with a reference you've given them.
- Create a "red herring." Bargain for a minor point up front in order to have it later when you need to make a concession or trade. As an example, if you want the client to pay expensive model fees directly, and they balk, put that aside. Later, if the clients are reluctant to give you enough advance on expenses, offer to pay the models yourself in return for the advance you requested. If they agree, as one expert says, "You've traded your red herring for a gold fish!"
- To find out how much authority the person you're working with has, if you arrive at an agreement, ask if he has the power to sign. If the answer is no, tell him that you will make your best offer but will not sign any agreement until the person who signs okays the deal. Since your bottom-line price may be rejected by the person who can sign, make it clear that you reserve the right to ask for changes if the deal you and the original negotiator agree on isn't approved. Then you are negotiating on the same level.
- Silence is a tactic. Being able to stay quiet is a must for the successful negotiator. Practice the art of listening, and when you ask a question, wait.
- Never hesitate to ask "why" when the answer could be meaningful to your deal. Show interest in the client's concerns. In considering his or her problems, you indicate your urge to be more helpful in finding solutions.
- If you work with a partner, try the good-guy—bad-guy tactic when negotiating money and rights, but be subtle. One of you may seem determined to maintain a certain fee, while the other argues for a reduction of a previously established number to cinch the deal. The good guy may persuade the client to give what you hoped for.
- You can choose to postpone a request until after an agreement is made, when you may ask, "How about half the expenses in advance this time?" When you know this might be a sensitive point, you've put it off instead of risking the whole deal over it. If they say no, at least you still have the job.
- Try surprise. If a client says he can get a competitor to shoot a job for a price you are rejecting, offer him a couple of names and phone numbers "as a service." You might add, "I think I can satisfy you on this job better than anyone else, but if I've failed to convince you, it's my fault. I'll

make it easy for you to call someone else." Calling a client's bluff can be effective negotiation.

- Avoid signs of weakness. During negotiations, look the other person in the eye as you talk. When you stand, don't slouch. Think twice before leaning against a wall as if you need support. Try to speak confidently. If you turn down an offer by saying it's not acceptable, offer an alternative. Don't spend half a dozen sentences saying what you could in two, because the client may think you are vacillating.

- When responding to "take it or leave it," if the offer is actually suitable, take it. The other side may be trying to make you think further discussion is futile. But if the offer is unsuitable, you might respond by saying a take-it-or-leave-it situation is unfair, and that cooperation on a project is more likely to be successful if a deal is fair to both sides. You may then have the opportunity to explain what you want to fit your needs. It's smart to turn a take-it-or-leave-it situation into further negotiation.

- Professionals shoot millions of photos in a year, maybe a few of which have predictable sales as stock, but no one can be certain which images those will be. So don't give away rights by ignoring their importance. Subordinate rights have to be negotiated separately to prevent clients from believing that indifference to them is the way photographers normally do business. Be consistent. Do not sell a copyright or do work for hire without being well compensated. Explain that if you don't own your work, you can't lease images again, and you deserve to have them as a source of income. When you find it monetarily worthwhile to turn over a copyright, at least reserve promotional rights. Chapter one also presents a variety of points that can be made when negotiating rights.

- When you are negotiating fees with a client who claims his manufacturing processes are secret or who doesn't want his logo published without permission, win friends by leaving the proprietary photographs in the company's custody, and keep only other shots. A client's possession of images is not ownership of the copyright. Stipulate in your agreement that if a client wants to reuse the pictures later, as copyright holder you expect to be notified and paid a further fee.

- Rights for advertising, magazines, books, Web sites, geography and foreign languages may be negotiated separately. Clarify this in your discussions and agreements. Clients may try to buy more rights than they need, so each type of usage should have its own price. Don't ask what rights they want, but which ones they need. Often it's better to discuss usage rather than rights, which may have a controversial connotation. Ask how pictures will be used, for how long, in what media, etc., and explain that's how your fee is figured. If they don't seem to understand, explain that the more often they want to use the pictures, the more they will pay.

- There's more background about terms and conditions in chapter three to guide you in negotiating fees.
- Ideally, when the parties do not approach discussions in an adversarial way, when the client outlines his needs, the photographer tries to explain clearly the conditions necessary to do a first class job, and each party tries to see the other's point of view, it's a win-win situation.

PERSONALITY AND RESPONSIBILITY

Many years ago I co-wrote a book with a psychiatrist, Dr. Leonard Zunin, titled *Contact: The First Four Minutes* which analyzed how people interact when they first meet. In many places, such as at the office, school or a social event, personal appearance (among other things) makes a definite impact. Physically attractive people often get more attention than less appealing individuals, and usually sooner. Experiments, and our own observations, prove this true, but the phenomenon works two ways. Though a client may receive you more cordially because of your looks, and negotiating might be a little easier at first, a positive first impression may be temporary. You also must be prepared to explain how the quality of your work and your reliability deserve the fees, rights and other conditions you want. If you don't have your goals clearly in mind or on paper, or you are hesitant when you respond, your original advantage may fade. First physical impressions, terrific or not, should not outrank clear thinking and persuasive negotiation.

If you don't look like a movie star, but you're a competent photographer, an out-going personality combined with sincerity and preparation are an equally worthy combination. Realize you are a creative person, but without airs. Show your technical expertise using sample images. And equally important, be resourceful, intuitive, diplomatic, disciplined, realistic and reliable in business. Those qualities are essential for getting assignments, conferring on agreements, negotiating fees and rights, and delivering your work on schedule.

When you like the work you do, a persuasive and engaging personality helps ease the way to successful discussions that protect your rights, improve your professional fees and produce pleasant working arrangements. Sincerity is integral to effective communications because it shows that you'll get the job done well and on time. I emphasize these points because getting along with and skillfully influencing people are essential to making more money in photography. College courses may not include the effects of personality, but be aware that it colors everything you do with associates, clients and business contacts. In any negotiation your personality helps smooth the way.

I am not suggesting that anyone should adapt a phony personality to negotiate with clients and get assignments. If you're a good actor and adept at game playing it might work, but you risk being discovered and branded "phony." You could lose business. I am suggesting that you think and talk positively and enthusiastically. The better you realize the client's point of view, even if it's selfish, the better you can contend with it.

You Are Also Selling Responsibility

There are hotshot photographers who seem to come on too strong in negotiations. They seldom reveal much about themselves, so we may not know they aren't very successful. There are also more sensible moderate types who follow directions, exercise imagination and initiative, and don't complain or boast excessively. The latter are more likely to be dependable, an essential quality to success. They maintain schedules, stay within budgets, shoot pictures without irritating other people and deliver the work on time. They may also be known for a sense of humor, a good disposition, especially when things get tough. It's no surprise that if you have talent and try to understand clients' problems you will be a more successful negotiator. Dependable business people with cameras build solid reputations by satisfying clients' needs without sacrificing their own identity. All the above can add up to more money in photography. At the same time, keep in mind that photographers also have these responsibilities:

- Never lease or sell photographs for advertising or in any market that you have promised a client you would not offer to competitors.
- Keep your word, written or oral, about money arrangements, deadlines and other practical or ethical issues.
- Do not undercut a competitor intentionally, unless your offer is legitimate and you can make a suitable profit from it. Becoming known as a cheap photographer will threaten your future.

ADDITIONAL GUIDELINES

Here are additional guidelines for negotiating.

- *Use creative compromise.* It is reasonable to assume that a client may be cool to the first price you ask. Hold your ground, but inquire tactfully what the client perceives as a reasonable price for the work. If the response is much lower than what you've quoted, explore why the difference exists. Look at your figures again. If possible, ask the clients to explain how they came to their figure. Pay attention to what they may be overlooking and point it out. If they concede, leaving only a small difference, accept the job. If the difference is still steep, try to show how a figure closer to yours is more logical.

 If you want to give them a reduction, find a trade-off if possible—perhaps in expenses, perhaps in time spent shooting, perhaps in additional usage time. Never reduce your price without making clear the reason. Try to justify fees by reminding the client of your excellent track record. Show tearsheets that might help sell your points. Remind the client that you don't want to lower the price because it might affect the time you can spend on the shoot. Make it clear that you don't want to cut corners. Talk reliability and aesthetic quality.

 Remember there's no such thing as one right fee. What you charge and what they'll pay should come about by balancing your interests with theirs. Be skillful at creative compromise. If an ad client is spending

$500,000 for media space or an editorial client agrees to unusually costly expenses, they think enough of their projects to invest in them, and that involvement should extend to paying for first-class photography and experience.

- *Make it a win-win siutation.* Try not to turn negotiation into a contest. You need an agreement that is advantageous to both sides. If there is a clear winner or loser, negotiating has failed you or the client in some way.

- *Be aware of negotiation patterns.* Try starting with the easiest problems to set a discussion pattern that smoothes the way for more difficult points. If money talk is last, there is a better chance for you and the client to gain a job overview, so the fee you ask will seem more reasonable. Try to allow the client to mention money first. The figure offered may be higher than what you were going to propose. If you open the subject, you might say, "Suppose you had to put a dollar figure on all this. . . ."

 If their first offer is too low, counter with a better figure. Avoid sounding sarcastic even if an offer is absurd. Counter with facts and feelings about the size of the job. Mention recent impressive photography you've done. You might even reveal how much you were paid in the past for comparable jobs. You are offering a challenge in disguise, but try not to make the client defensive.

- *Reverse positions.* Try to imagine trading places. If you were the other party, how badly would you want this deal? How important would you seem to the client? Can you imagine the client's real limits on money and rights? What are the client's options if the negotiations fall apart? Will the negotiator have to answer to an account executive, a publisher or an editor? Is the client considering you because you are talented or because you seem indecisive? Asking yourself how the other party sees his goals and consequences can improve your bargaining position.

- *Show empathy.* When it's useful, acknowledge a client's position and proceed from there. For example, if a magazine editor asks you for a buyout (all rights) because his publisher is pressuring him, you might respond, "I can understand how you feel. It's uncomfortable when another department pressures you for something you may not feel is necessary. However, the publisher (use his or her name if you know it) doesn't understand all the facts and options. Could you get it across to him that the magazine will save a bundle by leasing first rights, and then additional rights if and when they're needed? I'll put it all on paper for you if you wish."

- *Disarm with a question.* When you don't like a client's comment, ask politely what it really means. Sometimes this helps someone gain perspective and soften a stance. It may also encourage more talking, so listen carefully to detect a weak area in the other side's position.

- *Don't ignore a position.* If you purposely don't respond to a client's point or position, he may become irritated, which could derail negotia-

tions. When you want to delay discussing something, ask to put it off for later. If you are unclear about something, say so. Don't leave the other side frustrated.

- *Speak candidly.* Tactfully reveal your feelings and don't tiptoe around the facts. If you say directly, "I want this assignment," indicate as well that you have limits on concessions. You might say frankly, "It's important to me to retain subsidiary rights to this series of photographs because I foresee other markets, but your rights will be protected." Candor and conciliation often go hand in hand.
- *Express disagreement.* Don't be afraid to show disagreement during negotiations, but never react in anger. Emotion is a forceful tool and like all tools, it works best when you're in control. If a client has an emotional outburst, consider it a loss of control. When you remain composed, you are at least momentarily in charge of the situation. Suggest talking about the topic later, and move on to another issue on which the client may be more flexible because of embarrassment.
- *Be aware of time restraints.* Don't let the client know you face a business time limit, or that you may give in on something important to conclude the negotiations if the client holds out. If delay means a scheduling conflict, however, you can mention it as a prod to progress. Conversely, if you have an insight into the client's time constraints, use it to your advantage.
- *Reach a deal.* When you feel you'll ultimately settle for whatever the other party has offered because you want the job, save yourself time and trouble. Accept the deal and curtail negotiations. Thank the client, talk about preparations and try to feel satisfied.

SUMMARY

- Negotiation is a normal process in business, divorce proceedings or deciding who will stay home when the children want the car.
- Understanding a reasonable viewpoint is a key to compromise. There should be good reasons for each position you take.
- When you work out an agreement, praise the client. This will make negotiation easier the next time and may make the shoot more harmonious.
- Try to put the client in an agreeable frame of mind by asking questions you know will get positive responses. Later when you ask more difficult questions, a "yes" may come easier to the client.
- If you fail to resolve differences, commiserate with the client. Expressing mutual disappointment may help inspire additional negotiation.
- Never take credit for successful negotiations, or the blame if the client complains that what he's signed is unfair.

I know a married couple who, when they have been favorably considered for a job, immediately send the buyer a friendly letter with a list of their terms,

and a note reminding the client that travel time is billed separately and other pertinent items. They explain that if they are kept aware of job plans, they can advise about efficient ways of scheduling and shooting. When they get a job description (in a purchase order, for instance) they say they can give a fairly accurate estimate of the time and costs involved.

The couple explains that their working arrangements include editing the take, retaining copyright to all pictures, granting rights to clients and other details. "We're selling technical and artistic ability to illustrate ideas photographically," they point out, "plus rights to reproduce those images in agreed-upon media."

The letter concludes, "We hope we have paved the way for more detailed discussion." Sometimes this couple offers a similar letter as a prelude to negotiations before they have cinched the work. In either case we can learn from their approach.

Q&A *with*
Elyse Weissberg

Elyse Weissberg has been representing photographers since 1982 and has a track record of winning top accounts for her talent. Weissberg offers creative consulting to an international clientele including individually tailored guidance on how to build a personal image, define marketing goals, structure a portfolio and sharpen presentation. She was a featured speaker for the national ASMP *Strictly Business* seminar series, and regularly lectures on bidding, estimating, negotiating and representing for associations and trade shows. Weissberg writes a monthly column for the ASMP National newsletter and is a platform speaker for the Professional Photographers of America (PPA).

Q In your experience dealing with advertising and editorial clients, what can photographers do to improve their negotiating skills?

A When a client wants to talk about a photo shoot, money and rights are always important, but the underlying issue is more about the value of the photographer. Imagine photographers A and B, negotiating for the same job. A is a better photographer, has a better reputation and his portfolio is better organized. B's portfolio is less presentable and his photography skills are not as developed as A's. So, B is thought of as having less value than A to the client.

When B negotiates with the client and learns that A is also up for the job, he feels he must try harder. B feels like the second fiddle. Photographer A knows he is likely to be preferred and approaches the estimate with a better mental attitude. A has the track record. Most important, the client is going to show A more consideration than B, because he is well regarded.

So an important part of negotiating has to do with the psyche. Even if a photographer is not always the best, if he feels like he is really valuable, he's going to do better in negotiation. Photographer A tells the art buyer, "I will get you the shot and you will be happy." He gives the client confidence. Giving your client a sense of security during the negotiation puts you in a good position. I do talk about money and rights, but I also talk about a photographer's value. What is that worth to the client?

Q What happens when a not-so-well-known photographer tries to gain advantage by lowering a price?

A Before lowering a price, ask the client, "Is this a money issue?" I don't think that more than 10 percent of the jobs I negotiate are awarded to the photographer with the lowest price. Clients can always expand the budget a bit. On the lowest-price jobs they just want a guy with a camera, and I'm happy to walk away from them because it seems obvious they don't want a quality photographer. Of course, when someone doesn't have money for rent and takes a $100 job, it doesn't matter to experienced pros who are not competing on that level. When offered a price too cheap, walk away. If they chase you, you're in a good negotiating position. If they let you walk away, you shouldn't have been there to begin with. When a client wants the security of working with you, they have to pay for it.

Q I read that when disputes are mediated, "both parties win because they've come to a resolution." Can successful client-photographer negotiations be described in this way?

A I don't like the terminology. It sounds like when two people negotiate they are on opposite sides. The most successful negotiations I've had are when I visualize walking to the client's side of the table. I feel more comfortable negotiating if I'm on their team because we need to make this job happen together. That applies to fees and expenses. I avoid an adversarial point of view. If expenses increase, that's what we needed to get the shot for the client. I try to avoid getting into who's spending whose money.

Win-win is not as contemporary a concept as creating an atmosphere of working together. That way negotiation is not always opposite sides, the photographer vs. the client. You and your client should be looking at the job as a team.

Q Talk to me about a bid versus an estimate.

A An estimate is a list of what the expenses on a shoot could be. Date the estimate, and if the client calls months later and says you've got the job, say you want to review it to be sure the expenses have not changed.

There are comparative and competitive bids. The government likes competitive bids, in which the lowest price gets the job. Comparative bids are for the cost control people at agencies who want to know where the money is spent. When an art buyer questions the amount of film you estimate using, it can be compared to that item in another photographer's bid. A bid can give the client a good idea of how you intend to produce the job.

Q Are your negotiations with clients usually in person or by phone?

A It's been a long time since I've negotiated in person. I discuss jobs over the phone, and usually fax a bid or estimate to the client and follow with a phone call. The same arrangements can work for an individual photographer 99 percent of the time. If you do visit the client and show your book, and the client asks for a bid on a job, you might say, "Let me think this through. I'll probably have some questions because I know you want the best job possible." Return to the studio and work it out. If you are nervous at a meeting, you might start quoting prices that you may regret.

If the client says he needs a number immediately, the photographer should say, "I know you're in a rush, but I also know you want the most accurate estimate I can give you. I don't think you want me to just throw out an amount." Soon after, during phone contact, your careful attitude may convince a client of your value.

Q Should a photographer think ahead and decide what reasonable concessions he's willing to make to get an assignment?

A That kind of question scares me because I hate to go into a negotiation thinking about what I'm going to give up. I go in knowing the lowest figure my photographer can work for. For instance, I may tell a photo editor that a certain editorial job will be $1,000. "Too much," he says. "We pay $750." We talk and the figure becomes $850. I may then negotiate for a more prominent credit line. They owe me $150 and I'm negotiating for ways they can make it up to me.

Q Is it sensible to make a fee or rights concession if "the next job" is promised?

A It's the kiss of death. In my twenty-year career I've never received the next job, though it's been promised. I'm still waiting.

Q Can photographers who understand where you're coming from represent themselves successfully?

A Yes they can, though they should hire someone like myself as a consultant to put together a portfolio and devise a marketing plan. It's difficult for photographers to do everything themselves.

CHAPTER FIVE

Written Agreements and Contracts

IT'S ABOUT COMMUNICATION

Buyers in today's competitive photo markets expect outstanding pictures. Your personality may attract attention or publicity, but talent, reliability and meticulous business methods are just as important. As noted in chapter four, to make more money in photography you must express yourself clearly and tactfully when you negotiate fees and rights. Another meaningful means of positive communication with clients is the forms and agreements you present to them. In a quiet way, paperwork helps build your reputation, as it protects your rights and maintains your professional status. Proper agreements, contracts and letters are part of the first impression you make on clients. They are covered in this chapter.

Business letters. Here are some guidelines for projecting professionalism in letters and other written contacts with clients and associates:

- Be clear, specific and thorough, but not abrupt.
- Limit the superlatives, such as "best" or "most wonderful," that you use to describe your goals or work.
- Don't make promises you can't keep.
- Be patient with clients while trying to subtly persuade them toward your views.
- As you and clients achieve more rapport, respectful informality is in order.
- Letters on stationery or by E-mail may have similar style. E-mail is less formal.
- If you aren't satisfied with your writing or speaking skills, enroll in classes or hire a tutor. A representative (also called a "rep") or business manager can do your talking and writing, too, but you'll have to pay for their services.

WRITTEN VS. ORAL AGREEMENTS

For nearly all business arrangements, the client should sign an agreement that protects your mutual interests. As the ASMP says, "If you don't get it in writing, you may not get it at all." Successful bankers, contractors, automobile dealers and others all insist on operating with written agreements. For the

same reasons, photographers and their clients need to know what their obligations are when they commit to working together.

Oral Agreements

It may be true that oral agreements are legal in some states, but there can be pitfalls if an oral agreement ends up as a court case.

- The first thing a judge or arbitrator will ask both parties is, "What do you have in writing to back your claims?" If the work seemed so trivial that nothing about rights was included in your bill, your case is immediately weakened.
- If neither party has a witness, each of you could testify how you understood the arrangements, and you'll hear glaring differences, true or not, to amplify the discord. His word against yours is a hazardous situation.
- Even if each party has witnesses, they could contradict each other in testimony, compounding the mess.

Without convincing evidence that a client promised you a specific payment, or that your permission for use of pictures did not cover how the other party used them, you could be out of luck. It's too bad, but agreements sealed with a handshake can become acrimonious disputes. Most business arrangements are worth a written record, especially when they specify fees for, and licensing of, your work.

An ASMP booklet titled *Forms* (which is now out of print) states "In general, photographers dislike paperwork. It's not a creative experience, but paperwork is critical to the proper management of a business. Successful photographers do paperwork first, then they shoot pictures." The concept that only photographers with known reputations rely on paperwork is misleading. When any professional gets it in writing, he or she appears more competent to clients, which usually adds up to a better living. This includes all photographers who sell and lease their work, full-time or part-time. Part-timers are often more vulnerable than full-timers, who usually have more experience with paper work.

An oral agreement, or an incomplete one on paper, may seem reasonable when a job appears to be quick and easy. But evaluate the consequences of any job or assignment with care, because the unexpected can come back to bite you. "In an oral agreement you can avoid dealing with the hard facts," states *Forms*. Maybe you discuss terms with a client, and assume that everything is fine concerning publication rights, money and ownership. But memories fail, conciliation becomes contention and details can devolve into grievances. If you shoot a job on faith, you must be able to trust the client. A verbal agreement can lead to damaging assumptions. Even if the client is honest, each of you may not interpret your intentions the same way.

Written Agreements

The ASMP has been promoting the use of written agreements since before 1973, when it published its first business practices book. Since then the ASMP's staff and many expert members have written, debated and rewritten dozens of useful forms designed for photographers. Now all of these are gathered into *ASMP Professional Business Practices in Photography*. For *The Big Picture* I have devised forms that are composites of existing ones from various sources. These are written as clearly as possible, and I encourage you to further adapt them to fit your own needs. (Explanation of the forms in this book begins on page 73.)

As an example of the necessity of forms, a neighbor asked me to photograph him with a group of people dressed as clowns. It was for the newsletter of a charitable organization to which my neighbor and his friends contributed their efforts. We agreed on a price for color prints, and I gave him a letter of agreement. On it and the invoice I wrote, "For personal publicity use in one organization newspaper. Additional fee to be negotiated for any other usage." He assured me no other usage was planned, but I told him if the group was "discovered" by a magazine, and they gave an editor pictures, I would have to grant rights to use the pictures for the additional usage. I explained that a magazine might not want to pay me for pictures he gave them, and I deserved additional compensation. He understood and signed a copy of the letter for me. This was a dinky job, but that I asked for an agreement was enlightening to him. (His group has yet to be discovered.)

Some photographers worry that their clients will refuse to sign a business agreement form, or at least will give them a hard time. If this happens, take it as a warning. Someone reluctant to negotiate and sign a fair agreement may also be unwilling to honor the rights leased, or to pay for the work. When dealing with a skeptic, diplomatically continue to require the agreement on paper. Ask any colleague about his or her experiences when agreements were flimsy or nonexistent. You'll hear horror stories that explain why photographers should insist on adequate written arrangements before they begin a shoot.

You may also hear about unscrupulous clients who misuse photographers' work in spite of written agreements. If you have the paperwork, you can put pressure on them and sue if necessary. People can be deceptive and unpredictable. When a client says your written agreement is unnecessary, consider the consequences. Proceed to shoot at your own risk.

I also feel that a majority of clients try to be honorable. Unless your feelings indicate otherwise, deal with picture buyers with respect, and expect the same from them. Most photographers will tell you that most of their clients are worthy.

TIMELINESS

It is good business practice to begin discussing details of a shoot as soon as plans seem serious. Experience indicates, however, that too many photographers wait to send forms. They tend to rely later on invoices to set agreement terms. Since

you don't send an invoice until the job is done, it may be too late to iron out potential differences. (I used an invoice to explain terms with my neighbor, but here I'm talking about much larger jobs.) Your invoice may have surprises in it that have not been discussed before, and the client may complain that you are trying to impose a contract after the fact. Under such circumstances some or all of the terms in your invoice would not be binding on the client.

Forest McMullin, a busy corporate and advertising photographer from Rochester, New York, tells me he adapts Jim Cook's *Hindsight* forms (you'll find ordering information for this software at the end of the chapter). Before a job he sends an estimate form, and when that is accepted he goes back to the computer and revises it into a job description (or assignment confirmation) form. After the job is done, he revises the previous form into an invoice. Each form has terms and conditions on the reverse side. I used Forest's statement on timeliness at the bottom of the editorial invoice I adapted for this book. See this form on page 84.

When dealing with magazine editors, designers and other buyers about assignments made by telephone, I make notes while talking and ask the caller to fax me the job specifications. I make time to fax back an assignment confirmation form to summarize my understanding of the job and submit data on fees, expenses and rights. These chores can be done quickly by fax or E-mail. After a relatively complex assignment offer by phone, take time to do some thinking and call the client back *before* sending a form. Discussion is vital to mutually acceptable clarifications. Then send an assignment confirmation form.

By now you should have the message: Offer business details on fees, terms, expense estimates, etc., *before the work starts.* A fully informed client who okays proceeding with the work indicates consent to the terms you present. If a confirmation form is not signed, it has at least been given to the client and it will be more difficult for him to make fundamental changes after you get into the shoot.

But suppose there's a tight deadline and you start shooting quickly, before the client has time to review your assignment confirmation form. Even though you seemed to agree in discussions about the work, at the earliest opportunity, stop and explain that you made a concession at his request to start shooting before you had a signed agreement. Request that he now read and okay your agreement. Take time to discuss any items he questions. If this leads to negotiation, try to limit the areas under discussion. Convey the message that you are equally disadvantaged until you have both signed the document. If the client will not sign, emphasize that though you prefer not to, you'll have to stop shooting and bill him for uncompleted work—a situation he instigated. This is not blackmail. It is a normal business practice. Should the client continue to hold back, make it clear that your expenses and fees could increase because of delay, and you really want to negotiate and get back to shooting.

What recourse do you have when you get an assignment in the morning,

shoot the pictures that afternoon and send unprocessed film the same day? If possible, fax or E-mail assignment confirmation form showing your fee and expenses before you send the film. Repeat what you and the editor agreed upon so it arrives before he sees the pictures. Don't panic or make rash phone calls. Most clients, even those you barely know, are not "bad guys." Business forms are simply a kind of insurance.

A number of magazines, however, have been trying to dictate rates and rights to photographers by sending the company's contract, often after the shoot is completed and sometimes after the pictures have been shipped, with your invoice stating the fee and rights granted. Aware photographers have informed picture editors that the magazine's contract is invalid when presented after the fact and has not been negotiated by both parties. There are excellent legal grounds for this stance, so stand your ground. Some publishers' contracts offer inferior day rates, no additional payment for foreign editions and no extra pay for use of images on their Web site. (For more information, go to www.editorialphoto.com. There you can learn about joining the Editorial Photographer's list where over 1,500 professional photographers discuss contract issues over E-mail.)

Having the correct forms and releases signed does not fully guarantee that misunderstandings and legal hassles will be avoided. Some clients are unpredictable. A paper trail is your best protection if you deal with someone who may be litigation-happy.

DESIGN YOUR OWN FORMS
Self-designed forms, based on those offered by the ASMP, in *Business and Legal Forms for Photographers* by Tad Crawford, those in the *Hindsight* software, or the ones presented here can be used for most jobs. In this time of fax, E-mail and other high-speed communications, the efficiency of a ready-made form from a book is also quite acceptable.

Feel free to use the forms shown in this book as is, or as guides to creating your own. Include just the components you need. Or convert preprinted forms (from sources listed earlier and below) into versions for estimates, confirmation and delivery. Adapt forms to match each of the photographic areas in which you work. Or use software (like the CD-ROM with Crawford's book) that allows you to copy, create and revise forms for specific purposes. When you adapt your own forms, you may also decide on appropriate terms and conditions that apply to your business. Forms explained below are illustrated at the end of the chapter.

Letter of Agreement
A letter agreement may cover all the bases for simpler jobs. Write the confirmation in a letter and summarize the terms. A letter seems more personal and less formidable than other forms. Cover the necessary terms and details to make the letter complete enough so that it can't easily be challenged. Be

thorough, specific and concise. Use numbered lists when appropriate. State fees, rights and expenses in a business-like way. The sample letter of agreement (Form 1, on page 79) has a flexible format that can be revised to suit your needs. It should be written in your own style to personalize it. Avoid completely copying another person's letter form. You don't want clients to wonder, "Couldn't he write his own?"

Assignment Estimate

This form (Form 2, on page 80) is often the first form used unless you start with a letter form. It gives the client the projected cost of the assignment plus a description of the usage rights granted. It's the first time the client will see what the job will cost, even though it may be an educated guess, plus he gets confirmation about rights. After you cover these bases in a telephone conversation, tell the client you will be sending a written estimate reiterating your discussion. Fill out and send the estimate form as soon as possible before you start shooting. Fax or E-mail the forms. If the client doesn't call you, call him to be sure he received them because now is the time to iron out details.

The estimated charges on the assignment estimate form will be echoed on the forms that follow. Remember that Forest McMullin converts this form into those that follow, and prepare your forms so you can do likewise, if you feel it will save time.

Estimate of Photography Fees and Expenses

This form (Form 3, on page 81) is an alternate to the Assignment Estimate form for sending an estimate to a client after a telephone discussion. It allows more detail for advertising and corporate jobs, which often have their complex variations. It can be shortened or revised for editorial photography. On the form I've added notes about some items to guide you. If this form includes too little space for rights and usage for bigger advertising and corporate jobs, enlarge it to two pages or more. Give priority items more space.

Assignment Confirmation and Conditions

Adapt this form (Form 4, on page 82) to cover editorial, advertising, corporate and other media photography. Advertising work may require added details about rights. For further guidance, look at forms in the books mentioned in this chapter and ask to see forms used by colleagues. Editorial photographers may give themselves less protection when they use a letter instead of this form. So do so only with smaller magazines with editors who have been around a while and have earned your trust.

A form like this is essential for larger magazines such as those published by Conde Nast and Hearst, which have been offering contracts to editorial shooters that include no payment for electronic (Web site) rights. In mid-1999 editorial shooters were also making a strong effort to get these publishers to raise day rates.

When you get too comfortable without anything in writing, you risk financial security. "On rush jobs," says Tad Crawford in his book, "there is a tendency to skip the paperwork." But send a confirmation letter or form whenever possible. On some jobs, purchase orders, more common in advertising and corporate work, may be issued after full negotiation takes place. Crawford points out that all parties benefit from having terms and conditions spelled out in a confirmation form *in addition* to having a purchase order.

Explanation of headings

Assignment confirmation forms for advertising and corporate work may require more headings than those for editorial jobs such as:

Cancellation: If the client cancels a job, charges should be made for all preparations and for shooting time. If any pictures were taken you may charge for jobs lost because you could not schedule them, based on your shooting fee, depending on how much notice of cancellation was given. Forty-eight to seventy-two hours' notice is reasonable. Cancellation rates are negotiable. If the photographer must cancel, the client should be reimbursed for expenses and advances. Such a cancellation would only be expected in case of illness or other unavoidable reasons.

Reshoot conditions: These can be fully covered on the back of forms under "Terms and Conditions." If the fault is the photographer's, reshoots would be done without charge. Expenses can be negotiated. If it's the client's fault, the photographer would be paid the full fee and expenses as stipulated for the original shoot. If someone else is at fault (such as the lab for causing processing errors) the client may pay or split expenses, but no fee is charged.

Magazine rights granted: The standard would be "onetime nonexclusive single language rights for editorial usage in [name of publication], with a circulation of [number], for [month or edition and year if you know these] for distribution in [country or region], to be published only as [cover or inside page, portion of page, number of pages if you know]." Define whether the media intended is print, electronic, Internet or a combination. Provide the subject of photography (name or description) and copyright by (photographer's name). Without previous negotiation, no rights are granted for advertising or promotion of cover photographs or inside pages. Fees covering reprints of magazine material must be negotiated separately with photographer. All rights are reserved except those noted on the invoice or estimate.

Foreign rights: As I write, a large magazine is attempting to change its assignment contract to include broad rights for reuse of assignment photos, even outtakes, in their foreign editions. Photographers and photo agencies are responding with sharp criticism on the basis that additional usage should be paid for, since the company earns additional revenue. Foreign rights must be negotiated separately and payment should be covered under this heading in an agreement. You need the right to earn additional income from reselling your pictures.

Delay conditions: If a job must be delayed for a short time because of illness or unavailability of the client or photographer, arrange to extend the deadline, and negotiate for a standby fee, when you are on location or could be working for another client.

Some magazine editors are not familiar with these conditions, which are more common in the advertising industry. If you meet resistance, be persuasive and explain that both parties are protected. Some editorial photographers, eager to be published and quick to trust, tell disturbing stories about exploitation. That's one reason I emphasize storing forms on your computer so they'll be ready for instant use. You are simply reiterating facts and figures on paper that you have agreed upon previously.

Expenses: Itemize whatever applies. If you are not sure how much the lab or shipping will cost, estimate them. When the time frame for starting work is tight, or when you must fly and rent a car, stipulate a cash advance to be deposited to your bank by wire transfer. These are details to work out by phone.

Delivery Memo

When photographs made on assignment or from stock need to be sent to or left with someone, use a delivery memo (Form 5, on page 83) to list the images and to make the recipient aware of their limitations and your rights. Years ago an artist asked for a series of my nude photographs from which he could paint. I selected twelve black-and-white prints and listed them by file number and short description on my delivery memo. I set a two-year holding limit because I trusted the artist, and included in our agreement was a small painting he would give me in return for using my photos as image references. The delivery memo made him aware that he could not sell the photographs, and reminded him of my copyright. His signature on the delivery memo made our agreement binding.

A separate stock photo delivery memo is included in chapter eight.

Editorial Invoice

I've adapted this invoice (Form 6, on page 84), but there are many variations possible. It should be printed on your letterhead and be dated and addressed to an individual editor or art director with company name and address. Include a job number if you use them, plus the client's purchase order number if applicable. In a separate section describe the assignment photography with such details as "color coverage of the new library's Edgar Wilson rooms, library personnel, computer setup and exteriors." State the rights you are leasing, perhaps copied from a previous form. Include any limits on usage such as "magazine use only." In the case of items such as album covers or posters, state the limit on the number of units the license covers. Note that the copyright symbol must be used with photographs.

Bill photography fees for usage described, and add fees for travel time, standby time, etc. List expenses. Refer to Forms 2 and 3 for more thorough lists.

Terms and Conditions

Terms and conditions can be included on the backs of some forms. I adapted these terms and conditions (Form 7, pages 85-86) from those suggested by the ASMP. Print them on the reverse side of your own forms. When you send a letter form, if you choose, they could be sent on a separate page. Consider having an attorney read the terms and conditions you use for accuracy, suitability to your location and perhaps simplification.

For editorial, advertising and corporate forms, terms and conditions are nearly the same. In each category it is expected that forms will be signed by an editor, art buyer or someone in charge, and a copy is to be returned to the photographer.

Other Forms

Chapter eight: Stock Photography Delivery Memo (Form 10, page 134), Stock Photography Invoice (Form 11, page 135), and Model Releases including an adult short form, a form for adult-minor combined and one for minors alone (Forms 12, 13 and 14, pages 136 to 138).

Chapter Ten: Query Letter for Photographically Illustrated Children's Books (Form 15, page 161).

Chapter Eleven: Commercial Photography Licensing Agreement (Form 16, page 172) and Licensing Contract for Images on Paper Products (Form 17, pages 173-174).

Chapter Twelve: Portrait Photography Contract (Form 18, page 185) and Wedding Photography Contract (Form 19, page 186).

Chapter Thirteen: Gallery agreement (Form 20, pages 196-197).

ELECTRONIC USAGE

Terms in a form for use of pictures on a Web site should parallel those for magazine publication. To set fees, consider picture size, length of lease time, distribution and placement. Small thumbnail shots used on banner ads by search engines should have the highest price of all, according to expert Seth Resnick. He offers a Web pricing guide on his site, http://www.sethresnick.com.

In contracts and invoices use the following wording:

All rights granted under this document for publication in a collective work [such as a Web site, magazine or book] *exclude all usage rights for any revision of that collective work or any other later one, unless such rights are directly granted elsewhere in this document.*

If you want to limit Web usage, add:

Among those usage rights excluded *are rights of publication, display and transmission in any media, including traditional print,* electronic and digital media, *as well as media not yet known.*

clear to editors and art directors what kind of fees and rights you want and explain you need to make a living by being paid for each use of your photographs. Ask your magazine, ad agency or corporate contacts to discuss your views of rates and rights with their bosses. Sometimes you may need to talk directly to someone of authority to explain your needs. You must take risks to improve your opportunities. Whether you protest or not, it is illegal and unethical for publishers or a publication to assume rights to your images without your agreement. The additional income you deserve may have to be fought for.

SOURCES OF FORMS

- *ASMP Professional Business Practices in Photography* includes numerous forms and information. Published by Allworth Press, it is also available from Writer's Digest Books.
- *Business and Legal Forms for Photographers* (Allworth Press) by Tad Crawford, attorney. Informative material about business forms also appears on a CD-ROM included with the book.
- For many years photographer Jim Cook at Hindsight Ltd., Highlands Ranch, Colorado, has been producing software programs for captioning stock pictures (see chapter eight), as well as business forms that are easily adaptable and available on CD-ROM. You can preview the company's wares at http://www.hindsightltd.com on the Internet, or call (888) 791-3770 for product literature.
- *Small Business Fundamentals*, a program on CD-ROM from Model-Office (http://www.modeloffice.com or [800] 801-3880) offers many types of help in running a small business, and includes contract forms you can adapt. It contains advice sections and spreadsheets you can open with Excel. ModelOffice comes with its own browser, making it easy to find the document you need among its more than two thousand tools, guidelines and spreadsheets. (The company also sells *2,001 Sales & Marketing Letters* with advice on how to sell yourself, your business and your products complete with sample letters.)
- Sample business letters are available on the Internet from Intuit, some for free. Intuit's small-business Web site (http://www.quicken.com/small_business) offers free documents, forms and spreadsheets for business planning and management.
- The American Express Small Business Center (http://www.americanexpress.com/smallbusiness) offers guidelines on how to buy, sell and manage a business.
- The Small Business Administration (http://www.sba.gov/library/sharewarroom.html) offers a number of useful business programs, sample documents and spreadsheets.

FORM 1 Letter of Agreement

YOUR NAME OR BUSINESS NAME
Your address • Telephone number • Fax number • E-mail address • Web site address

Date
Name of client
Address of client
City, State

Dear Client's Name,

I enjoyed talking to you this morning, and thanks for the assignment to photograph [*description of assignment such as "the meeting of the XYZ club"*] on March 22 and 23, 2000. [*If assignment requirements are fairly extensive use a list such as:*]

Dale Winston and the morning meeting of the XYZ Club
Individual photographs of six speakers on the program
The XYZ Club's new building, exterior, and a few interiors
Close-ups of the XYZ Club's new publications for members
Cover social event of the XYZ officers in the evening of the second day

It is my understanding that these story illustrations will be used on three pages of [*name of publication*]. Here is an estimate of my photographic fees and expenses:

Two days of photography of the XYZ Club meetings and HQ @ $450 per day
Two half days traveling to XYZ Club's HQ @ $225
Estimated expenses for mileage (or airfare), film, processing, lodging, food, shipping and misc. are $300.
Estimated total of photography fee and expenses: $1650

The above assignment includes onetime usage rights in your magazine as well as promotional use of photographs for that issue. Use of any photographs for advertising or re-use in other forms or publications to be negotiated. All transparencies (or negatives) are to be returned to me within 30 days after the issue in which they appear is published. A copyright symbol (©) will accompany my name in credit line.

[*If you wish to ask for an advance on expenses, do so here. In a case like this ask for the whole $300. Later when you itemize the expenses, you can bill for more or refund if necessary.*]

I'm sending two signed copies of this agreement letter, and will appreciate your returning a signed copy to me. Please call if we need to clarify anything. Thanks.

Best regards,

FORM 2 Assignment Estimate

YOUR NAME OR BUSINESS NAME
Your address • Telephone number • Fax number • E-mail address • Web site address

Assignment Estimate

Client _____ Date _____
Address _____ P.O. # _____

Assignment Description _____

Rights and Usage _____

Photography Fees _____

Total _____

Expenses

Assistant's service . _____
Film and processing [*this could take two lines*] _____
Travel expenses [*car rental, airfares, etc.*] _____
Food and lodging [*for photographer and assistant*] _____
Shipping and messengers . _____
Special equipment rentals . _____
Insurance [*special riders if applicable*] _____
Models. _____
Location rentals and props . _____
Sets . _____
Miscellaneous . _____

Total . _____

Total estimated fees and expenses . _____

Upon acceptance a cash advance of _____ is required prior to the start
of the assignment.

This estimate is valid for 60 days from the date above. Estimated amounts are subject
to a normal trade variance of 10%. Fees and expenses quoted in this estimate are
for the original layout and job description only, and for the uses specified.

FORM 3 Estimate of Photography Fees and Expenses

YOUR NAME OR BUSINESS NAME
Your address • Telephone number • Fax number • E-mail address • Web site address

Estimate of Photography Fees and Expenses

Client _____ Address _____
Photography Fees _____ Assignment Desc. _____
Travel Time Fee _____ Rights and Usage _____

[The following expense headings may be applied to all types of jobs. Choose those that fit your work in editorial, advertising, corporate, or other applications, to create your own forms. Main expenses have been listed and can be itemized on separate lines to fit your needs.]

Film and Processing [*It is standard to mark up these charges by 10% or more to cover travel to and from labs*]. _____

Travel Expenses [*Air fares, excess baggage, cabs, car rentals and mileage, truck rental, parking, tolls, etc.—may be itemized*] _____

Food and Lodging [*Hotels, motels, RV parks, restaurants including guests you may be photographing, groceries and miscellaneous food items, which may be itemized*] . _____

Telephone [*Include charge card calls and use of mobile phone*] . . _____

Shipping and Messengers . _____

Special Equipment Rentals [*Cameras, lenses, electronic flash, etc. It is customary to have these expenses authorized by client before renting*] . . . _____

Insurance [*A portion of your premiums on liability, equipment and other business insurance, or full premium on one-time riders*]. _____

Following are expense items more applicable to advertising photography work

Casting [*Agency fee, film, time for casting from files*] _____

Models [*Estimated payments for adults, children, extras, etc.*] . . . _____

Assistants [*Expenses for photo assistants, home economist, production coordinator, stylists (hair, props, wardrobe), animal trainer, teacher for minors, etc. These should be itemized*] . _____

Locations [*Expenses for scouting, film, other research, location fees for homes, etc., permits, travel (car, plane, hotels, food, etc.)*]. _____

Props [*Those you need to buy, rental, food and other expendables*]
. .

Sets [*Carpenter, painter, hardware, plumber, paint, wallpaper, set design and research, backgrounds and backdrops (custom made or stock), other studio materials. Remember to include take-down of sets as well*] _____

Misc. [*Gratuities, non-professional talent, unexpected expenses*]. . _____

FORM 4 Assignment Confirmation and Conditions

YOUR NAME OR BUSINESS NAME
Your address • Telephone number • Fax number • E-mail address • Web site address

Assignment Confirmation and Conditions

Client _____ Date _____

Date Assignment Begins _____ Job# _____ Due Date _____

Assignment Description _____

Usage Description _____

Photography Fee _____ Advance Payment _____ Est. Expenses _____

Total _____ Note: Details of fees and expenses are on attached schedule.

Conditions of this transaction:

1. Upon receipt of full payment, photographer grants to the client the following rights: _____

2. Usage shall be for the following publication(s) _____
 In the following countries _____

3. Usage shall be limited to the following time periods or frequency of use _____

4. Electronic rights are not included unless specified here _____

5. The copyright to all images created or supplied under this agreement remain the sole property of the photographer unless agreement is otherwise noted. This agreement does not include assignment of copyright, work for hire, or intention of joint copyright unless otherwise noted. This sale is subject to all terms and conditions on the reverse side of this form.

6. Proper copyright notice which should read: © [date and photographer's name] must be displayed with photographs in all media unless otherwise agreed. Where applicable, if omission of copyright notice results in a loss to the licensor photographer, client will be billed triple the invoice fee.

7. Estimated expenses are listed on Photography Fees and Expenses form.

8. Usage in addition to that defined above requires additional written license agreement from the photographer.

9. Invoices are payable upon receipt. Unpaid invoices are subject to a rebilling fee of _____ after 30 days.

10. Advance payments agreed to must be received at least 24 hours prior to start of the assignment.

11. When client orders the performance of any services required to complete the assignment described above, it constitutes an acceptance of this original estimate in its entirety.

This confirms the details of the assignment which you have awarded to [photographer's name]. Thank you for selecting us to do this important work for you. Please sign one copy and return immediately to photographer via fax, E-mail or other delivery service.

Client signature _____ Photographer _____

Please print _____ Please print _____

Subject to all terms and conditions above and on reverse side.

FORM 5 Assignment Photography Delivery Memo

YOUR NAME OR BUSINESS NAME
Your address • Telephone number • Fax number • E-mail address • Web site address

[Adapt for editorial, advertising or corporate use]

Delivered to: _____ Date _____
 [company name]
Address _____ Memo No. _____
_____ Purchase Order No. _____
Delivered to [*individual*] _____ Phone No. _____
Description of photographs _____

[Describe job by name and subject in photographs] _____

Intended use of photographs _____

[This is additional validation of pictures being delivered] _____

Conditions of transaction:

1. Copyright to all images created and supplied in this shipment remains the sole and exclusive property of the photographer unless specific other terms have been agreed upon in writing. There is no assignment of copyright, agreement to do work for hire, or intention of joint copyright expressed or implied in this delivery. The client is licensed the above usage according to specifications in Assignment Confirmation and Conditions form dated _____ and previously delivered to client.

2. Usage specified by previous agreement mentioned is licensed to client only upon receipt of full payment.

3. Usage beyond that covered in item 2 requires additional written license from the licenser.

4. The sale is subject to all terms and conditions on reverse side of this memo.

5. If client orders the performance of any services required to complete the above described assignment, it constitutes an acceptance according to the original estimate in its entirety.

Please review the attached schedule of images. [*Attach a careful list of the photographs by roll number, file number, frame number or sheet number, or by whatever system you use, depending on how they have been identified.*] The number of images shall be considered accurate and the quality deemed satisfactory for reproduction as planned by client, if a copy of this delivery memo and a full explanation of circumstances is not received by photographer or his representative by return mail, FedEx, or other carrier within _____ days. Your acceptance of this delivery constitutes your acceptance of all terms and conditions on both sides of this memo, whether signed by person addressed to or not.

Acknowledged and accepted by _____
For [*name of company*] _____
Date _____

FORM 6 Editorial Invoice

YOUR NAME OR BUSINESS NAME
Your address • Telephone number • Fax number • E-mail address • Web site address

Editorial Invoice

Client _____ Date_____

Address _____ P.O. No. _____

_____ Job No. _____

Assignment Description _____

Rights and Usage [© *with name credit must appear with photographs*]_____

Photography Fee _____

Travel Time Fee _____ Total Fees _____

Expenses

Assistant's service . _____

Film. _____

Processing. _____

Travel expenses [*car rental, airfares, etc.*]. _____

Food and lodging [*for photographer and assistant*] _____

Shipping and messengers . _____

Special equipment rentals . _____

Insurance [*special riders if applicable*] _____

Models. _____

Location rentals/props . _____

Telephone charges . _____

Miscellaneous . _____

Total Expenses . _____

Fees . _____

Total fees and expenses . _____

Less cash advance . _____

Final total. _____

Granting of right of usage is contingent upon payment and is subject to the terms and conditions provided in the Assignment Confirmation. Payment is required within 30 days of invoice date. Balance is subject to monthly rebilling charges applied thereafter. Adjustment of amount, or terms, must be requested within 14 days of invoice date. All expenses are subject to normal trade variance or 10% from estimated amounts.

Use of photographs without payment of above fees and expenses will constitute copyright infringement.

FORM 7 Terms and Conditions

Note: If terms and conditions are not used on the reverse side of Assignment Confirmation, Expense Estimate or Invoice forms, your name, address and other data should appear here.

Terms and Conditions

1. **Ownership.** Unless otherwise specified, rights to all photographs, including copyright, remain the exclusive property of the photographer. Photographs means transparencies, negatives, prints, etc.
2. **Additional Usage.** May be incorporated in this agreement. Otherwise terms must be negotiated separately with the photographer, and must be in writing and signed by both parties; additional payment must be included as part of the arrangement.
3. **Rights Limitations.** Unless otherwise specified, any grant of rights is limited to the United States for a period of one year from date of the invoice. For magazines, unless otherwise stated, only first North American serial rights are covered. All rights not specifically granted remain the property of the photographer.
4. **Image Modification.** [*Cross out clauses not applicable.*] **4A.** No permission is granted in this agreement for modification or manipulation of any images by digitizing or other process. **4B.** Client is limited by 4A, but cropping, alterations of contrast, brightness and color balance consistent with the application are permitted. **4C.** Client may make or permit alterations, digital or otherwise of the images, alone or in combinations with other materials subject to provisions in paragraph 5 below.
5. **Indemnity.** Client will indemnify and defend photographer against any and all claims, liability, damages, costs and legal fees arising out of any use of any images altered by the client for which no release was furnished by the photographer. Unless furnished, no release exists.
6. **Materials Furnished by Client.** Client will be responsible for loss or damage of items lent to photographer and shall insure such items. Photographer shall take all reasonable care of same.
7. **Return of Images.** Client is responsible for any loss, damage, or misuse of the photographs which shall be returned to the photographer prepaid, fully insured and undamaged by registered mail or bonded courier which provides proof of receipt within 30 days after first use. In any event images must be returned, published or unpublished, within _____ days after the date on this agreement. Client accepts full liability for its principals, employees, agents, affiliates, successors and assigns, including messengers and freelance researchers, for any loss, damage or misuse of the photographs.
8. **Valuing Images.** The parties agree that each original transparency shall be valued at $1,500, or such other amount agreed upon to represent fair and reasonable value of each item.
9. **Rights Transfer, Payment and Amendment.** Client may not assign or transfer this agreement or any rights within it. Client, its employees, et al are jointly liable for all payments and obligations in this agreement. No amendment or waiver of any terms is binding unless set forth in writing and signed by the parties. However, the photographer's invoice may reflect, and the client is bound by, oral authoriza-

tions for fees and expenses which could not be confirmed in writing because of insufficient time. [*Optional: This agreement incorporates by reference Article 2 of the Uniform Commercial Code, and the Copyright Act of 1976 as amended.*]

10. **Tear Sheets.** Client will provide photographer with two free copies of each use of photographs.

11. **Copyright Credit.** Credit of photographer's name and © shall accompany reproduced photographs unless specified otherwise on the reverse of this form.

12. **Arbitration.** Any disputes shall be submitted to binding arbitration in [*photographer's city and state*] under the laws of [*the state*]. In the event of any judgment or award in favor of the photographer, client shall pay court costs, photographer's reasonable legal fees and expenses, and legal interest on any award in case of delayed payment.

13. **Use of Federal Courts.** Client consents to jurisdiction of Federal courts with respect to claims by the photographer under the Copyright Act of 1976 as amended.

14. **Overtime Payments.** In the event a shoot extends beyond eight (8) consecutive hours, photographer may charge for the excess time of assistants and freelance staff at the rate of one-and-one-half of their hourly rates.

15. **Expenses.** If this form is used as an estimate of expenses, all expense estimates are subject to normal trade variance of 10%.

16. **Reshoots.** Client will be charged 100% of original fee and expenses for any reshoot, in all or part, required by the client. For any reshoot caused by an act of God or the fault of a third party, photographer will charge no additional fee, and client will pay all expenses. If client pays for special contingency insurance for photographer, who is paid in full for the shoot, client will not be charged for any expenses covered by insurance. A list of contingencies and variations will be supplied on request.

17. **Cancellations and Postponements.** Client is responsible for all expenses up to the time of cancellation plus 50% of photographer's fee. If notice of cancellation is given less than two (2) business days before the shoot date, client will be charged 100% of the fee. For weather delays, client shall pay full fee if photographer is already on location, and 50% of the fee if photographer has not yet left for the location.

18. **Binding Agreement.** This agreement shall be binding upon the parties, their heirs, successors, assigns and representatives. Terms can only be revised in writing signed by both parties.

Q&A *with*
Will and Deni
McIntyre

Will and Deni McIntyre are a freelance photography team who work on location for corporations, editorial clients and advertising agencies. They have shot major assignments for clients including Varig Brazilian Airlines; the Mexican Ministry of Tourism; Glaxo Wellcome; Credit Suisse; Duke University Medical Center and *Time*, *Fortune*, *People* and *Beyond Computing* magazines. They also shoot CD covers and portraits, and are the authors of two books, *Vanderbilt, A University Portrait* and *No Place Like Lowe's: 50 Years of Retailing for the American Home*. Since 1979 they have traveled and worked in more than forty countries. The McIntyre's stock photography is handled by Tony Stone Images Worldwide and Photo Researchers Inc. in New York, and by Picturesque in Raleigh, North Carolina. Will is a former member of the Board, ASMP. In addition to her photography, Deni is a writer. Her annual reports for Lowe's Companies have received gold, silver, and bronze awards from *Financial World* magazine. Will and Deni are currently working on a new book of their travel photographs and stories titled *All Over the Map*.

Q Do you use agreements or contracts that you have adapted from other forms? In general, do you feel that's the best way for photographers to go?

A We generally use ASMP forms as the basis for all our agreements and contracts. When you join, the ASMP provides you with materials that you can adapt to your own business. We've made some minor changes to the ASMP forms, but they give you a good start.

Q How important are the terms and conditions on the back of many forms? Do clients bother to read them? Are the terms and conditions you use from a source readers could find?

A Terms and conditions are vital. On several occasions they have saved us financially. We use the ASMP terms as a basis with a few slight modifications. For instance, the ASMP used to specify arbitration to resolve disputes.

In New York or Los Angeles, that might work; in North Carolina, it's not practical. Our contract specifies court action, but we've never had to resort to that, perhaps because of good fortune, or it's the quality of our clients. With our first contact, we discuss the client's needs and our methods of operation, and we often fax them a copy of the terms on the back of our invoice form. Recently we heard from a well-known art director who had visited our Web site, and decided we were creatively right for the job. He asked for a copy of our terms which he had his client read and initial, and then sent a hiring letter to us. The whole process took less than an hour. We knocked ourselves out on his job, and all parties got what they wanted.

Q Do you have a short case history about someone who failed to use suitable paperwork and was exploited without having the appropriate recourse?

A Back in the 1980s, we had a couple of very expensive hand-made printed portfolios. An art director called from the Midwest wanting to see our work. We sent a portfolio with a cover letter but, sadly, without any documentation that required him to sign an agreement covering receipt, return, and valuing the portfolio. Time passed and we remembered that the guy still had our book. Will called him. "Oh yeah," he said. "We got your book, but we hired somebody cheaper." Will asked about our portfolio. "We don't have it," the man said. "I'm pretty sure we put it on a truck." We had awful visions of some truck hauling our fancy portfolio all over the country, but it never was traced. We learned to insure our portfolio as if it were an assignment, and never to send it out without a delivery memo or a letter from a responsible person assuming responsibility for it.

Q What do you tell clients who shy away from signing agreements "because they're not necessary," or for some other reason?

A Once you've worked out deals with a few clients, you'll be familiar with the major issues. If a client won't agree to fair terms on paper, you don't want to work for him. With a new client, we usually work out the terms by phone and then fax or E-mail a letter (or a copy of the terms on the reverse of our invoice) to confirm the deal. With clients of long standing, we don't necessarily negotiate or send new paperwork each time. If they ask for a different deal, or if a new art director or editor comes on board, then naturally we review the account. Later they get our invoice with the terms on the back.

Q The previous chapter is on negotiation. Is it wise to avoid springing small details on a client after negotiations are over?

A In our experience, it takes two to tango: you, who are doing the work, and the party who will pay you for the work. Either you agree on mutually acceptable terms, or you move on. Springing terms on someone later doesn't sound like fair play.

Q Should photographers avoid starting any job before paperwork is completed? Does it depend on the size of the job and the budget? In other words, should one measure the risk and decide?

A Savvy risk assessment is a good survival skill. It doesn't take long to cover the basics: What rights does the client want and for how long? How much are they willing to pay? When can you expect payment and in what form or currency? What guarantee of satisfaction does either party offer or require? Be analytical. Then, if the reward seems worth the risk, you should be able to start the job as soon as you reach an oral agreement. If you have doubts, it's best to put something on paper and fax it. If your prospective client is too rushed to hang in there for even that long, it may be a sign of other trouble to come.

Q Most advertising and corporate assignments require previously forged agreements. How about the first editorial job for a publication with a good reputation?

A We've been doing editorial assignments for more than twenty years. If there's a magazine out there now that doesn't ask photographers to sign a contract before starting a job, we're not familiar with it. Ask the assigning editor about terms and payment, especially if it's a first job. The length of the assignment is irrelevant.

Q When sending stock pictures to a client or prospective client, does one need to send a delivery memo as well as a separate list (too long to fit on the memo form) of the images sent?

A It's never a mistake to send a delivery memo with anything of value that leaves your possession, and the more accurate the documentation, the better. However, we deal with our stock agents differently from the way we deal with prospective clients. On a huge submission, we'll just count the sheets of slides by subject and list that on the memo (i.e, "sixteen sheets of India"). If you can't trust your own agent, get a different agent. Or sell the pictures yourself.

About stock submissions to prospective clients, put your transparencies on a photocopier and backlight the whole thing. Or use a flatbed scanner and

make low-resolution files. If that's too much work, describe the images verbally and send lists as a multiple-use record. We used to do something like that, before we owned a photocopier and a scanner.

Q Do you use software to help keep track of photographs going to clients? To your stock agency?

A We use Microsoft Word and Excel to keep a stock log file. We can quickly find out anything we need to know about our stock submissions. Filemaker Pro is also a good tool for this job.

Q Are there specific forms necessary for selling or leasing pictures via a Web site?

A We use the same forms we've been using for years. If an image used on a Web site gets abused by someone, don't go after your client. Go after the thief. Or write it off to bad luck, and get on with life.

CHAPTER SIX

Dealing with Editorial Clients

TYPES OF EDITORIAL MARKETS

Editorial photography means working for publications, especially magazines. Information and entertainment are the prime purposes of editorial pictures, and varying editorial style photography is also used in annual reports and photographic books, as well as in advertising.

Photographer's Market, from the publisher of this book, lists consumer magazines, newspapers, newsletters and trade publications. "These markets," it says, "include large circulation magazines as well as specialized publications. Magazines are the easiest market to research because [many of them are so] widely available . . ." *Photographer's Market* offers this advice: "Do your homework. Before you send your query or cover letter and samples, before you drop off your portfolio . . . look at a copy of the magazine. Once you've read a few issues and feel confident your work is appropriate . . . then it's time to approach editors." There are 182 pages of magazines in every flavor of the rainbow listed in *2000 Photographer's Market*. Whether you are just getting started or not, you need a guide like this to help you make contacts to sell pictures and ideas. This category is wide and deep with opportunities for freelancers, but your competition is aware of the markets, too. Here are the main categories of publications:

- *General interest magazines*. The most attention-getting camera work in magazines is photojournalism, frequently news-based, realistic and emotionally stirring. Many magazines also want *feature pictures* taken to show how people live, how things work, etc. These may be topical single pictures or stories, dramatic or graphic, and sometimes bizarre. The market for feature photography is huge in all types of magazines, but much less in newspapers because they use staffers, hand-out photos or wire service pictures.

 In contrast to the above is the photo illustration category that includes still life, fashion and interiors. Some of this is done spectacularly in studios, and some shots come from stock files. New freelancers are most likely to make sales in the feature category. Photojournalism subjects are harder to find, and illustrations are usually done on assignment.

- *Specialized magazines*. This category covers popular topics such as food, fashion, pets, sewing, sports, cars, biking, home decoration and others.

Special interest magazines outnumber all others. Some are hobby maga-
zines that need photo coverage of subjects such as doll houses, games,
flowers, sailing, tennis, photography or scouting. The best special interest
magazines pay well and display photographs nicely. Find ideas that
interest you and pitch picture story ideas to magazine editors in enthusias-
tic queries.

- *Newspapers and newsletters.* Larger newspapers have budgets for pic-
tures but buy from freelancers only when they can't get photos from
staffers or wire services. Newspapers with circulation under ten thousand
are more likely to welcome freelance pictures and ideas, but usually pay
poorly. Newsletters often rely on amateur photographers who will work
for credit lines, but those published by large companies may be good
markets.

- *Trade publications.* Pictures in these magazines are focused on specific
businesses, industries and professions from plumbing to religion. Trade
publications can be good markets for assignments and stock, and many
are listed in *Photographer's Market.* Make yourself and your work
known to those devoted to subjects which interest you. Some have large
enough circulations to pay reasonably well, and others are subsidized
by professional organizations. To discover the variety of trade magazines,
check the subject index in *Photographer's Market.*

SELLER BEWARE

Be careful when newspapers, magazines or the wire service Associated Press
presents a contract to you offering their minimum day rate. Egregious contracts
may try to assume all rights to your film or prints for little or no additional
payment.

A typical example: J. Photog (JP) receives a call from a magazine with a
circulation of two million to shoot an assignment. They fax him a contract
offering $300 a day plus expenses. It stipulates that the fee covers magazine,
Web site and subsidiary rights in their two foreign editions. JP says he'll call
back and takes time to figure the logistics. He then faxes the photo editor his
terms: Two days at $450 each, an assistant at $200 a day, and travel time at
half the day rate. He offers onetime usage only, and says he will bill them
for any images used on their Web site or in foreign editions after previous
negotiations about payment. In a short time the photo editor calls and agrees
with his day rates, but insists on Web and foreign rights without additional
payment. "Sorry, that's our deal," JP is told. To which he responds politely,
"Each time and place you use my pictures, your company will profit. I deserve
to be paid accordingly," and he gives the photo editor the approximate cost
of additional rights. The photo editor says she would discuss it, then calls
back and says, "No thanks." JP is sorry to lose the work, but not for long.
That afternoon the photo editor calls again and tells JP they were sending a
revised contract using his terms.

What happened? First, JP is an experienced photographer whose previous work for the magazine was outstanding. Second, the photo editor must have tried to find a replacement for the money and rights deal she offered, and failed to interest JP's competition. Third, the photo editor evidently felt JP's terms were fair, and arguments to her bosses prevailed. If you don't feel you have JP's clout yet, keep in mind his logical appraisal of his own worth and his willingness to stand up for his rates and rights. You will be able to get more money and protect your rights better when you understand what is at stake, know what you're worth and stand up for your convictions about onetime use plus more money for added rights. The sooner you tactfully assert yourself, the sooner you'll rise to a JP level.

As I write, numerous editorial photographers are protesting low rates and plundered rights. Many are negotiating higher day rates and refusing all rights deals. You can learn more at http://www.editorialphoto.com.

BREAKING IN
Start Modestly

To make more money working for magazines, expect to start modestly. Discover what you shoot best, spend your money on good equipment and be practical. Most successful photographers start with a minimum of equipment, and rent or borrow necessary gear until they can buy their own. Top notch cameras, lenses, lights and other equipment are expensive, so choose carefully. You can compete with just two basic cameras, three to five lenses, and some lights. Editorial photographers learn to travel light.

For better access to success in the editorial field, consider it in terms of specialties such as sports, automobiles, celebrities, children, health, camping, agriculture, politics, medicine, or whatever. Pick areas you know something about or that fascinate you. Read newspapers and other sources to find ideas and potential markets. Go places and ask questions. Locate several subjects, and contact people or organizations to gather background for queries to send editors. Concentrate on markets that publish photographs well, and pay enough to meet your needs. Maybe you can also afford to work for a few publications that use photos well, even if pay is not adequate. When you can arrange to shoot multiple jobs in areas away from home base, it's called piggybacking and it can be profitable because you can charge expenses to each magazine.

Many editorial photographers also send their best images to a stock agency or market the photos themselves. As you will discover, the best duplicate slides are made in the camera. This means you shoot two, three or more similar slides of the same person, place or thing whenever possible. These can eventually be submitted to several agencies that are not directly competitive. Take care not to send out stock dupes until a magazine returns the originals. While stock sales often take a year or more, the magazine that paid you to shoot should have ninety-day exclusive use of the images.

Charge Sensibly

In the editorial field, fees and page rates increased very slowly in the 1990s, so magazines will often say they pay less than you would like. It's not good business to allow magazines to dictate your fees when you know you are worth more. Once you have a portfolio of work published, negotiate for more money, especially when colleagues tell you the market will pay more. If editors won't budge, turn down unrealistic payment offers. (Refer back to chapter three to determine how much you need to charge to run a profitable business.) If an editor wants your photography or idea, the magazine will up their rate. Publishers continually boost their charges for advertising space, and they can pay contributors more if pressured. Don't be too easily discouraged. Remember JP's faith in himself. Asking for more money or improved rights is appropriate when you know your work is worth it.

WORKING TECHNIQUES
Query Letters

Let editors know you exist by sending postcard samples of your work. Follow that up with a query letter. (You'll find a sample at the end of this chapter.) In the letter, introduce yourself, suggest an appropriate story idea, give the editor an estimate of the time involved, and include a few color prints (with your name, address and copyright on the backs). Have 4″ by 6″ prints made from color slides, because they're cheaper than dupe slides and can be seen more easily. You may also send tear sheets of printed work as credentials. Enclose a self-addressed stamped envelope (SASE). If you get no response in several weeks, send a polite postcard, E-mail or fax asking about the editor's interest. If there's no response in a reasonable time, query another potential market. Queries should be concise, factual and thorough enough to grab the editor. Try to keep it to one page.

Simultaneous Submissions

It is frowned upon in the editorial field to send the same story or photographs to more than one publication at the same time. There is good reason for this, because you may create a conflict for a publication and cause problems for yourself. However, because editors may take a long time to respond (especially in the book field), it is permissible to send a story query to several magazine editors simultaneously. A query asks the editor's interest in an idea or subject. It does *not* promise that you will shoot whatever you're pitching unless you choose to, if an editor responds affirmatively. Editors consider numerous queries in a week or month, so it is only reasonable that a photographer may submit ideas simultaneously to two or more markets, especially when a subject is especially timely. It's considered professional courtesy to note in the query that it has also been submitted to one or two other editors as well. I'm ambivalent about giving editors notice about simultaneous submissions. Many of them believe they deserve your ideas exclusively and may be less likely to

consider a query you've sent to others as well. However, some editors may be prompted to act more quickly so a good project isn't lost to a competitor. If you do submit ideas simultaneously, accept the first offer. It's first come, first served. Simply contact the other magazines or publishers and ask them to remove your query from consideration. No need to explain further.

EDITORIAL ADVICE

- Consult with others more experienced in the editorial field for answers to questions about dealing with publications. If you don't know anyone, contact the ASMP; tap into the ASMP Web site, at http://www.asmp.org, for access to a roster of members in your area. Call a few locals until you find someone willing to discuss business customs. If you are not on the Internet, call ASMP at (609) 799-8300 or write to 150 N. Second St., Philadelphia, PA 19106. Ask for a membership application while you're at it.

- Acquaint yourself with magazine payment practices in guides such as *Photographer's Market* and *Writer's Market*, both from Writer's Digest Books. Payments are often slow, up to sixty days after you deliver pictures. When a publication's fees are below a decent minimum for "inside color use," prepare to negotiate for a better fee. Or, you may conclude it's not worth your time to complete an article for the magazine.

- If you get an assignment, be friendly, not pushy. When you are not familiar with a publication's payment rates, ask the editor, "Do you pay by the page or the job, and what are your rates?" Don't be afraid to discuss money and rights. It's the professional thing to do to avoid surprises. And don't be afraid to ask for more money than they initially offer.

- Try to stay away from publications that "pay on publication." This practice can become a disguised form of speculation. To shoot pictures in such circumstances without an agreement is speculation. If you do approach such publications, send pictures that are already taken. The editor may rave about them, but say he's not sure when he'll schedule them. Even if you know a publication pays on publication, send a note with the pictures that says, "Invoice for story and/or photographs will be sent if these are not scheduled and/or paid for within sixty days." Before sixty days ask questions, by phone or E-mail, about a publication date in a friendly fashion. If it looks like your work will be rejected, negotiate a kill fee (see below). Without a signed agreement, a bill you send is likely to be ignored because the publication didn't promise payment until the work was published.

- I recommend not doing an "assignment" for a market that pays on publication because it's *not* an assignment. If your pictures may not be scheduled for weeks or months, you had better have an assignment agreement that provides payment after a specified time for all expenses

plus your day rate. Stipulate that the pictures be returned immediately, and have another market in mind. Editors often assign more work than they can use, and when they pay on publication, you are financing the magazine's inventory. You may want to avoid pay on publication markets.

Payment for assigned but unpublished work is called a *kill fee*. If you work on a feature story especially, and your pictures may be held a while, negotiate a kill fee in your contract. If they decide not to use your material, they should pay your day rate plus expenses. The latter should be paid within thirty days. You may have received more money at a space rate, but you get all the photographs back to resell. Try to find another market and sell the returned pictures as stock.

Independent Production

Besides sending queries to get work, it is often worthwhile to shoot self-assignments, also called independent productions. These are usually picture stories that evolve from your convictions about subjects that appeal to you. It's your choice to speculate, and no publication has control. You are free to sell the story before it's finished or afterwards. Self-assignments can be excellent portfolio pieces. They show the quality of your photography, and demonstrate your editing (and sometimes, writing) skills. An independent production shows that you work well with people and can get cooperation on a project. Try to choose a subject that could interest several markets. Before you finish, contact an editor. Describe your story, ask to send a few sample prints, or what you've completed, if there is interest. Whether you get a commitment or not, you may elect to finish the story. Then query editors with enthusiasm.

SUBMITTING IDEAS AND PICTURES

Never send *unsolicited* photographs to a publication or any potential buyer. Publications are not legally responsible for material they have not asked to see. Most magazines include a warning that "unsolicited material will not be returned." Even when you send a SASE, an editor can legally throw your unsolicited pictures in the trash and not respond. After you have an okay to submit something, the publication has a legal and ethical obligation to return the material, especially when you send postage and a return envelope. If you inquire and are told a story is under consideration, ask if two more weeks is enough for a decision. Setting limits is good business for you and indicates a professional attitude. The same precautions apply to sending photographs to book publishers and corporations to acquaint editors with your work.

Making more money in photography involves being aware of the ways you present your work and yourself, as well as charging proper rates. In *2000 Photographer's Market* is a concise checklist about submissions. I'm going to echo a few pointers here and add my own.

1. *Send duplicate slides or prints (except on assignments), but never negatives.* If a publication loses or damages original slides, you can sue for

negligence, but that's expensive and lawsuits can be difficult. Dupes are replaceable for modest fees. As an alternative, for a recent book proposal I shot color slides but had prints made from some of them to show editors. Prints are easier to view than slides, and they are easy to replace.

2. *Insure the package.* To submit photographs, pack them securely and insure them. The U.S. Postal Service pays claims "on the actual value of an article at the time of mailing." It does not feel that an industry standard of $1,500 per slide establishes fair market value. The post office handles claims for lost slides on an individual basis, and you may "submit documentation such as a contract (a letter of agreement would work) dated prior to the date of mailing, showing that a company or individual had agreed to buy or lease specific slides at specified amounts." Otherwise, if photographs are lost or damaged, the post office pays only to replace film, prints and processing.

For its shipping fee the United Parcel Service (UPS) includes insurance up to $100 for loss or damage, but offers additional insurance coverage at thirty-five cents per $100 up to $50,000.

The fee for Federal Express also includes up to $100 worth of insurance, and offers more insurance in two ways: For photographs sent in a Federal Express letter envelope the insurance limit is $500, which costs $2.50. Photographs shipped in a Federal Express box can be insured at fifty cents per $100, up to $50,000. Both companies pay for irreplaceable materials according to the photographer's valuation with some form of proof.

3. *Label everything.* Use a rubber stamp or stick-on label on each slide or print. Your name and the copyright symbol is minimum on slides, plus address when possible, and all should be included on the backs of prints.

4. *Place a file number on every image.* One method is to number each roll and put a roll and frame number on slides and prints, such as 856-22. Add a letter of the alphabet to distinguish color from black and white or for images from different camera formats. I use the slide file numbers to identify pictures when writing captions.

5. *Send pictures to an individual.* Address them to an individual editor or person, not just to a company. An anonymous secretary should not be responsible for routing your material, and on letters, "Dear Sir" or "Dear Ms." is painfully impersonal. If you know no one, find out by phone or from a magazine's masthead. Choose the managing editor or art director or check a marketing guide for names. At a public relations firm or ad agency call for the name of a manager or art buyer.

6. *Send a cover letter.* It will remind the receiver of previous contact with you, and you can describe the pictures you're enclosing. Add a few notes about the story, about your background and previous publication or whatever will help sell yourself.

7. *Use a computer.* Letters, captions and copy should be generated on a

computer. Word processing makes your written material look professional, and provides easily retrievable files for reference and revision. Many magazines accept or prefer written material on a disk for easy access. In due time digitized photographs will be acceptable as well. See chapter fourteen.

8. *Cultivate relationships with processing labs.* Find a convenient trustworthy lab by asking for recommendations from local photographers. Work out ways to help keep your costs down, such as making 4″ by 6″ machine prints as proofs for yourself and clients. Slide film can be developed in a few hours by an E-6 lab. Experiment with labs, including one-hour labs, for enlargements. You can also scan slides, negatives or prints into a computer, retouch or manipulate images, and make prints for reproduction from modern printers costing under five hundred dollars. See chapter fourteen for more information about digital technology.

9. *Keep a log of submissions.* In a notebook, on file cards or in a computer file, keep records of when and where you send pictures. If they come back, log them in before submitting them again. Your memory is never as reliable as a written record.

10. *Package appropriately.* Send slides in plastic sheets that hold twenty each, and prints in individual envelopes. Keep captions and copy together. Use padded envelopes or regular envelopes with corrugated cardboard lining. Send odd-size materials in boxes.

11. *Always send a SASE* until you have a rapport with an editor. Once you are in contact fairly regularly, expect the publication to package and pay return postage routinely on independently produced material.

WRITING WITH YOUR PICTURES

For numerous publications, you can make more money in editorial photography when you shoot and write copy for the photos. But there are exceptions:

1. On some assignments, the client already has a written story that you will illustrate, or a writer will cover the subject. In that case, just write captions.

2. When you cover a news story with a close deadline, the client may get written material from a wire service or, if a celebrity is involved, from a publicist. Ask the client if he or she wants rough copy.

3. When you do a feature story as an independent production, such as the one described in my sample cover letter on page 103, and you include five hundred to one thousand words, the editor will usually be pleased. You'll make more money if the publication pays separately for the copy, and when feasible, make it clear that's what you expect. On feature story assignments, ask if the editor wants more than photo captions. If you are a competent writer, when possible, offer to do copy for a separate payment. When a publication pays good page rates, and has a relatively small staff, being able to write a suitable story will make you more

popular. I've received repeat jobs in the past because I wrote text too. You won't be expected to write rough stories when you become a well-paid editorial photographer, unless you choose to.

SELF-PROMOTION AND PORTFOLIOS

Whether you take pictures to a publication or public relations office, or send them, it is a good habit to leave a printed sample of your work with an editor or art director. Several companies print color postcards or you can have a simple mailing piece designed. The magazine *PDN* regularly features stories about self-promotions created by photographers or designers.

Photographers used to leave portfolios of original prints in large format boxes at editorial offices to promote their work. Now they are more apt to leave or send potential clients a CD-ROM of photography samples. A disk can display pictures in various sizes, in color or black and white, laid out in groups or singly. *2000 Photographer's Market* says, "Whichever way or ways you choose to showcase your best work, you should always have more than one portfolio and each should be customized for potential clients."

Editorial photographers may also use tear sheets presented in clear plastic covers for a portfolio. Or these may be scanned and transferred to a CD-ROM by a computer service bureau. Original shots can be on the same disk. A CD-ROM format would make having several portfolios more feasible. In a conventional portfolio, use only dupe slides. Be sure your name, address and a copyright symbol is on each image.

Several books about self-promotion are published by North Light Books. *The Photographer's Guide to Marketing and Self-Promotion* by Maria Piscopo and *Best Small Budget Self-Promotions* by Carol Buchanan are both out of print but may be available at your local library. *The Best Seasonal Promotions* by Poppy Evans and *Fresh Ideas in Promotion* by Lynn Haller are available in bookstores or from the publisher.

ADDITIONAL EDITORIAL MARKETS AND IDEAS
Public Relations Photography

Working for public relations firms is often like magazine photography. You photograph people, places, things and events, usually in circumstances controlled by the firms being publicized. Get to know public relations people, show samples, and discuss your specialties. If you have friends in the magazine field who might make space for pictures from a public relations client, that's a plus for you. Charge for first rights at a higher rate than for magazines, and double or triple the fee if the client wants all rights. Public relations photography may give you entrée to shooting annual reports, which can be very lucrative. See chapter nine on page 145 for more information.

Newspaper Photography

Most newspapers are not much of a market for freelancers because they rely on staffers and wire services. But photographers living in cities where

newspapers have few staff photographers can present portfolios to become irregulars, also called stringers. If you are hired as a stringer, be sure you specify first rights only and get your negatives, prints or slides back quickly. Make sure the editors understand they may *not* submit your work to the Associated Press or other wire services without your permission and additonal payment. Many newspapers may want to pay once, then own your work without paying anything extra for it. This is work made for hire, so you should get a salary and all the benefits of an employee. Don't be afraid to assert your rights.

For news coverage, if that's your ambition, it's preferable to work with an assignment agency such as Liaison International or Sia, especially when you become adept at transmitting digital images. Fast-breaking stories are best sent directly to an agency that can distribute pictures to magazines, often digitally.

Fees, Photo Magazines and Workshops

- Fees for editorial photography can be determined using the guidelines in chapter three. Generally, magazines pay in accordance with their circulation. However, the correlation between circulation and payment is not consistent. Listings in *Photographer's Market* demonstrate this. Payment is based on page rate or day rate, whichever is higher, or on a story rate. If you charge $400 a day and work two days, you would bill $800 plus expenses. If those pictures later cover three pages and the publication pays $350 a page, that's $1,050. You then bill for an additional $250 for the higher space rate. Some magazines pay a story rate. You still bill your day rate, but if the story rate is higher, you may bill for the difference.

- Your experience and reputation as a photographer must be factored into your payment formula. Notice that in *Photographer's Market* listings, especially for consumer magazines, there are a number of publications missing such as *Time* and *Ladies Home Journal*. These and other top magazines tend to give assignments to photographers they know and fees are negotiated according to time, reputation and the negotiating skill of the photographer. Those well-known to a publication receive a generous minimum guarantee to make it worth their while to do the work. You may apply these principles as your experience and success increase.

- Photographic magazines, the largest of which is *Popular Photography*, can display your work for editorial photography users to see. Photo magazines use all kinds of photos including multiple exposures and digitally manipulated work. They can also be good showcases for stock images in your files.

- Workshops and seminars listed in magazines such as *Popular Photography*, *Outdoor Photographer* and *PDN* can be helpful to photographers

on the way up. Expert shooters explain using their skills and discuss markets at workshops. Many are willing to share good business practices.

THE LAST WORD

A magazine photographer from Santa Monica, California, responded to an unwelcome contract sent him by a magazine publisher with this letter printed on condition of anonymity.

The magazine's letter read: "Dear Mr. [photographer's name], We look forward to working with you on [name of story]. I am enclosing three copies of our Photographer's Agreement. Please sign all three. Once our contract has been approved and fully executed, a copy will be sent to you. Please be advised that strike-outs deleted or modifications to our agreement will not be accepted, and will delay processing the contract. Should you have questions. . . . Thank you."

The photographer responded in writing: "First off, a contract is meant to be a legal meeting of the minds. As any first-year law student would know, a contract should reflect mutual assent and consideration. To suggest that it is not modifiable, as you do, would void the legal concept of a contract which would have to be signed under financial duress. It would incorrectly indicate my consent. Any contract is modifiable! Your letter seems misleading, unfair, and intimidating to me. Is this your intent, to intimidate the people who create pictures for you?

"Second, there seems to be a misunderstanding. I am the copyright holder of my work. I am the seller, you are the buyer. I set my terms, not you. I was commissioned at a rate, for onetime North American rights in one issue of your magazine only. Please check my paperwork already provided, since the shoot has been completed. You are presently committing copyright infringement (these images have been registered with the Library of Congress) for not paying me before publication of said images.

"Lastly, my business is one of licensing rights. The contract you have presented me, after the fact, is egregious in terms of the rights you expect for the money you pay. These expectations go against industry standards and the nature of my profession. Please inform your licensing department that no other rights have been agreed to. All future use will not be unreasonably withheld, but terms must be negotiated before hand. I have enclosed the contract in the form that is acceptable to me. Thank you for your time."

Faced with a copyright infringement lawsuit, but admitting no fault, the client accepted the photographer's contract and paid promptly.

FORM 8 Query Letter for Magazines

YOUR NAME OR BUSINESS NAME
Your address • Telephone number • Fax number • E-mail address • Web site address

Date

Editor's name
Name of magazine
Address, City, State

Dear _____

I have been following your magazine for some time now [*if no previous work for them*], and I believe that the picture story idea below would be welcomed by your readers.

Some years ago I became acquainted with Charlton Heston and his wife, who live surprisingly unpretentious lives in several celebrity circles. Mr. Heston's dozens of movies make him familiar to millions of people who may be surprised to see him in his office at his computer writing a book, or in his favorite chair in a spacious living room talking with his eight-year-old grandson, Jack. There is a Wyeth painting on the wall behind them.

Lydia Heston is a fine photographer, and has exhibited her prints in many cities in the U.S. and Europe. At one time she did her own processing in an ordinary darkroom. Today she has an elaborate computer setup in a studio she added to the house. "For our 50th anniversary Chuck offered me a diamond necklace," she told me. "When I told him I wanted to update my computer, he thought he was getting off easily, but that was hardly the case." Lydia has become a wizard using PhotoShop, a photo manipulation computer program that allows her to refine her own color and black and white images in subtle ways.

My story would show a couple of days in the Hestons' lives. I'll attach a picture list of potential situations, which require coverage at several locations. I can promise they will be spontaneous. I'll caption the pictures and can write a short story, if you wish, for a separate fee. Would you prefer color slides or prints? I'm also enclosing three photographs I've made of the Hestons informally in the past, plus a list of pictures and stories I have done for various magazines.

Your suggestions for tailoring this picture story to your needs will be appreciated. I look forward to your response, when we can discuss further details. Thanks for your attention.

Best regards,

Enc: SASE
[*Not necessary if you know the editor*]

FORM 9 Cover Letter to Accompany Independent Production

YOUR NAME OR BUSINESS NAME

Your address • Telephone number • Fax number • E-mail address • Web site address

Date

Name, title
Address
City, State

Dear _____

Enclosed is the picture story about the new horse racing track just opened in [*name of town*] which you said [*on a specific date*] you'd like to see. There are 36 slides with captions and a background story of 800 words.

As you will note, the new track [*use its name*] has the latest electronic starting gate, newly designed comfortable seats, and closed circuit television monitors placed so most spectators can see the action when horses are at a distance. I'm told this is the first track in the U.S. to feature these monitors, though they've been used for some time in France and Italy.

[*You might go on to point out other unusual, unique or interesting things about the place or subject in your picture series. This can be an important sales pitch to increase the editor's attention to the pictures he's about to see. Be concise. Try not to leave the impression that you are hard-selling because the idea isn't strong enough.*]

I have more slides if you are interested in the story, and I can send you additional copy according to your needs.

I've had my work in [*name a couple of publications if possible*] and I have been a professional editorial photographer for [number of years]. My photographs have been [*exhibited or used in ads or brochures, or whatever you can mention. Or mention you were an assistant, worked on staff, or any other appropriate experience if possible.*]

I'd like seeing my story in [*name of magazine*] and hope you feel it is relevant. Please contact me within two weeks. If you are not interested, I'd like the opportunity to try another market. Thanks for your attention.

Cordially

Enc: 36 slides w/captions
SASE

Q&A *with*
Leif Skoogfors

Leif Skoogfors is recognized in the field of war-related journalism as well as for his health care photographs and assignments in foreign countries. A former professor and assistant dean at Moore Art college of Philadelphia and former director of photography for Greenpeace in Washington, DC, he has worked for magazines such as *Time, Newsweek, Business Week, Forbes, Stern* and for a number of Fortune 500 corporations as well. His book, *The Most Natural Thing in the World*, about the war in Northern Ireland, was published in 1974 by Harper and Row. Skoogfors resides in the Philadelphia area where he is past president of the ASMP chapter there. Currently he is national co-chair of the ASMP's photojournalism group.

Q Do a lot of photographers make the opportunity to shoot stock images when on certain kinds of assignment? How does one ethically separate potential stock from assignment pictures?

A Most of my assignments have had lasting value as stock. However, when on assignment, I never concentrate on anything but the job. It is unethical to take time from your client to fill your files, but that said, if I have a day off on location and can do the mental separation necessary, I'll do some stock shooting. So stock becomes an important bonus to an editorial assignment. However, most of my stock income comes from resale of my editorial work.

The only way editorial photographers can survive on today's low day rates is to maintain control of their copyrights, and to be very smart in finding markets for stock. From most of my editorial assignments I expect to make as much from stock sales in the futures as I made on the day rate. Lose your copyright and you lose your future.

Q I've advised entry level readers to start modestly, narrow down their interests to focus on markets, and begin introducing themselves to editors by sending well written queries, perhaps with samples of their photography. What other advice would you offer them?

A The key word you've used is "well written." To add to that, I'd stress being brief. In a time when media mergers are financed by downsizing

staff, editors are overworked. Phone calls don't get returned, though it's usually not intentional. Editors are just too busy to take time to except for dealing with emergencies. A story proposal should be no longer than one double spaced page, otherwise it will be passed over. Photo editors are working under intense pressures. There is very little "think time" on anybody's part, much less dealing with telephone calls from beginning photographers.

Q I've suggested that readers can send the same query about feature material (not spot news) to several publications to accelerate the process. I feel that the query describes the idea, and offers to shoot it, but is not a commitment. Exclusivity should not be offered unless there's a good reason. What are your views about simultaneous queries?

A I've always felt building relationships with individual editors is the key to access and assignments. I feel a certain loyalty to my editors, and I would only submit a story to one at a time. But, for a photographer starting out, I think submitting simultaneous queries may be acceptable. However, if one editor takes the story, and you start work on it, and then have to turn down another editor, you may face problems. The second editor may very well try to rush your idea into print hoping to scoop the other magazine. Then, you have some problems.

My stories have involved large areas of subject matter, such as the expansion of NATO or Special Forces missions. Not the sort of thing I can count on my subject sticking with me, when *Time* may be trying to scoop *Newsweek*. For less significant feature story ideas, I understand your view. Perhaps letting the editor know that other magazines are considering the story will help them make up their mind.

Q I suggest readers ask editors how they pay and what they pay, if they are not sure. Have you some further guidance for doing this?

A Absolutely, go over every financial detail. Don't be shy. Be sure of what their day rate is, whether they understand they are paying for first rights only, if they cover your assistant, what they pay for car mileage and if they have any offbeat expense restrictions. It isn't pushy, it is the sign of being a professional.

Q Do you have an anecdote about a successful independent production of your own or another's? Was the story sold midway in the shooting? In the 2000 marketplace, is doing an independent production still valid?

A For a beginning photographer it may be the only way to get started. Most importantly, pick a subject you have a passion for and do it. You may have to borrow money to do it or get started. My first trip to Northern Ireland was financed by a $300 advance from a magazine and my own credit cards. It ran as a story, sold several other places and became my passion. I kept going back. Two years later I decided it was a book subject, so I worked on a proposal that I finally sold to Harper and Row. My advance from them was minimal, but I did the book, which came out in 1974. It never made a lot of money, but it made my reputation, and I've sold the photographs in thirty countries over the years.

Q A colleague told me when she gets an assignment from an unfamiliar publication, she asks for "sufficient advance up front so I am not chasing after them afterwards." She added, "Be sure to send them an agreement about usage as well as payment, and make sure you get photo credit. I've had to learn from my mistakes." What are your views about advances and unfamiliar clients?

A I have always been paid, and I always lay a paper trail. Twice I had to go to court, both times I collected. Two other times the ASMP stepped in to help with difficult clients. The settlements they negotiated paid my ASMP dues for ten years. Editorial shoots can be so fast moving, advances are almost unheard of. I have had two clients who started acting a bit strange on some major jobs. I quickly made it clear that payment was expected on delivery of the photos. One client I demanded an advance from, and their check bounced. They only got their pictures after they hand delivered a second check to my house and I had it cashed at their bank. Large magazines such as *Time* or *Newseek* may get slow at times, but they are good for the money. An unknown publication, I check out with the ASMP or run a credit check.

Q Smaller magazines often expect the photographer to write background material about a subject as well as captions. When getting started, is it better to include the words with the pictures for the same fee, if little extra time is taken?

A If the writing is minimal, do it. It pays off in honing your writing skills. But, I don't feel anyone can be a writer and a photographer at the same time. While in Poland during the solidarity crisis or in Bosnia, I often would take notes and "color" (descriptive material) for the writer who might be elsewhere. No extra money, but another good relationship was established. That is what helps build careers.

CHAPTER SEVEN

Dealing with Advertising Clients

THE BUSINESS OF PERSUASION

My main experience has been in editorial photography, though I've done some annual reports, a few ads, and I've shot a lot of stock. While advertising photography is familiar to me, it has always seemed a special challenge because it's so often a group operation, while editorial can be successful as a solo business.

Advertising photographs sell products and services in media such as magazines, newspapers, television, direct-mail, displays, billboards, and more. Clients often pay $50,000 and up for a magazine page, and photography to fit that space may cost $10,000 and up. When advertising pictures are shot on location, a crew of people accompanies the photographer, and expenses are expected to be high. These conditions are well known to ad agencies and their art directors, who are often there to discuss the job and okay Polaroid test shots. The pace and demands of advertising photography, even in a medium-size studio, can be grueling.

Advertising photographs cover an infinity of subjects and techniques plus many styles. In the beginning, ad photographers may work from a makeshift space, but for volume business and classier clients, one needs a well-equipped studio. Some are large enough to shoot several setups at once, and even larger ones have room to photograph cars or pickup trucks. It is not uncommon to have a pool table for client recreation while the photographer and staff wait for film processing. Well-equipped studios include banks of electronic flash, cameras in various formats, hot lights, numerous accessories, set-building equipment, and employees to assist on shoots. I know photographers who have been in business for ten years and are doing well enough to spend $250,000 to build and equip beautiful new studios. But you should be realistic about your prospects in this specialized, competitive field where making a good living is also dependent on smart business practices.

THE BASICS

Advertisers use stock photographs regularly (see the next chapter), but many advertising pictures are created to order. An ad agency develops an ad campaign, including media placement of images and copy, that may run for weeks or months. Many people are involved in planning, writing, and designing the

ads and buying media space for them. An agency account executive represents a specific client. An art director and staff create the look of an ad and may interview and assign photographers, or an art buyer may approach photographers in conjunction with the art director. The art buyer handles negotiations, estimates, forms, releases and paperwork, though a veteran photographer I know feels that too many buyers are not informed enough to be able to distinguish good pictures from outstanding ones. He's convinced that art buyers prefer a low price to exceptional creativity that often costs more.

A team conceptualizes the kind of images they need for specific ads. They make layouts called comps (short for comprehensives) that are eventually given to a photographer who is occasionally included in the creative planning stages. How closely the photographer is expected to conform to the layout depends on the ad and its creators, who may encourage interpretation according to the photographer's style. One must be imaginative to translate a comp into an effective image and photographers who earn the most are paid for their taste, ingenuity, sense of composition, mastery of lighting, supervision of sets and costumes and sensitivity with models plus their tactful-but-firm ways of working with art directors.

BUDGETS, ESTIMATES AND BIDS

The advertising agency team plans the budget for photography, subject to creative and practical revisions. Photographers are often chosen from those they already know, or from portfolios or promotional material in sourcebooks (like *The Black Book* in which photographers buy ads). Interviews with potential photographers usually follow. Once a photographer is chosen, he or she is asked for a written estimate, three forms for which are included in chapter five.

An estimate is your projection of the approximate cost of an assignment based on initial information provided by the agency. By industry practice, a photography estimate may be subject to plus or minus 10 percent, though you and a client may agree to other limits. All expenses agreed upon as necessary are borne by the client. Based on information in chapters three, four and five, you should be able to negotiate a photography fee and agree on rights being leased for the use of the pictures. (Note in the Q&A on page 117 what Nick Vedros says about a project fee.) Charges for additional usage beyond what's in the original estimate may be negotiated when the need arises, and can be stipulated in the original agreement. For example, the original agreement for picture usage may be for a regional magazine ad, but when the client decides to use images from that take for direct mail advertising, you'll need to negotiate an additional fee.

Essential questions to ask before writing an estimate include: What are the main purposes of the photographs? How are they to be used? When can you see the layout? Is there a main copy headline to which the photos must fit?

What is the message, feeling or flavor expected in the photos? What is the ad's primary market? What camera format would be most suitable? Are professional models or "real people" going to be used and who will do the casting? Will special props or effects be involved? How precisely do they expect you to stick to the layout? Do you have to make room for copy in the photograph's composition? Has the copy been written or will it be influenced by the photo? Will you need to build any sets, indoors or out? Who will have final approval of the your pictures? The more specific your questions, the better you will anticipate the needs of the art director, which will make it easier to estimate the creative fee and the expense budget necessary to produce the pictures.

Fees. The fee structure for advertising involves several important variables. Because a day's shooting usually includes other days of preparation, the fee should cover that time. The fee will also reflect the fact that ad photographers have larger overhead expenses than other specialists. Your agreement should allow reuse of the photographs for your portfolio or as promotional pieces. Photographs that are not used in an ad, but are similar to those in a layout, customarily belong to the photographer, unless otherwise agreed. The agreement might stipulate that the photographer will not try to sell any images containing trademarked products without permission. It might also include a waiting period for selling any photographs from the shoot.

Bids. In the advertising field a bid is defined as a firm offer to shoot a specific assignment for a specific fee. A bid is usually binding on the photographer unless the client makes changes that are not included in the written specifications. An art buyer may describe a bid as "a fixed cost for a project without flexibility." This requires the client to give you precise requirements for the job, and if bidding is competitive, it is helpful for the assignment to be explained with all bidders present so everyone hears the same requisites. Only a portion of photography jobs are put out for bids. An art buyer explains, "The rest are given to a unique talent that the art director feels can do the job."

Comparative vs. competitive bids. In a comparative bid, photography specifications are given to perhaps three photographers, and the lowest bidder may or may not get the job. In a competitive bid the lowest bidder usually gets the job. An art buyer has to decide if a bid indicates how the photographer would approach the job and its costs. "We choose the person we feel can best shoot the photographs we need," one says. Most experienced photographers dislike the bidding process, which inevitably pits one shooter against another in what may be a way that encourages price cutting.

Almost a decade ago Joy and Al Satterwhite wrote a book for Amphoto titled *Lights! Camera! Advertising!* which describes many of their photo projects. In the introduction they say, "A great picture has to have soul. This comes when you love your work." The Satterwhites say about bids: "When you make a bid, you have to come up with an angle that will set you apart from the competition and guarantee that you get the job. The angle can be

either an individual skill, an innovative approach, or a low price. Keep in mind that dramatically reducing your price can be dangerous. It sets a precedent that is hard for you, as well as the entire industry, to undo." The Satterwhites feel innovative ideas and personal photographic strengths are better ways to hook the client.

Data for an estimate

Here are pointers for properly estimating an advertising assignment in order to make a profit:

- What is the media and its distribution? For instance, a newspaper ad may only be regional, while a magazine's circulation may be national and larger so the photography fee would be greater.
- How else will usage influence a picture's value to the client? For instance, will the photographs be in color and used as an insert in local advertising throw-aways, or for packaging?
- How long does the client want to use the pictures?
- Are the rights requested reasonable? It is rarely cost-efficient for an agency to buy out all rights, or request a work-for-hire arrangement, either of which may be the equivalent of selling the copyright. If a client requires a buyout, ask how he defines it. A complete buyout (worth three or more times a basic fee) means the purchase of all rights with the copyright as in work for hire. A rights buyout (not as expensive and more limited) usually covers buying a group of rights but not the copyright. A limited buyout is least expensive but costs more than buying added rights. Buyout does not always mean the same thing to people. In a rights sense, it does not mean a transfer of copyright.

 It is preferable to avoid the term "buyout" in licensing rights, and better to clearly state whether or not the copyright is being transferred. If faced with a buyout request, ask the client to explain their needs or fears, and then negotiate to license rights they need as economically as possible. Clients often want control of images for future use, and to prevent them from being used by competitors or in other objectionable ways. In your negotiations assure the client by agreeing on written limits about what you can or will do with the photographs. Arrange a time when you could use some of the pictures for stock providing brand names don't show. Clients want protection and they want to keep costs down, and you can help them achieve these goals by carefully explaining how handling the rights can benefit you both.

Advertising media categories for rights billing purposes

- Consumer magazines, single page, half page, quarter page, etc.
- Newspapers, according to size of space involved
- Billboards
- Point-of-purchase counter ads, according to distribution and complexity

- Direct mail advertising and catalogs
- Stills for television commercials
- Also to be factored into fees are distribution—local, regional or national—and length of time needed

Advance payments

For many advertising jobs advances are essential to avoid shelling out large sums for expenses. Normally, an advance is paid before you start spending your own money, and certainly before you go on location or get very involved shooting. Ad agencies are accustomed to advancing expenses.

Work for hire

An ad agency may try to pressure you into a work-for-hire deal. Copyright law states work for hire is only legal "if the parties expressly agree in a written instrument signed by them." When you are a newcomer in the business an art buyer may tell you, "We paid for the photographs and all your expenses, and we are entitled to own them." Explain that ownership will come at a high price, because you own the pictures by copyright law, but they may lease whatever rights they need. As soon as possible, get an agreement on paper setting fees and rights. Newly minted photographers do not charge the highest fees, and should be wary of pressure to give rights away.

A veteran advertising photographer who is also financially successful made these comments on rights protection: "If a client insists on work for hire, I explain in that case I'll shoot only one or two situations of any picture. I tell art directors that work for hire stifles initiative, because creative people will not be as motivated when they have to give up all rights. It should not be a struggle to arrange for limited fees for the rights a client needs, and later negotiate for added rights."

In contrast, another photographer who shoots products such as home workshop tools says he can't imagine resale markets for his pictures. "I make good money for shooting on a work-for-hire basis," he admits. That can be a short-range viewpoint unless he doubles or triples his fees. Otherwise he may be categorized as a competent photographer who doesn't bother to negotiate. More experience is unlikely to add to such a photographer's income when he undermines his future.

LEGAL DEPARTMENT INFLUENCE

Sometimes the unfair terms photographers may face in advertising purchase orders originate in the agency's legal department, which aims to protect the agency or advertiser, but not the photographer. When you negotiate, there may be a legal department behind the scenes that believes owning all rights is the ideal way to avoid future payments and negotiations. Legal minds may assume that limited rights or all rights should cost the same, because advertising photographers are well paid.

It has taken years of educational efforts by the ASMP, the APA and many individuals to counteract the one-fee-fits-all theory of personnel in some ad agencies. Experience shows that business and creative people inside an agency can overrule legal department recommendations about rights, in order to get the photographers they want and trust. When the legal department prevails, it's usually because a photographer hasn't been convincing enough to the creatives.

AN ADVERTISING PHOTOGRAPHY CASE HISTORY

Dale received an assignment from the XYZ Co., which makes skis. It's a new account, has a good reputation, and was highly recommended. Dale negotiated a good fee plus expenses for three ad photographs to be run three times within a year. In four days he was to shoot in Colorado, and he requested a purchase order be faxed to him at his studio. Concentrating on preparations, he didn't really study the purchase order until he reached Colorado. Then he saw the numbers were okay, but didn't realize the purchase order did not stipulate how many magazines in which the three shots would be inserted. The purchase order did include the correct fee for three pictures.

If Dale had noticed the omission, he could have insisted on a revised purchase order faxed to his office. Instead he focused on creative decisions and got excellent pictures. Two months later XYZ Co. ran the ads with his photographs three times in three magazines. Later he was surprised to find the same ad photos converted to black and white in two newspapers, and in a fourth magazine. Then a contact at XYZ Co. sent him a brochure that used one of his main shots and some outtakes. Dale called the art buyer at the ad agency as soon as he saw the newspaper ads, but she was gone and her substitute was evasive. "Why are you making such a big deal?" he was asked. "You got paid, didn't you?"

Dale's attorney wrote to XYZ Co, and billed the company the original photography fee again "for unauthorized additional usage and copyright infringement." The company ignored attempts to solve the problem, and the ad agency blamed the company president for being obstinate. Dale filed a suit, and the trial date was set for eight months later. His photographs had still not been returned from the agency.

Two days before the trial was to start, XYZ offered to settle for half the amount Dale billed for additional usage. A guilty client may figure to save money with a last-minute offer to settle. This pressures the photographer to accept less money to end his aggravation and legal fees. Dale's attorney countered by reducing the reuse fee by only 10 percent, plus all legal fees, since Dale had registered his pictures at the copyright office. Within forty-eight hours XYZ agreed and signed a settlement and Dale received all his slides.

Moral of the story: Thoroughly read purchase orders and other documents and never make assumptions.

AD AGENCY LISTINGS

Search for the names of companies in markets that interest you and become familiar with ad agencies that represent those companies. You'll find many useful directories in your local library.

- *Photographer's Market* is more affordable than most references. It includes an excellent section on advertising, design and related markets. They are divided into five regions covering the U.S. and each regional section opens with a list of its leading advertisers. The most notable ad agencies in each region are highlighted, followed by general listings of agencies, their needs and related data.
- *Adweek Directory of Advertising Agencies* also divides the U.S. into five regions, but does it in five volumes, listing the top fifty ad agencies in the nation and 200 to 550 agencies billing $1 million per year or more.
- *The Standard Directory of Advertisers* and *The Standard Directory of Advertising Agencies* are comprehensive sources for national agencies.
- *The Design Firm Directory* contains a state-by-state listing of over fifteen hundred design firms and their major clients.

Additional Business References

- The business section of many daily newspapers covers new products, services and mergers, and you may find clients who need photography for promotional material. The largest newspapers regularly do special lists of the hundred most successful companies in the region or state, and they usually note these companies' products and services.
- Weekly business magazines and newspapers offer similar lists, plus articles that could include good leads for researching future photography business.
- Trade magazines devoted to markets such as electronics, toys, retailing and dozens of other specialties can be sources of valuable advertising information.

Every business that prospers is based to some extent on marketing efforts. Advertising photography is no exception. The more client possibilities you seek, the greater success you'll have.

Q&A *with*
Nick Vedros

Nick Vedros first became interested in photography at age thirteen when he saw the work of his uncle, Mike Mardikes, an accomplished photographer. "I purchased a 2¼ twin lens reflex and Mike was my first instructor." His formal education was at the University of Missouri School of Journalism as a photojournalism major, where he received a good education in how to "take" photographs, "but I quickly learned that I wanted to 'make' photographs."

After graduation from college in 1976, Vedros was hired full-time at the *Kansas City Star* and assigned to cover the Republican National Convention. For Vedros the highlight of this one-month stint was being chosen to ride in the press car of the presidential motorcade on the day they nominated Ford for president. "The next day, my photograph of Ford with outstretched arms was the front-page picture." At age twenty-three, he borrowed $10,000 from a bank and signed a five-year lease on a loft space in downtown Kansas City. With no experience in advertising photography, he set out to show his work to ad agencies. Black and white, people and travel pictures from Europe caught the eye of a creative director, who hired him to shoot environmental portraits of his creative staff. He then gave Vedros his first ad to shoot. "After that I got lucky and worked for a very good group at Brewer Advertising, a subsidiary of Young & Rubicam, who taught me a lot about how to think more like an art director. I taught myself more technique and learned to envision photographs from scratch."

Q Is it fairly common that advertising photographers start out as, or later become, specialists in one or more categories? Is one likely to fare better as a specialist?

A In Kansas City, which is a medium-size market, I started as a generalist and did both people shots and still life. I got into sets later after I built a big enough studio. I did a lot of black and white early on, and still do a fair amount. I am very much a generalist and refused to specialize from the beginning. Later I started to focus nationally on doing people and sets, and I naturally gravitated toward humor. I wanted to taste a little bit of every type of photography. I enjoy the variety.

Q What is the size of your studio and staff, and how many jobs might be in progress at one time? How often do you work on location?

A My studio is inside an old firehouse that was built in 1911. It has five floors and approximately thirteen thousand square feet. I have a staff of six people who help me immensely. Sometimes we'll have up to three jobs in progress, but you only shoot one at a time. I wanted to create a dream workspace. It has carpeting, a very low dust level, nice lighting, and it's comfortable. The shooting spaces are large enough to leave sets up until the film comes back, so I can make corrections when necessary. Having a large enough studio allows me to be creatively strong, which was my goal from the outset.

My philosophy from the start was to design my career around the lifestyle that I wanted, and I've been at it for twenty-two years. You can learn so much during your first ten years but you need to avoid burnout because you've lost the creative desire. There are so many details involved in producing good advertising that it's very easy to get bogged down with the noncreative side of things. I've tried to create a studio environment with a support staff to allow me to concentrate on the creative aspects of a project. I work on location 5 to 15 percent of the time. Being centrally located in Kansas City makes it easy to fly from here to just about anywhere in the continental U.S.

Q I recently discussed advertising photography with a veteran who is semi-retired now, and he claims that creativity is in short supply at ad agencies, at least the ones he worked with. He added that agency personnel avoid taking chances. How do you feel about these issues? Did you have more creative leeway in years past?

A I know the veteran shooter you mentioned and he's pretty cynical about the ad business, which he was in for a long time, and I respect his opinions. I have definitely run into some people who fit into the category he mentions. I think we've evolved to working with groups who are extremely creative, and on the contrary, give us some great ideas that we aim to execute so they remain great when they reach the printed page. Sometimes you can turn a mediocre idea into a great piece with excellent execution.

Ad agencies that don't take chances definitely do exist. Some agencies are very client-driven and they want to please the client. They'll take idea after idea to the client. When the client finally accepts a layout, it may not be the strongest idea, but that client doesn't want to take a risk. They don't want to place their product on edgy terrain, so to speak. They feel it's safer to mimic what's being done in the industry right now, which many times is ready to "change." Often the art director will tell us the best ideas got trashed. Some of the best agencies that rise to the top have the ability to fight for their best ideas, so I remain optimistic that you can still do great work in this industry.

Q My cynical friend also said that in some ways photographers are their own worst enemies, referring to their inability to maintain sensible prices and retain suitable rights. Have you experienced more pressure from clients regarding fees and rights?

A This is sometimes a tough thing, but fortunately, we get calls from very high-end ad agencies that know what it takes to produce quality work on decent budgets. Sometimes a good agency requests an estimate for a national ad client, and we submit our estimate and don't get the job. They may come back later and say well, you guys were too low and we didn't think you could do as well as this guy in Los Angeles whose bid was 50 percent higher than yours. We're shocked because we know we could have produced the work and done an excellent job. Those kinds of situations make us really skittish when we estimate a job. Other times we'll hear that our price is too high. We know that each situation and client is different.

Everything is open to negotiation and you have to work very hard to determine the client's expectations. The best scenario is when the client is sold on using you creatively, and you are given an opportunity to revise your estimate to better meet their budget. When this happens, we have to be confident that the budget allows us to profitably produce the work without diluting the concept. If you get 20 to 30 percent of the jobs you compete for, I think you'll be a very successful photographer.

I've seen a higher percentage of advertising shoots being canceled in the nineties than in the eighties. After you bid on a job, everybody says everything is great, you'll start to schedule the job, it will get dragged out, and all of a sudden it will go away. The agency will say the client canceled it.

Regarding rights, we refuse to shoot for somebody who wants to own the copyright for the photographs and pay only a standard photographic fee. We just don't bid on such projects. We can arrange to sell extended usage or unlimited licensing to our images for a higher fee. We want them to purchase the rights they need to succeed on their end. They get more benefit for a little higher fee.

Q Do you feel that a photographer's personality and that of his representative and staff who deal with clients are important elements to success in advertising? How does personality express itself in your business and photography?

A Personalities are always important. I think you need to communicate well and be able to apply sound logic to your communication. After all, we are in the business of creating communication tools that our clients will use to sell products or services. It's also important to show enthusiasm in this business because if you are not fired up about doing this kind of work, you probably don't belong in this business. I've tried to design our studio environment to reflect my personality. From the way I dress to the way my

studio is organized, designed and painted, is a reflection of my taste level. I strive to convey in all those things, a certain level of class and stability, with a bit of whimsy thrown in for good measure. In my studio are funky props and interesting things that I've collected from shoots or travels. The studio decor is a work in progress as we regularly change the pictures on the walls and the props on display. Your image is also projected by your business cards, stationery and ad designs for which you may need to hire a designer who is going to represent your identity.

As far as negotiations go, I think that you have to start with top-notch photography to compete in today's environment. At the same time it is important to have realistic goals when you negotiate with clients. Fortunately, I have a very good representative in New York, Bob Mead, who has a very nice personality, and has been my representative for twelve to fifteen years. My producer, Mike Lee, who does a lot of negotiating, has a very easy persona and voice. And I routinely hear compliments from clients about his attention to detail. In this business we must be detail-oriented to comfort clients.

Q If you are asked to estimate the fee and expenses for a job that may take five working days to prepare and shoot, and you know there will be a couple more days of postproduction work, do you do so on a day rate, a job rate or how? If a job falls through, is all the time spent to estimate just absorbed?

A When we estimate a job, we consider how many days of my time will be required. Say that I'm charging $5,000 for a day of shooting. On my estimate, I put it down as a project fee. I recommend not calling it a day rate. State that the fee for one day of photography is a project fee. If I can finish the shoot in six hours, I'm not going to reimburse the client for working a short day. On the other hand, if it takes me ten or twelve hours to finish, I'm not going to charge the client overtime. We are experienced enough to accurately gauge the amount of time needed for a given project. Clients will seldom agree to pay overtime for a long day, but they will ask reimbursement for a short day, on a day rate basis. When the project is complex, we also factor in the amount of time I'll need to spend lighting studio sets, traveling, etc.

If a job falls through and we've spent a lot of time estimating it, unfortunately that time has to be absorbed. That's the only way to get work. We're the guys that seem to get the headache projects that are very intricate in estimating, but we've never charged a fee.

Q Do you have any comments about work for hire? Is it a way agencies ask you to work very often? How do you try to educate them?

A As a rule, regarding work for hire, we don't do it! There have been two projects in my career where I have ended up selling a photograph outright for a much higher fee. If a photograph has no future market value for you and the client is willing to pay four to five times the normal rate to secure ownership, then why not?

Q From what you hear talking to colleagues, would you encourage talented, qualified photographers to go into advertising if they are motivated? What are several things they should know or remember to get into and stay in business?

A The best way I can evaluate a photographer's talent and motivation is in person. By the way, we have an intern program at my studio. I can see how a prospective photographer's brain works and if they would be good at putting up with all of the annoyances that are a part of advertising work. I'm an immediate-gratification person. I love seeing the results of what I'm working on daily. When I finally shoot the job, it's always exciting to see the final film. As far as recommending that someone go into advertising, it's such a collaborative process that it takes a staff of integrated people to cover all of the details. I think that an important qualification has to do with how well you coordinate and integrate with other people.

Q Can you end with a short case history of a job that went well?

A One of my favorite projects to work on was in 1991. Several years earlier I was sent to Asia by Eastman Kodak to lecture photographers, after which I traveled through Tibet for another twelve days, joined by my wife and a good friend. As I watched the faces of the Tibetan people, I so much wanted controlled lighting to record some of them and the costumes they wore. A couple of years later the art museum in Kansas City invited a group of visiting Tibetan monks to create sand paintings, and I accidentally stumbled upon them. I learned that they were touring to raise money for the children of Tibet, and I invited them to my studio the next day to photograph them for free and maybe help out their cause.

Their faces and costumes were wonderful. As I worked, finally doing all of these great portraits I had dreamed of doing years before, I was struck by another idea. I had recently completed work on the ad campaign that introduced the Apple Powerbook. The group seemed a perfect opportunity to create a unique image for the Powerbook campaign. So I called the art director, Susan Westre, at her home in Los Angeles on a Sunday morning. I described the monks and the writer traveling with them, who used a laptop. I suggested that we give him a Powerbook to hold and surround him with monks for a

portrait, and maybe instead of paying me, Apple could donate a thousand dollars to their fund and pay the writer five hundred dollars for being the primary model. She said to go ahead on spec, and I spent an hour shooting what I had described. I sent the film to her and sure enough, the agency and Apple loved the image, which became a very successful Powerbook ad. They sent me expense money and talent fees for the monks and the writer. I just wanted to help out the Tibetans and also to produce a really cool piece of advertising. The Tibetans were happy, the writer was ecstatic, the agency was very happy and of course I had a great piece for my portfolio.

I'll end with some words of advice. If you are going to get into the advertising business or to start a freelance studio, it's important to set clear goals for yourself. Know what you want to accomplish at the start of each year and analyze your results at the end of the year. Create a five-year plan and work toward that end. You also need to develop good business skills. I've seen many talented artists fail in business because they couldn't deal with the noncreative things. You must be able to talk to a banker, manage your credit wisely and pay your employees and suppliers on time. You need to be constantly working on your portfolio and marketing your new work, especially when you are busy, because that's the way to stay busy.

CHAPTER EIGHT

Dealing with Stock Clients and Agencies

THE TRUTH ABOUT STOCK

Until you try selling stock yourself or through an agency, the concept may seem fairly easy to undertake. But making much money in stock can be something of a fantasy. It's a self-starting business in which you most often make your own "assignments" that may be fulfilling and lucrative—or the pictures might just age in a file. Stock agencies offer their photographers ideas, but rarely make stock assignments. To be successful you must choose salable subjects and find markets for a huge diversity of image possibilities, from aircraft to zoo animals. Handling your own sales can be an uphill road, yet numerous freelance photographers do it successfully. It's also a challenge to be accepted by a good stock picture agency that handles a large number of sales, offering images worldwide.

All that said, there is a big market for stock photographs to be licensed by magazines, ad agencies, book publishers, corporations, television, and other markets. Stock is big business, but the field is crowded with excellent as well as mediocre photographers whose files are filled with a smorgasbord of subjects. Stock agencies have millions of images on hand, and some individual shooters may have 250,000 photos for lease. Success depends partly on volume, partly on what subjects you shoot, and partly on how well you or your agency markets your work. Though pictures of almost everything you can name already exist, many are out of date. At a theoretical average of $250 to $400 per image, how many sales per month would you need to support an office and feed a family? Remember, a stock agency takes about 50 percent of the sales price, but it leaves you more time to shoot.

STOCK CONCEPTS

What sells: Successful stock photographs have one strong characteristic in common: *simplicity*. Pictures should read quickly, like good posters, without distracting elements or technical flaws. To see what's selling, check agency Web sites or gather some catalogs. Ask for catalogs on the basis that you want to see what an agency offers and if your work would be a good fit.

Pictures from assignments: A stock file may be fed by photographs you make on assignment. Extra frames of worthy stock situations can be added to your files. Assignment photographs should not be leased as stock before

they appear in the publication that hired you. It takes a year or two (or longer) for many filed pictures to be leased, so publication conflicts are easy to avoid.

Production stock: A majority of best-selling stock shots are custom made to fit current and future needs. Paid models are used and model releases are standard operating procedure. A released people picture is always preferred for lease to higher-paying advertising and commercial markets. Released images are an important means of making more money in stock photography. Jon Feingersh, whom a magazine article called a "stock impresario," specializes in shooting people situations and is successful because he conceptualizes and shoots what sells well. His "Keys to Success" in production stock are at the end of this chapter.

For guidance on what to shoot in production stock, get the advice of a worthy stock agency. Most agencies send want-lists to photographers to inform enterprising shooters to set up or seek images for which there's a demand. (Keep in mind there's a market for both color and black-and-white stock.) A friend of mine shops for antique kitchen and home equipment, such as old scales, bottles and radios, and arranges still life pictures that his agency has sold well. They also sell his outtakes from years of high-tech assignments, including computer fantasies and imaginative laboratory patterns. For a concise analysis of how to produce marketable images, check Rohn Engh's *Sell & Re-Sell Your Photos* from the publisher of this book, or *How to Shoot Stock Photos That Sell* by Michal Heron from Allworth Press.

MODEL RELEASES

At the end of this chapter are several examples of model releases for various purposes. You may use them as is or revise them. The more words there are on a release, the more likely it will intimidate people, who may refuse to sign unless well paid. However, the fewer the words on a model release, the more problems you might have if one is challenged. It's worth consulting an attorney to be sure you've touched all the bases.

I asked attorney Christine Valada, who supplied the Q&A in chapter two, if there are large enough differences in state laws to make a release valid in one state and inadequate in another. She said the validity of a model release should depend more on the state in which it was executed than the one in which it may be enforced because it is a contract. For clarity, there should be language stating that the release is entered into and will be interpreted under and in the courts of a particular state.

California and New York are among states that have statutes dealing with the right of publicity and image appropriation, which are different for living and deceased celebrities. In California consent is all that's necessary to use a picture of someone for commercial purposes. In New York, a written release is required, signed by the model or a guardian. Valada believes that a written consent is best in California as well. She says, "When dealing with celebrities,

dead or alive, consult an attorney for special conditions that may apply to leased photographs."

Rohn Engh wrote in his Internet weekly, "Notes for Stock Photographers," that "stock photographers seldom get sued because people are more likely to target the publisher, not the photographer. Publishers have deeper pockets."

Valada responds, "The deep pocket theory of lawsuits may be small comfort for some, but the truth is that stock agencies and publishers are now demanding photographers make warranties and indemnify them for these very things. I'd say a photographer must make sure his business insurance is paid in full and that he is totally judgment-proof unless he wants to take extra risks. An insurance company isn't going to like a photographer they know can't provide proper releases."

SELLING YOUR OWN STOCK
Part Time vs. Full Time

Successful stock photography may augment editorial, advertising or corporate work, but stock will be less profitable when it's not a full-time job. Shooting mainly subjects you enjoy may be fun, but carefully selected subjects are usually more apt to sell. Income will be intermittent until you spend most of your time shooting, filing, market researching and servicing stock users. You will probably need a substantial file of images, around two thousand or more to make a significant start. Sales from smaller files are feasible, depending on how you market the work, but selling stock is like playing roulette: The more slides your money is on, the better your chances to win.

Creating a Stock File

The best way to build a stock file is to shoot carefully chosen subjects, either those you arrange with models, still life or existing scenes and situations. Attractive setups in controlled settings, indoors or out, have sales appeal. Study catalog examples. Keep in mind that stock for editorial markets may pay less than sales for advertising, but in many cases you won't need model releases.

Some photographers do well by concentrating on specific subjects. They specialize in hard-to-reach geographical spots, exotic animals, seniors, pretty girls, couples or children. Jim Pickerell, co-author of *Negotiating Stock Photo Prices*, once rented a courtroom, hired twelve people for a jury, plus models to represent a judge, bailiff, prosecutor, defendant, lawyer and spectators. For two days he shot a long self-made list of courtroom situations, and though his cash investment was high, his stock sales eventually paid all the bills and the pictures went on earning profits for years.

Filing

You need a succinct filing system to find pictures easily. Each slide or print needs a separate file number used to keep track of submissions, returns and

sales. One popular computer program for filing and maintaining a business, called StockView, is produced by Hindsight, Ltd. Inquire at (888) 791-3770 or check their Web site, http://www.hingsightltd.com. Another stock business program is Filemaker Pro 4, widely available from software retailers.

Duping

Excellent duplicate slides can be made today and many buyers accept them. They protect your originals and relieve clients from large monetary damages when transparencies are lost or damaged. Dupes are good business insurance, as is shooting plenty of slides of every worthy situation, because the best dupes are made in the camera. Compare lab duping prices and quality, or learn to make dupes yourself with precision copy equipment or a scanner.

Digitization

You can scan images onto your computer hard drive and manipulate them with PhotoShop or other programs, or have this done by a service bureau. Excellent transparencies and enlarged prints can be made from digitized images. Original slides can be stored in your files, and digitized images are saved on a CD-ROM, from which they can also be delivered directly to clients via the Internet. See chapter fourteen for more information.

DIRECTORIES, PROMOTIONAL BOOKS AND NEWSLETTERS

The books listed below are sources of information about both the visual and business aspects of stock. Some are books in which you and stock agencies can advertise. They are distributed, some free, to a wide variety of picture buyers. A few of these references will also be useful when you choose a stock agency.

PDN'S Photo Source available from the publishers of *PDN*. The monthly news magazine for professional photographers, *Photo Source* lists equipment, rentals, labs and more. It also lists stock agencies, and those marked with an asterisk are members of the Picture Agency Council of America (see page 128). Inquire about *PDN'S Photo Source* at (212) 536-5196.

The Green Book from AG editions. In this directory, subtitled "The Directory of Natural History and General Stock," freelance stock photographers buy space to describe their picture files according to specialties, and list their publication credits.

The Blue Book from AG Editons. Its subtitle is "The Directory of Geographic, Travel and Destination." Freelance stock photographers and some stock agencies list their image categories and credits. For either this book or *The Green Book* contact AG Editions at (212) 929-0959, E-mail: office@agpix .com or visit them on the Web at http://www.agpix.com.

Stock Photo Deskbook. This is another directory in which photographers and agencies advertise their files. It lists over three hundred stock agencies as well as many sources of stock pictures for potential buyers. For information, call

(201) 692-1743 or (800) 391-3903, E-mail: info@stockphotodeskbook.com.

Direct Stock. You buy space in this catalog. Their brochure says, "We work best for photographers who show a body of work with a recognizable style." They try to make photographers aware of stock-buying trends. The catalog is distributed to over thirty-thousand potential clients who contact photographers directly when they want to see work. You make the sale and there's no commission for the catalog. Call (212) 979-6560 for information.

Advertising in promotional books can help increase your business, but you should have plenty of images on file. Photographers in a recent *The Green Book* describe files numbering from ten thousand to one million slides, with many in the hundred thousand category.

Post cards. Clark Cards, at P.O. Box 1156, Willmar, Minnesota 56201, (E-mail: clarkco@usa.net), prints full-color cards. You provide the picture and text, they print the cards. In mid-1999, an order of one thousand cards cost about $.30 each. The same type of service is offered by Postcard Productions at P.O. Box 703, Rockport, Maine 04856 or (207) 691-0000. Each company will send you samples.

Photosource. Author Rohn Engh runs a Web site called Photosource International, on which photographers can list stock for sale. Visit http://www.photo source.com or inquire at (800) 624-0266.

PhotoAIM. Another Rohn Engh stock aid, this is a free informative weekly newletter which arrives via E-mail. To sign up, send an E-mail to info@photosou rce.com.

Painet Stock Photo Agency. An online operation that offers buyers free photo research of their database, then sends requests to members for additional images. These are posted on their Web site at http://www.painetworks.com/mock.html. They use fotoQuote for pricing and charge a 50 percent commission. Inquire by E-mailing painet@stellamet.com.

Selling Stock. A monthly stock newsletter published by Jim and Cheryl Pickerell is available online at http://www.pickphoto.com/sso. A printed version is published six times a year. For subscriptions call (301) 251-0720 or fax (301) 309-0941.

Stock Photo Report. Published since 1990 by Brian Seed, my Q&A subject in this chapter. The monthly gives current news of the stock industry along with photography, marketing and picture management data. A yearly subscription is $225. For more information, call (874) 677-7887.

PhotoStockNotes. Available by monthly subscription in printed form, this is an enlarged version of Rohn Engh's online PhotoAIM. Visit http://www.photo source.com or (800) 624-0266.

Reference Guides

Sell & Re-Sell Your Photos, by Rohn Engh, published by Writer's Digest Books. In more than three hundred pages of words and pictures, Engh covers the

whole stock scene from shooting to marketing to keeping records. The book is in its fifth edition.

How To Shoot Stock Photos That Sell, by Michal Heron, from Allworth Press, New York. Aimed at the self-starting photographer, the book presents twenty-five stock assignments to shoot, with all the steps needed to edit, run your own stock business, market your work, negotiate prices and find a stock agency. It also covers computers and digital work.

ASMP Professional Business Practices in Photography, from Allworth Press, New York. This all-purpose business reference includes a comprehensive 122-page chapter on the business of stock photography, plus the complete version of twenty-three keys to success by full-time stock specialist Jon Feingersh. (An abbreviated version of the keys is included at the end of this chapter.)

Picture Agency Council of America (PACA). This is a trade group of stock agencies that coordinates information and publishes a list of its members. Call (800) 457-7222 to request the list.

PRICING STOCK PHOTOGRAPHS

I do not suggest specific prices for stock photographs here because there are so many variables, and because the value of photographs changes. Prices are set according to the type of image and its rarity, quality and exclusivity; the type of publication and its circulation; the picture size, type of rights leased, length of time the image is needed and the photographer's reputation. Stock buyers lease usage rights only, so pictures are resaleable in the future. It is not good business to sell all rights to photos unless the price offered seems to equal your estimated future income. For instance, if the shot is worth about $500 for small-circulation ad usage, and you estimate it could sell four more times, a $2,500 fee could be considered for all rights. Fortunately, there are some excellent pricing guides available.

Negotiating Stock Photo Prices by Jim and Cheryl Pickerell of Stock Connection, 110 Frederick Avenue, Suite A, Rockville, Maryland 20850, (301) 251-0720. This is the best known reference for understanding many aspects of the stock business. It includes sixty-four pages of pricing schedules, as well as detailed data on running your business. It discusses specific publications and has lists of their circulations plus several forms.

Pricing Photography by Michal Heron and David MacTavish, Allworth Press, New York. It has chapters on pricing stock plus a large selection of pricing charts, along with a wealth of other information. There's also a chapter on opportunities created by the electronic media. Both authors are experienced in the photography field.

fotoQuote for Windows and Mac is software that guides you through the process of marketing stock photos. It covers 140 categories of photo pricing, and is regularly updated. According to the Web site, many stock agencies and companies use this program. Call (800) 679-0202 or go to http://www.cradoc .com.

Stock Photography Business Forms by Michal Heron, Allworth Press, New York. The book includes thirty-eight forms for four main areas of the stock business. It's a comprehensive source of special forms.

Photographers Index. In fall 1999, this was a new Web site at http://www.photographersindex.com/stockprice.htm. The pricing service is free. You describe the type of usage, press run and size and the Index comes up with low, average and high price suggestions that apply. Advice about selling copyrights is included. Pay attention to the disclaimer: If the service "causes you distress, financial loss or marital discord" they take no responsibility.

SELLING THROUGH A STOCK PICTURE AGENCY
Qualities of a Stock Agency

A good stock agency stimulates sales with catalogs and CD-ROMs. Only a small percentage of images in an agency file make it into these, which is a source of disappointment to photographers because catalog exposure increases sales. Agencies may also advertise their extensive files in professional journals, and their representatives visit the offices of present and prospective clients. Agencies may also give photographers personal advice on suitable subjects and picture quality.

An agency makes sales, does billing and sends sales statements to photographers. In return for its efforts, the agency shares income from your leased images. The standard commission is 50 percent, though some agencies take a little less and some try to take more.

Finding a Stock Agency

Talk to other photographers about their agencies. How effective do they feel an agency has been? Is their work handled with care? Is communication between the agency and photographer helpful? Do they trust the personnel and agency operators in general? Do they get regular sales statements and current needs lists? Are the people friendly and encouraging? Make notes from their comments. It may take a while to find an agency with a reputation for honesty that suits your images and taste.

At an agency, talk to someone in charge, ask for a catalog and visit the office if that's feasible. Check their CD-ROM catalog as well the print one. Ask about their contract. If they have one, read it for details about renewal, and what happens if the agency goes out of business. Find out how long it would take to get your images back if you wanted to leave the agency. Ask for a sampling of prices charged for pictures in various market categories. Inquire about the markets in which they are the most successful, and about their interest in subject specialties you may have. Find out about the size of the staff, how many photographers they represent, how much photographers pay to be included in a catalog, whether buyers are charged a research fee, how much the agency bills clients for lost or damaged pictures, if the agency makes dupes, and who pays the cost.

Photographic prerequisites: An agency will be interested in how many images you have for an initial submission. Typically, you will need 750 to 1,500 slides, depending on the agency. If they want than you can supply, consider other agencies. Remember, your relatively large number of images will be whittled down when the agency returns pictures it feels are not salable. After a relationship is established, my experience has been that when I send an agency 150 slides, and they keep 25, that's about par. Of course, many slides are similar, and the agency chooses the most salable.

If you are accepted, ask if the agency expects a certain number of new images each month. Can you comply? Find out how many images their most successful photographers have on file to gain perspective on what it takes to make a reasonably good living as a stock photographer.

Agency location: Stock agencies are located all over the U.S. and in principal countries abroad. It is not necessary to be able to visit the agency to have a successful relationship, but a local agency is a pleasant asset. Communications by E-mail are common with distant agencies.

Multiple agencies: At first, send your edited take to one agency. In due time it is feasible to be represented by two, three or more agencies. Be careful not to send the same shots to multiple agencies which could cause conflict if two agencies submitted the same picture of yours to a client. When you specialize in one or more subjects, stick with an agency that welcomes your pictures. When you get returns from one agency, remove pictures too similar to those that were kept, and submit the batch to the another agency. Choose agencies that are not directly competitive because of location or the nature of their files. If you work with a third agency, it might have different markets, such as sports or celebrities, to avoid conflict. If you become a high volume stock photographer, an agency will usually want exclusivity. In turn the agency should promote your work because it makes a good income for you both.

SELLING STOCK ONLINE

More photographers are establishing Web sites to display a sampling of stock photos to thousands of potential buyers. Consultants are available to help you build a Web site, and help you learn the techniques of digitizing, manipulating images and getting them online yourself. Read about this subject in chapter fourteen.

One drawback of exhibiting stock online may be the possible theft of your pictures via illegal downloading. Rohn Engh addresses this topic in his digital weekly newsletter. "If you discover someone has used your photo on the Internet without permission, look into companies that provide protection for digitized photos by encoding your copyright into the images in a way that cannot be detected by the naked eye. You are given a secret password to verify ownership." Two popular image protection companies are Digimarc, (503) 626-9944 or http://www.digimarc.com, and SYSCOP, http://www.crcg.edu/syscop. Some photo agencies imbed an identification feature with their images

and captions, together with the photographer's name and copyright notice.

For a detailed explanation of how to sell stock online, look for *sellphotos.com* by Rohn Engh.

Selling Royalty-Free Stock

In recent years, photographers have been persuaded to sell rights to some of their stock photographs to companies that provide pictures at very low prices. Available on CD-ROM, these images are known as clip art. Photographers who license bundles of images expect to be compensated despite low royalties, because, the producers claim, the volume of sales will be very high. The gamble may seem appealing to photographers with large numbers of unsold slides who think it's okay to get rid of them for a few dollars each.

The ASMP's executive director, Richard Weisgrau, calls clip art a scam in which producers are exploiting photographers who risk the possibility that their cheap images will force down prices in conventional markets. The best markets are always looking for custom-made stock that has quality, but a number of stock users are satisfied with a CD–ROM from which they can choose largely generic images for newsletters and other projects. Quality and prices of royalty-free photos vary depending on the agency involved.

KEYS TO SUCCESS IN PRODUCTION STOCK PHOTOGRAPHY

Jon Feingersh, who shoots stock exclusively, is a people specialist who orga- nizes his own stock shoots on a regular basis. He sells exclusively through The Stock Market, an agency he has worked with since the mid-1980s. He has successfully focused on salable situations that he shoots in commercially successful ways, working closely with his agency. I have been kindly allowed to list some of his *Keys to Production Stock*, copyrighted by Jon Feingersh and used by permission.

1. *Start today.* Put a shooting date on the calendar and keep it. Treat it as you would an assignment. Post another date to shoot two weeks later.
2. *Invest in yourself.* Plan to invest at least $5,000 for shoots the first year, and double that the year after.
3. *Put it in writing.* Write yourself a business plan and stick to it. Note what you intend to shoot, how often and how much you can invest. Set high standards and goals, and keep raising them.
4. *Be patient.* It takes a long time to see results, at the very least, a year, and often much longer. Be prepared to work without any feedback, compliments or income for at least two years. Probably 90 percent of those who think they want to pursue stock will bail out within the first two years.
5. *Study the market.* Become aware of current media trends. Don't copy others' work, but realize that the concepts you see in national ads have been thoroughly tested.
6. *Start a concept file.* Clip magazine ads religiously, and add to your files

constantly. On slow days go to your file for inspiration. Look at ads for clues to trends, style changes and cultural movements, and mirror them in your stock photography. Don't try to copy, but use clippings as a resource to learn what your photos might need.

7. *Observe current media for trends and themes.* Study ads on popular television shows which should indicate what the print ad market also needs. Think of yourself as a film director, not just a cameraman. Try to give your pictures life to distinguish them from other photographers' images.

8. *Shoot model-released people.* It's the photography most in demand, and the best way to make your fortune in production stock. Get model releases *every time.*

9. *Plan and review your shoots.* Do a preproduction storyboard or a list of the shots you want to accomplish, to be more productive. A postproduction review helps you see where you can improve.

10. *Shoot verticals.* Few photographers will do so unless forced. Many sales are lost because the subject wasn't shot both horizontal and vertical.

11. *Aim for the top.* Set your sights high. Do enough great work to be accepted by an agency with national and international significance. If that doesn't work, you should be good enough to dominate a smaller agency's files.

12. *Read contracts carefully.* Don't get stuck in an agency that doesn't deal fairly with its photographers. Make sure you control your images, and that you have the right to extricate yourself if necessary. Hire a good lawyer to be sure the contract is fair.

13. *Listen to your agency.* Become a creative partner. Study their want lists, talk to the researchers and editors about what they need and what is current. Constantly ask how you can improve your photographs. Don't be afraid to change.

14. *Specialize.* Learn what your strengths are and develop them, keeping in mind what the market needs. The best way to become significant in your agency is to be a specialist.

15. *Stress quality.* You are competing against photographers who are used to shooting big-budget campaigns and annual reports. Only the highest production values will be effective. The best way to fail is to scrimp on costs. If you can't afford to make your photographs big-budget, just be sure to style and construct them so they look as if they were.

16. *Volume, volume, volume.* The most successful stock photographers shoot on a production basis, and have tens of thousands of images in their files. Commit yourself to produce continuously. It will take a few years before your earnings will catch up to your efforts. The payoff will begin when you have a vital mass of photos on file.

17. *Hire help.* If you can't do it yourself, hire people who can help you. A production coordinator, stylist and extra assistants will help you do a

better job, leading to better sales. Get a good computer program to label slides, and hire someone to put the labels on.

18. *Forget the money.* Do take a businesslike approach, but remember that being concerned with money only will undermine your images. Think about your hopes, your craft, your vision, your particular viewpoint of our culture. Try to remember those creative impulses that made you enter photography, and shoot accordingly.

19. *Choose the right agency.* Choosing the wrong one can be an awkward detour. The right agency will treat you fairly, pay you on a timely basis, feed you ideas, grow with the field. The wrong one will drag behind the times, cheat you on sales, be unable to pay you at all, lie to you and will file your work and forget it.

20. *Don't copy other photographers' work.* Be true to yourself and your own vision. Don't collect stock agency catalogs only to use them as shooting scripts. The stock photography market and the country's demographics change rapidly and those photos may be way out of date. The best way to success is to be original.

21. *Look for niche markets.* The obsolete files of some stock agencies are often devoid of images for ethnic markets that need a constant supply of fresh imagery, well-shot and well-targeted.

22. *Know who is buying your work.* Realize you are no longer shooting for yourself. Clients rarely care about your beautiful photos. All they care about is advancing their products or services. Though your work must be desirable and worthwhile to many decision-makers, the ultimate buyers are the consumers. Your work must be tailored to be acceptable and resonant to them.

23. *Be artistically flexible.* Constantly try to find your own creative vision. Be prepared to change your style if necessary. Try to find a new you out on the edge of what you thought was photographically possible.

Read over Feingersh's keys to success occasionally. Focus clearly on how each point can help you make you a more successful stock photographer.

FORM 10 Stock Photography Delivery Memo

YOUR NAME OR BUSINESS NAME
Your address • Telephone number • Fax number • E-mail address • Web site address

Stock Photography Delivery Memo

Shipped to: _____

[individual name]

Date _____

Client's Company Name _____

Address _____ Reference, P.O. _____

_____ or Other No.

By request of _____

Return due date for photographs _____

Extension _____

Description of images

Qty.	Original	Duplicate	Format	Subject/File	Value

[For larger shipments, please attach separate list(s)]

Total count _____

Title in the copyright to all images created or supplied in accordance with this agreement will remain the sole and exclusive property of the photographer. There is no assignment of copyright title, agreement to do work for hire, or intention of joint copyright expressed or implied hereunder. The client is licensed only by subsequent written license on an invoice. Proper copyright notice which reads © 20____ [*photographer's name*], must be displayed with the following placement _____. Notice is not required if placement is not specified. Omission of required notice results in loss to the licenser, and will be billed at triple the invoice fee.

Check the count of images and acknowledge receipt by signing and returning one copy. Count shall be considered accurate and quality deemed satisfactory for reproduction if said copy is not immediately received by return mail with all exceptions duly noted. Photographs much be returned by registered mail, air courier, or other bonded messenger which provides proof of return.

SUBJECT TO ALL TERMS AND CONDITIONS ABOVE AND ON REVERSE SIDE

Acknowledged and accepted _____

Date _____

Your acceptance of this delivery constitutes your acceptance of all terms and conditions on both sides of this memo, whether signed by you or not.

FORM 11 Stock Photography Invoice

YOUR NAME OR BUSINESS NAME
Your address • Telephone number • Fax number • E-mail address • Web site address

Stock Photography Invoice

Date _____

Reference No. _____

Your Purchase Order No. and Date _____

Client Name _____

Address _____

Description of Images _____

[Attach separate list if needed]

Description of Usage and Rights [*Suggested wording: One-time nonexclusive repro-
duction rights to the photographs listed above or separately, sole for the uses indi-
cated; limited to the individual edition, volume series, issue, event, etc. contemplated
for this specific transaction (unless otherwise indicated in writing).*]

Use Fees _____ [see above] Price(s) Total Price _____

Research Fee _____ Sales Tax _____

Holding Fees _____ Total _____

Shipping _____

Misc. _____

Conditions of Transaction:

1. Copyright of all images created or supplied re: this agreement remain the sole
 and exclusive property of the photographer. There is no assignment of copy-
 right, agreement to do work for hire, or intention of joint copyright expressed
 or implied herein. The client is licensed the above usage in accord with the
 conditions stated herein. Proper copyright notice which reads © 20_____ [*pho-
 tographer's name*] must be displayed with all placements designated above. No-
 tice is not required if placement is not specified. If omission of required © notice
 results in loss to the licensor, client will be billed at triple the invoice fee.

2. Usage specified above is licensed to client only upon receipt of full payment.

3. Usage beyond that covered in item 2 requires additional written license from
 the licensor.

4. The sale is subject to all terms and conditions on reverse side of this memo.

5. Invoices are payable on receipt. Unpaid invoices are subject to a rebilling fee of
 $_____.

6. If images are not returned to photographer within _____ days, a holding fee of
 $_____ for each image shall be charged per day until such images have been
 returned.

7. Use of any image described above constitutes an acceptance of all terms and
 conditions expressed, whether on the face or reverse of this invoice.

FORM 12 Photographic Model Release

YOUR NAME OR BUSINESS NAME
Your address • Telephone number • Fax number • E-mail address • Web site address

Photographic Model Release

[Short form]

For good and valuable consideration, the receipt of which is hereby acknowledged, I hereby irrevocably consent that the photographs taken of me by *[photographer's name]* (herein known as "the Photographer") may be copyrighted and sold for reproduction in editorial, advertising, trade, art, display, exhibition, and all other media in such a manner as shall seem proper to the photographer and/or publications, with or without using my name or the minor's name.

I do further consent to the use of my photograph by successors and assigns, and anyone acting under the authority or permission of the Photographer for all of the aforesaid purposes. I certify that I am over 18 years of age and am free to give this permission and release which I have read and understand.

Name of Minor _____

The undersigned represents that he or she is the parent or guardian of the minor named above, and represents that he or she has the legal authority to execute the foregoing consent and release, and hereby approves the foregoing and waives rights in the premises. No other permissions are required.

Date _____ Signed _____
 Address _____
Witness _____ City, State, Zip _____

FORM 13 Model Release

YOUR NAME OR BUSINESS NAME
Your address • Telephone number • Fax number • E-mail address • Web site address

Model Release

[for adult or minor below]

In consideration of my engagement as a model, and for other good and valuable consideration herein acknowledged as received I _____
[print model's name] hereby grant to _____
[photographer], his/her heirs, legal representatives and assigns, those for whom the photographer is acting, and those acting with his/her authority and permission, the irrevocable and unrestricted right and permission to copyright, in his/her own name or otherwise, and use, re-use, publish, and re-publish photographic portraits or pictures of me, or in which I may be included, in whole or in part, or composite or distorted in character or form, without restriction as to changes or alterations, in conjunction with my own or a fictitious name, or reproductions thereof in color or otherwise, made through any medium at his/her studios or elsewhere, and in any or all media now or hereafter known, for illustration, promotion, art, editorial, advertising, trade, or any other purpose whatsoever.

I hereby waive any right that I may have to inspect or approve the finished product or products and the advertising copy or other matter that may be used in connection therewith or the use to which it may be applied.

I hereby release, discharge and agree to save harmless the photographer, his/her heirs, legal representatives and assigns, and all persons acting under his/her authority or permission or those for whom he/she is acting, from any liability by virtue of any blurring, distortion, alteration, optical illusion, or use in composite form, whether intentional or otherwise, by chemical, physical, digital or other means, that may occur or be produced in the taking of said picture, or in any subsequent processing thereof, as well as any publication thereof, including without any limitation any claims for libel or invasion of privacy.

The undersigned hereby warrants that I am of full age* and have every right to contract in my own name. I have read the above authorization, release and agreement, prior to its execution, and I am fully familiar with the contents thereof. This release shall be binding on my and my heirs, legal representatives, and assigns.

Signed _____ Witness _____
 [model]
Address _____ Addresss _____
Date _____

Release for minor if applicable

As the parent or guardian of the minor named above, I have the legal authority to execute the above release. I approve the terms states above and waive any rights in the premises.

Signed _____ Witness _____
Address _____ Addresss _____
Date _____ *[Delete this sentence for minor's release. Parent or guardian must then sign.]*

FORM 14 Model Release For Minor

YOUR NAME OR BUSINESS NAME
Your address • Telephone number • Fax number • E-mail address • Web site address

Photographic Model Release

In consideration of the engagement as a model of the minor named below, and for other good and valuable considerations herein acknowledged as received, upon the terms hereinafter stated, I hereby grant to _____ [*photographer*], his/her legal representatives and assigns, those for whom the photographer is acting, and those acting with his/her authority and permission, the absolute right and permission to copyright and use, reuse, publish and republish photographic portraits or pictures of the minor, or in which the minor may be included, in whole or in part, or composite or distorted in character or form, without restriction as to changes or alterations, in conjunction with the minor's own or a fictitious name, or reproductions thereof in color or otherwise, made through any medium at his/her studios or elsewhere, and in any or all media now or hereafter known, for illustration, promotion, art, editorial, advertising, trade, or any other purpose whatsoever. I also consent to the use of any published matter in conjunction therewith.

I hereby waive any right that I or the minor may have to inspect or approve the finished product or products and the advertising copy or printed matter that may be used in connection therewith or the use to which it may be applied.

I hereby release, discharge and agree to save harmless the photographer, his/her heirs, legal representatives and assigns, and all persons acting under his/her authority or permission or those for whom he/she is acting, from any liability by virtue of any blurring, distortion, alteration, optical illusion, or use in composite form, whether intentional or otherwise, by chemical, physical, digital or other means, that may occur or be produced in the taking of said picture, or in any subsequent processing thereof, as well as any publication thereof, including without any limitation any claims for libel or invasion of privacy.

I hereby warrant that I am of full age and have every right to contract for the minor in the above regard. I state further that I have read the above authorization, release and agreement, prior to its execution, and that I am fully familiar with the contents thereof. This release shall be binding upon the minor and me, and our respective heirs, legal representatives, and assigns.

Signed _____[*Father/mother or guardian*]
Minor's Name _____ F/M Address _____
Minor's Address _____ _____
Date _____ Witness _____

Q&A *with*
Brian Seed

"My first job, in 1946, was as a seventeen-year-old office boy in the London offices of *Time* and *Life* magazines," says Brian Seed. "By 1949, I had become *Life*'s general factotum, which included assisting photographers such as Mark Kauffman and Cornell Capa. By 1951 I was shooting for *Time*, and soon after for *Life*. Then began a twenty-eight-year period under contract to all Time, Inc. publications, including nine years as *Sports Illustrated*'s photographer in Europe. I also produced a number of Time and Life books.

"I came to the U.S. in 1979 on a year-long assignment and never went back to Europe. My wife was American and we settled in Skokie, Illinois, close to her family. In 1981, Barbara Smetzer and I started a stock agency, CLICK/Chicago, which was purchased in 1988 by Tony Stone as his U.S. launchpad. Tony Stone/Getty Images has now become one of the three most powerful stock agencies in the world. With money from the sale I started *Stock Photo Report*, which is now a wide-ranging monthly covering the international world of stock photography with subscribers in twenty-six countries. I also work as a stock photography consultant and marketing advisor for photographers and help them find new markets for their work, or locate dependable agencies. For experienced photographers I provide a highly critical sounding board."

Q More stock agencies and more individuals shooting stock have come along in the past few decades. How has this enlargement affected business for freelancers? Are there too many photographers? Or has the demand for stock increased to absorb additional images and photographers?

A There have always been too many photographers. There are also too many would-be photographers, but not so many with real creative ability, determination and drive who understand the importance of shooting stock. The market for stock has grown and the Internet has given it a quantum boost, creating new categories of image buyers who are now more demanding, so stock agencies are far more critical when reviewing work for their files. Photographers submitting photos to many agencies are in competition with the most creative photographers from around the world for space in the agency catalogs, and files. But the range of subject matter

is virtually unlimited, and expert photographers who concentrate on little-photographed areas will almost certainly do well.

Q Is the advent of clip art primarily a bummer for photographers? Has clip art been responsible for lowering prices in general?

A Clip art is selling well to the bottom and middle sections of the marketplace. There is no longer much sales potential for the kinds of generic images clip art is able to provide at a very low cost to the photo buyer. While clip art has largely shut down sales in certain categories of images, it has also opened up the market for clip art photographers. Of course, many photographers are offended by the clip art concept which floods the market with low-cost images, but clip art now provides significant income to some of the major agencies.

Q What are your feelings about selling through a stock agency, or agencies, as opposed to selling your own stock?

A How you market your images depends on what is in your files, but it is indisputable that individual photographers, even the most wildly success-ful ones, just cannot match the depth and volume of sales achieved by the major agencies. They maintain large staffs and are spending millions of dollars a year promoting images. I feel photographers should focus their energies on shooting and let someone else to do the marketing. This means using a wide spread of agencies around the world, and possibly, having someone else do your filing and filling requests for photos.

[Author's note: Very successful photographers like Seth Resnick, www.seth resnick.com have been able to sell their own stock successfully because they display the kinds of images many clients want. Resnick says he markets his stock through five agencies, and his site generates more revenue than all the images the other agencies sell for him.]

Q You mentioned on the phone that photographers need to do their homework in terms of salable subjects and that their personal passion for certain subjects should guide them. I think your thesis was "specialization is worthwhile," right?

A Because of an abundance of photographers, it really pays to create in-depth files on the subjects that interest you. Being known for a speciality makes you much more visible in the marketplace. Hit-and-run photos just do not hack it with present-day buyers. You need to plan and shoot pictures that capture the essence of the subject.

Q Are agencies squeezing photographers more and more in terms of commissions?

A Agencies are increasingly concentrating on the bottom line. Some commission their own photography, meaning that they are paying photographers a onetime fee and keeping all of the earnings generated, or at least the giant's share. One agency pays only a 40 percent royalty to its photographers for sales via the Internet. The accepted royalty split has always been fifty-fifty for sales not involving a second agency, i.e. sales through agency overseas representatives.

Q How true is it that catalog pictures sell far better than those in agency files that are not displayed in catalogs? How can photographers increase their chances of getting pictures into catalogs?

A Getting your photos into catalogs is critically important because they produce significant sales in the advertising, corporate and design markets. Photography for most editorial markets is more likely to be researched from an agency's file. Photographers should listen when their agency tells them the kinds of images it needs for catalogs. This may be no guarantee that their work will make it to a catalog, but it is a move in the right direction.

Those not with stock agencies might consider taking space in a stock promotional book, such as *Direct Stock* or *The Stock Workbook*, though they can be quite expensive. *Stock Workbook* costs less initially, but keeps an agency percentage (50 percent) of sales. Results from promoting your work through promotional books depends on the subject matter and quality of images. The publishers do offer advice on image selection, and both of those mentioned now include your photos on CD-ROM as well.

Q I've seen a variety of catalogs, and a majority of the pictures are conceived with one quality: simplicity. Such poster-like photographs are obviously sought after, but there also seems to be a lot of duplication in generic image types. Has this been your impression?

A Agencies are always struggling to achieve a *fresh* look in their catalogs, and some images are being chosen because they are open to different interpretations. Images can be of obscure subject matter, skewed angle, blurred, soft focus, tinted or shot on Polaroid film to make them look different. Stock photography that has been crafted with care is designed not to look dated.

It is important to choose a stock agency carefully. Talk to colleagues and get recommendations. Avoid those that pay late, don't pay unless fiercely

pursued, are indifferent or unfriendly to photographers or don't return photos promptly. Some smaller agencies may not have adequate marketing clout.

Q Should today's photographers be learning to digitize their images, or should they rely on agencies to do it? Should we be shooting with digital cameras? Or will film prevail well into the twenty-first century because of its quality?

A Digital technology and the use of software, such as PhotoShop, has vastly expanded our control over finished images. The scanned or digitized image has made possible an explosion of creative possibilities, and most agencies offer digital images on CD-ROMs they distribute. Many individual photographers have images digitized and retouched by service bureaus.

Whether or not to shoot digitally very much depends on the kind of photography you do, and its end use. For the time being, traditional, film-based photography is for most of us the most cost-effective and highest-quality way of working. We can have both worlds: shoot on film, then digitize the image when it serves our purpose. Film is still by far the most efficient way of storing picture information.

Q There are several books and computer programs that serve as pricing guides for stock? Are they suitable?

A A pricing guide is an essential part of a stock photographer's armament. The two valuable ones are Jim and Cheryl Pickerell's *Negotiating Stock Photo Prices*, a paperback, and the Cradoc fotoQuote 3.0 program, for both the PC and Macintosh. The Pickerell book is easy to use and quite comprehensive in its coverage. The Cradoc computer software, which is more expensive, offers some important advantages, including the instant translation of dollar prices into a number of other currencies and the possibility of modifying suggested prices so they conform with your own pricing standards.

Q Do photographers still struggle because they can't keep track of their images well enough?

A There is now a plethora of programs designed to help photographers manage their image files. Some, such as InView made by Hindsight, help handle your business including stock sales.

Q Do you see the stock business in the next several decades as more of the same? If not, where do the trends seem to lead?

A Sorry, my crystal ball is rather cloudy. It is very apparent that in the future, digital imaging will play an increasingly important role, as will the Internet. Also, one can see an ongoing trend among some major agencies to minimize the importance of photographers. Examples of agencies that already own a lot of photography are Corbis, Comstock, and Superstock, with Tony Stone/Getty Images playing catch-up.

CHAPTER NINE

Dealing with Corporate Clients

ANNUAL REPORTS PLUS

Annual reports photography is a special challenge that pays well and is sought after by many professionals. Most companies consider annual reports so significant that it's not realistic for newcomers to the media field to expect to get assignments during their first few years. Annual reports for stockholders are required by the Securities and Exchange Commission from corporations that sell stock to the public, in order to state a company's assets, liabilities and accomplishments. Small companies may compile pages of statistics and facts without illustrations. Larger companies use annual reports as a kind of public relations tool. They promote the company image to the public and brokers through impressive photography and attractive design in beautifully printed booklets.

Because millions of stockholders receive annual reports year after year, corporations are looking for different ways to illustrate new and familiar information with photographs. Some companies use staff photographers, because they prefer people who understand the company, its production methods, products, services and internal politics.

Company photographers often do excellent work, but they are less likely to buck the status quo. Many companies realize that an annual report photographic specialist brings a fresh view of people, settings, products, factories and more. These photographers may be top-notch advertising or editorial practitioners who are experienced shooting in locations where they have to adapt to mixed lighting sources, high-tech electronic equipment and processes that resist interruption. Many branch plants and offices are located in foreign countries, too, where veteran photographers may know better how to cope. Flexibility is a key to successful annual report work, along with the ability to anticipate conditions that call for extensive lighting and camera equipment. (John Nienhuis talks about his equipment in the Q&A on page 149.)

Corporations expect that annual report photo experts will make exciting pictures in often mundane situations. Photographs I've seen using color filters, wide-angle or close-up lenses, dramatic camera angles, multiple exposures, planned blurs and other devices are examples of designers' concepts and photographers' ingenuity. Annual report photos often have to symbolize the quality of a company's products and services to make the company more

appealing, or to substitute for classified operations that cannot be pictured. The work requires the ability to improvise as well as to follow a designer's ideas to make the ordinary seem almost glamorous. If the idea of doing this type of work interests you, request some annual reports from large companies, and study the ways photography is used.

ANNUAL REPORT DETAILS
Qualifications

Many advertising photographers segue into annual report work. They may already be shooting ads for companies who admire their location work and request them for reports. Photographers' representatives may be familiar with company art directors and designers, and be in a good position to seek annual report jobs. Some clients favor noted editorial shooters whose work lends itself to a reporting style. Studio still-life specialists may be hired when an annual report theme would benefit from their expertise. Successful annual reports depend on strong visual appeal, meaning imaginative images, which is often a way to catch the attention of a mass audience.

Travel Requirements

Major companies' facilities are spread across the U.S. and in foreign countries. "The worst element of this," says an experienced friend, "is coordinating all the cases of lights, stands, and other equipment to arrive at the destination when you do." After film is exposed, many photographers insist on carrying it aboard a plane as hand baggage. "I never let it out of my sight," says expert Ken Whitmore, who also tries to keep his main camera and lens cases with himself and his assistant. "Did you ever try buying a Nikon and a zoom lens in a small Spanish town?" he asks with a smile. Most pros travel with at least one assistant, billed to the client, to make all phases of an assignment go more quickly.

Themes and Designs

Annual reports are usually designed by firms that specialize in such work. The designer creates a theme or style to distinguish this year's annual report from last year's. For instance, in a report I photographed, seven full-page pictures were close-ups of production tools and materials, visually related because the foreground of each shot was out of focus. In another report done by Whitmore, the lead photo for each plant or department used sharp foreground details to dramatize computers, machinery and human activities. Ken shot with a 21mm lens to achieve the designer's visual theme, and he got the assignment because his portfolio showed examples of this and other creative techniques.

To find out which design firms do annual reports in your city, state or area, in larger cities check the Yellow Pages where "graphic designers" are listed. Some designer ads will mention annual reports. If not, ask someone who answers if the firm does annual report design. In either case, call and ask

permission to send portfolio material. When your images are unique enough, designers will make arrangements to meet you. Being familiar with annual report photographs from seeing them in use, you'll be able to choose images for your presentation with strong and direct visual messages. Remember that designers see droves of photographs every year, and they continually face the need to devise different ways to give an annual report distinction.

Collateral Images

Along with the variety of possible photographs that may be needed to illustrate an annual report are more formal portraits of company executives, especially the president and CEO. This work is collateral, or related to, annual report imagery that the photographer may also be asked to shoot. Still life is also a prime example of collateral work used often in annual reports.

PHOTOGRAPHY FEES AND RIGHTS

In 1992, Scott Highton wrote a report (for the Northern California ASMP chapter's newsletter) about estimates on a typical annual report job by four photographers. These were meant as how-to examples; the photographers made clear they would never submit a blind estimate without some contact with the client. In each estimate fees and expenses varied widely. Day rates ranged from $1,500 to $2,400 a day, plus $750 to $925 a day for preproduction, travel and scouting locations, depending on the photographers' experience pricing such work. Assistants would be billed at $150 to $175 a day. Each estimate included additional fees for use of the photographs in advertising (in national magazines and/or newspapers). All four photographers would retain ownership of copyright, though some would allow original images to be retained by the client, while others would request their return. One photographer specified a one-year limit on his pictures for the report, while the others allowed unlimited corporate use.

One participant said clients prefer to work with a photographer who is easy to travel with, and makes using his photographs a simple process. When packaging the images for delivery to the client, another photographer includes a delivery memo listing every image enclosed, indicating that he doesn't show the unsatisfactory images. Designers would probably appreciate this, though some may want to weed out photos themselves.

In this project, one photographer required a 20 percent advance, another 50 percent. Other charges were for meals, messengers, shipping costs, props, backgrounds, car rental, stylists, telephone and equipment rental. The photographers agreed it was the sort of dream assignment (shooting time ranged from fifteen to twenty days) that few get anymore. Highton suggested I emphasize that rates have increased since 1992, and that photographers routinely mark up charges such as assistants, film and processing by about 10 percent.

Many of the same prerequisites of annual report photography still exist,

and as John Nienhuis says, now there is less corporate work for more photographers. Keep in mind that the most experienced photographers may work with admirable efficiency, and are paid the highest day rates. Should you have the good fortune to get an annual report job, you'll estimate the number of days the job should take including travel time and postproduction with the designer and someone from the corporation. Time to edit the take will probably not be paid for separately, and is factored into the day rate.

Basic Rights

Guidance in previous chapters applies here, such as stipulating rights just for annual reports, or for other corporate purposes as well. You will have to make decisions about pricing advertising as an additional use. Set your fees and charges high enough to cover minor future usage, but define it in your agreement. Don't be misled that earning a substantial day rate requires generosity elsewhere. Make concessions based on common sense, not guilt.

Other rights: Make a contract with a corporate client that restricts your further use of photos of plants, operations and products shot for an annual report. You should not have to limit sale of any stock pictures you shoot on your own time on location that do not pertain to the company.

As happens in advertising photography, corporations may "accidently" use your photographs in advertising or promotional materials, just because they are on hand. Stipulate usage limits in your agreement, and ask someone you know in the company to advise you if any annual report photographs appear in other places. Then contact a company representative, politely explain their negligence, and arrange to bill for extra usage.

On your own do some shooting in offices and plant operations, if possible, for experience and to start a portfolio. You might offer to do a small corporate job for free in order to gain access. Prepare yourself to make money in specialized circumstances with unusual requirements.

Q&A *with*
John Nienhuis

John Nienhuis (pronounced nine-hice) attended Milwaukee Area Technical College, then spent two years working at a lab called Visuals Plus. "In my early career," he says, "I had the good fortune to work with people who knew how to put a picture together." The owner of Visuals Plus, former newspaper photographer Ted Rozulmalski, also impressed on Nienhuis sound business principles and respect for a job. Nienhuis went into business for himself in 1979 and began developing a style based on making people at ease and using simple composition. This led to bigger projects including a nine-month association with photographer David Brill, while traveling widely for *National Geographic*. Niehhuis's first annual report, for Johnson Controls, came about in 1987, and he learned more about coordinating between locations. He did the company's annual report for years afterwards. Today he works with one assistant for clients including Strong Capital Management, M&I Bank, Journal Sentinel, Inc., Johnson Wax, Midwest Express Airlines, Universal Foods Corp., Case Corp. and three universities. His advertising accounts include Komatsu Corp., The Jacobs Group and Generac.

Q Can you describe the characteristics of corporate work to help readers understand why many photographers want to graduate to it? Is it because this category pays better than advertising and requires less overhead?

A I feel that in corporate photography it is still a buyer's market, but there's always a need for creative people. I started out stringing for newspapers and shooting for magazines. As I became more competent and qualified, I looked for bigger paying projects. I was already shooting CEOs and industrial processes so it was easy to move into corporate collateral (brochures and newsletters) and eventually annual reports. Based on new photographers whom I now bid against, I think this still happens. I do approximately 30 to 50 percent of my work in advertising and these tend to be bigger productions (in use of talent, location scouts, bigger crews following tighter layouts) than annual report shooting. Most annual reports take many days strung together as opposed to one to two days for an ad. Though the creative fee I charge is actually higher for ad work, corporate work tends to pay better with respect to time spent on the job. These projects pay best because of the amount of expertise needed to handle them.

Q I've shot a few annual reports and worked with designers who had created a concept for images and layout. At locations we looked over the subject and discussed the photographic approach. Does this way of working coincide with your own?

A For most of the annual reports I work on, that's still the way it happens. The only difference might be that, because of higher travel costs, most of my location shooting is done without an art director or designer on site. Once I arrive at the site I call the art director or designer and talk through any changes that might be necessary.

Q When you are deciding on annual report fees, what elements go into the mixture? Does the number of copies of an annual report printed and sent make a difference? How about the difficulty of shooting some of the situations? Would a day rate cover the latter adequately? How do you charge for travel days?

A I price projects based on the number of days involved (shooting, traveling, scouting), the difficulty of the shoot and usage, which includes the press run. Charging for travel and scouting days tends to run about 60 to 80 percent of the shooting day. I typically charge for any gear rental. Photography usage tends to be the wild card in pricing, because many clients expect to use the pictures as they wish for the basic photographic fee. Photographers may be afraid to exercise their ownership of copyright.

Q This is not a technical how-to book, but please tell readers something about your equipment; cameras, electronic flash units, etc.

A Almost everything I do now is on medium format. I have an entire Hasselblad system from 40mm to 250mm as well as a handful of bodies. Much of my recent shooting is on a Fuji 680 III system ($2\frac{1}{4} \times 2\frac{3}{4}$). I also have an entire Canon EOS system about three years old, but I use it so little that I have to pack the instruction manual. The rest of my shooting kit consists of two cases of Dynalites (four heads, two packs each), cases for film, hardware, stands and softboxes, cameras and lenses plus a carbon fiber Gitzo tripod. I have more lighting stuff that I use as needed. I always consider weight. My cases are custom-made at Lemsford Millworks just outside of London and can stand rough treatment. They're aluminum similar to the Anvil Cases made in the U.S.

Q What sort of rights do corporate clients usually want? If they want to own the pictures, what percentage do you increase the fee? Do you usually arrange to use some of your best shots for personal promotion?

A Rights and usage was, is and always will be the thorn to commercial photographers. We should learn from wedding and portrait photographers who own the copyrights to all work they produce unless they sell or give them away. Clients are always asking for more and more rights (now it's Web sites or electronic usage) and if you are going through a slow period or are young in the business, rights are the first to go. They often think, "I can make a certain amount today and give up the rights, or I could fight for possible future uses of the pictures, and maybe not get the job." It's very hard to say "no" when the rent is due. I tend to lose out on projects, often because of price, and about 50 percent of the time it's because I charge for added usage in my contracts. I charge based on usage, so my creative fee changes with usage. If the client wants unlimited usage for three years, I add 100 percent. If the client asks to own the copyright, I charge an additional 200 to 300 percent. In any case I always get portfolio and self-promotion usage of the selects (the best images).

Q An article about you in *PDN* (July, 1994) mentions that you rent a studio when necessary. Does that still apply? Is your office in your home? Do you have an assistant?

A I still rent studio space as needed. I have an office in the house and I work with at least one assistant on all jobs, sometimes more. I also use a stylist quite often. That's a big change in corporate work, the fact that the client requests a stylist, especially when the president of the company is the subject.

Q In terms of your creative challenge, technical complications, fees, personal satisfaction and whatever else, how do advertising and annual report photography compare for you?

A I love the big feel of a good ad campaign (talent, stylist, assistants, caterer, art directors and clients all at the shoot), but I still love the sense of doing an annual report. It's stimulating to have many days strung together, going to different locations, using a much smaller crew, thinking on my feet and trying to make the first shot as good as the last. Maybe I like solo creativity.

Q I believe that having a represenative is an asset. How do you and the representative go about finding new clients? Promotional pieces? Cold calls? What else? How handicapped would someone be without a representative?

A I'm actually with the second representative of my career. I was with the first one for six years (long for a representative/photographer relationship),

and it seemed best to go our separate ways. I signed on with Karen Elsesser in July, 1997. She's located in Milwaukee, but works the Midwest and has contacts coast to coast. So far she has exceeded my expectations business-wise. She is also a wonderful person who my house accounts also admire. Karen does many things: cold calls, mailings, source books. I supply her with portfolio pieces and the cases. We split the cost 75/25 on the mailers and sourcebook ads. Young photographers may fail to realize that it's hard to get a good representative if you don't have the profits. The representative needs to make a living too. If a photographer takes on a representative before he or she is ready, the 25 percent out the door causes hardships as well as tension. There may be a feeling that once the job is sold the representative does nothing, and consequentially the photographer feels taken. As painful as it is for some photographers to show their work, I think it's a good learning experience. You can get lots of feedback about your work that you might not get through a representative. Many times you get hired on your personality. Representatives can't show a photographer's personality, only their work.

Q Have annual report photographs changed very much since you started shooting them in 1987? How so?

A The biggest change is that there are fewer of them. With all the mergers and corporate failings, there are fewer projects for more photographers. Unfortunately, this can mean more downward pressure on pricing. You get the picture.

CHAPTER TEN

Proposing a Photo Book

Photographers enjoy having their work gathered in books, but perhaps the first pictures you'll sell for a book will be from stock. That was my experience, though since 1959 I've written and illustrated many books for children as well as numerous how-to books for photographers. I like the unique appeal and prestige of books, but not many photographers (including me) can make a living from books alone, because picture books to which you contribute or one-person shows between covers (if you're lucky) rarely earn much money. Photographic books which may result from images you've shot over the years are often motivated by dedication and creativity in finding a salable theme. The inspiration is first to create a collective entity, and then to make a living. If you have what you believe is a really worthwhile idea for a picture book, guidance comes later in the chapter.

PICTURE LISTS

In lieu of originating a book idea, to make a living, list your stock photographs by category (science, foreign countries, children's activities, sports). Refer to the latest *Photographer's Market*, and send lists to textbook publishers who may be doing titles, now or later, into which some of your photo inventory would fit. (Send lists also to selected magazines that might use your types of subjects.) Book editors may keep your list and call when one of your specialties is needed. Since book publishers often turn to stock picture agencies for images to illustrate all kinds of subjects, if you work through a stock agency, ask about the kinds of requests for books they get. Ask also for topic ideas you might shoot for potential book use.

TYPES OF BOOKS

Trade books. These are nonfiction books of all sorts that use photographs. Familiarize yourself by browsing through books with photographs in them in book stores and libraries. Photo collections on one or more subjects, such as archeological digs or popular history, are also trade books rather than school texts when they are entertaining and educational.

How-to books. They cover everything from building your own furniture (often illustrated by commercial photographers in studios) to raising a guide dog. If you are expert enough to both write and illustrate a how-to book, you won't have to split royalties with a writer (see page 155). But you can cash in on your special skills and interests via a how-to book you only illustrate.

Children's books. The market is small for photographically illustrated children's books, which are mostly nonfiction. A majority of juvenile fiction needs the flexibility of hand illustrations, because photographs are often too literal for fantasy stories. Search the shelves of juvenile literature in libraries and book stores, and notice the few with photos. Check for work by writer-photographer Tana Hoban, who has written almost fifty kid's books with photographs, and Richard Hewett, who has also done a large number of books with his wife Joan. Search in used book stores for out-of-print copies of older titles. I've done about twenty nonfiction books for children that are illustrated with photographs, though none are still in print. I wrote the books or took photos for another writer.

Kid's books can be satisfying and take less time than picture books for grownups because they're shorter, but ideas have to be inspired to interest editors. Book proposals and business arrangements covered later apply to juvenile books, too. The publisher of this book also offers *Children's Writer's and Illustrator's Market* which includes useful how-to material in the front as well as listings of children's book publishers.

Textbooks. There is a large market for stock shots of just about any subject in school curricula. The main classifications of education, such as science, languages or geography, require photo illustrations bought in quantity from stock files and individual photographer's lists. My pictures are sold entirely through stock agencies that service, among other markets, textbook publishers interested in subjects such as agriculture, airports, museums, zoo animals, life in foreign countries and more.

BOOK PROPOSALS

To propose a book you should have:
- *A good idea or theme.* Explain your book idea in writing. Include an estimate about how many pages it may be, with the number of photographs in black and white, color, or both, and how long it would take to complete the pictures. Make an outline of the book that consists of chapter headings and a short summary of each chapter. If you intend to write the book, do all or most of a sample chapter to show your writing competence. If you have a writer-collaborator, he or she should do the outline with you and write the sample chapter. If you have no collaborator and don't write, ask the publisher to pair you with someone suitable. If your idea is for a short children's book for young readers, editors prefer to see the whole story.
- *Research.* Check book stores to familiarize yourself with books that feature subjects similar to ones you want to propose, and while you're at the library, look at *Books in Print.* It's a reference book divided into categories. If you're thinking of doing a book about a given subject, *Books in Print* will tell you what other books on the same topic were

published and when. Those listings could discourage you from going on, or encourage you because what's been done is meager or fairly old.

- *Sample photographs.* Include sample photographs from more than one chapter, with your proposal together with caption material. Send more pictures for a long book than for a shorter one. Send 4" × 6" prints made from color negatives, dupe slides or prints made slides. Avoid boring pictures as you would avoid boring text.
- *Background and credentials.* What are your qualifications to do a professional job taking photographs, and writing, if that applies? Editors want to know, so include tear sheets, mention any previous books you've done or contributed to, refer to any work or experiences that would help build editorial confidence in you. If your sample photos are really good, they'll help sell you as well.

BOOK COLLABORATIONS
Working with a Writer

Hopefully, you and a writer will have equal abilities and common goals for the book. A lot of discussion and research helps create the foundation for a productive collaboration. When you are conceptualizing a book together, each of you should understand elements of the other's field to produce a convincing proposal. Cooperate to show off individual strengths and a good "blendship." Try not to consider preparing a book proposal as just a lark. With luck and skill, it could earn serious money.

When you are assigned to illustrate a book, an editor will brief you and the writer on the publishing pros, probe your viewpoints, and give you meaningful guidance. In collaborating with children's book writers, I've analyzed their book drafts and come up with ideas about where pictures would be most natural and helpful. They in turn have given me suggestions for places and people to include in the images, because they knew the material before I did. When words and pictures receive a somewhat equal amount of space in a book, royalties are usually divided equally between photographer and writer. If you and the writer originate the idea, make an agreement about appropriate financial division and create a contract to reflect your decisions (see collaboration agreement below).

Techniques for working with a writer assigned to write the text for a book featuring your pictures are related to the arrangements above. You will have a lot of research to help the writer, plus ideas for content and emphasis.

Collaboration Agreement

Collaboration agreements between photographers and writers are often complicated and cover many points. One reason is to set the groundwork so you and a writer can do the best job possible on a book subject. Agreement on royalty percentages for each of you is a primary goal. After that, expect the unexpected. I once did a book with a writer who was a friend, and we composed

our own agreement. We split the royalties fifty-fifty, the book was successful, and it eventually went out of print. When my friend wanted to reprint the book himself, he asked for 60 percent to defer some of the publication costs, which I felt was fair. Remember that business agreements with friends and relatives are as essential as with strangers.

There is a negotiation checklist for collaboration with dozens of suggestions and pointers in *Business and Legal Forms for Photographers*. All are aimed to see that photographer and writer, or two photographers working together, have the same concepts of collaboration. An agreement on paper regarding responsibilities and division of income is a necessity to avoid irrational misunderstandings.

COFFEE-TABLE BOOKS

These glamorous picture books can be impressive color or black and white showplaces for a photographer's work. Examine picture books in stores and libraries. Look on the backs of the title pages to see if any were reprinted, which indicates they sold better than average. Few coffee-table books go beyond one printing. Check the quality of photo reproduction because it's an area that suffers if a publisher wants to cut costs. Look at the cover price of the books, and compare it to the marked price. Marked down books may be *remaindered*, which means they didn't sell well and the remaining copies are discounted. No royalties are paid on most remaindered books.

Successful publishers tackle coffee-table books for the prestige value of the photographer's name and the classy look of the books. The publisher wants reflected glory and will risk financial loss. With some exceptions, editors prefer to take chances on well-known photographers with good track records who offer exciting pictures of appealing themes that are familiar to the public. The images are often stylish or romantic. If you are fortunate enough to merit a coffee-table book, give it time and effort and get as big an advance as you can, because you may not make a dollar more. A coffee-table book is a wonderful advertisement for yourself even if you spend your whole advance traveling and shooting pictures.

BOOK CONTRACTS
Contract Checklist

Book contracts are often written in terms that lawyers use, some of which seem to obscure the issues. Be aware of these important points:

- *Rights:* Be sure to understand what the publisher's rights are and for how long.
- *Foreign rights:* It is usually to your advantage to allow the publisher to arrange for foreign publishers to distribute your book, often in English-speaking countries, unless you have a literary agent to handle this.
- *Softcover rights:* Distribution may be the same for soft and hard covers. Royalties will differ as explained below.

- *Delivery deadline for manuscript and/or pictures:* Unless your book is of a very timely nature, you can negotiate with editors for a delivery date convenient to both of you. Most books are considered spring or fall books, because catalogs are published in those seasons. Be realistic when estimating how long you think completing a book will take, so you don't get jammed and disappoint the publisher. Be aware that production of a book, including editing and printing, often requires many months before the publication date.
- *Permissions:* Photographs used in most books are considered news or for educational use so you don't need releases for people in the shots. If you believe the subjects will object for any reason, get releases if possible. Where celebrities are concerned, get advice from the publisher's legal department. Some dead celebrities' estates hold copyrights to their names and likenesses, even if the photos are yours. When someone gives or leases pictures to you for your book, you'll need written permission from them to use the photos.
- *Publication deadline:* This important clause in a contract gives the publisher a specific number of months, such as twelve or eighteen, to publish the book. If the deadline is missed, you may terminate the agreement and all rights revert to you. You can then seek another publisher. The contract should state that if the book isn't published by the deadline set, you are not obligated to return *any* advance or expense moneys paid to you.
- *Royalties:* Royalty payments will be less for softcover than hardcover books because the former sell for less. Royalties should be based on the suggested retail price of the book, not the net price, which is the amount the publisher receives from book stores. Many publishers attempt to lower their costs by paying photographers a percentage of net prices. Royalties often begin at 10 percent (of suggested retail price) on the first five thousand copies, 12½ percent on the next five thousand and escalate to 15 percent on all copies after ten thousand. Royalties for children's books are similar, but may vary slightly.

 Royalties are usually paid twice a year, spring and fall, within thirty to sixty days after the close of the royalty period. Royalties are negotiable, especially after you have a successful book, but royalty rates do vary depending on the publisher.
- *Advance:* This is money advanced to you against royalties, which means that until a book earns royalties exceeding the amount of the advance, you will not receive additional royalty income. Only established authors and photographers receive advances to brag about because publishers trust that their next book will do as well as the last one did. Half of the advance is usually paid on signing a contract, and the second half on acceptance of the completed book. "Acceptance" means after all revisions are made and all photographs are delivered.

- *Expenses:* Occasionally, when a publisher wants photographs of a subject badly enough, the photographer's expenses will be paid for: transportation, hotels, food and materials. Such expense moneys should be separate from royalties so they do not have to be reimbursed by royalties. A few years ago a friend of mine went to a half dozen countries photographing kids for a CD-ROM and a series of books that the publisher thought would sell very well. He received nonreturnable expenses.
- *Subsidiary rights:* When a literary agent will handle the arrangements, the photographer should retain all rights for sales on abridgements, serializations (in magazines or newspapers), syndication, advertising, films, plays, radio, television shows and audio tapes. Otherwise, the publisher can make deals to benefit itself and you.
- *Separate royalties for each book:* When you do more than one book for a publisher, beware of a custom I call stacking royalties. This means royalties on newer books that are successful are required to help pay off advances on previous books that didn't sell as well. This is unfair to photographers (or writers), because each book deal should stand alone.
- *Copyright and credits:* Copyright for photographs should be in the name of the photographer, and the publisher usually registers the copyright for you. When the photographer is also the writer, this should be stated on the book cover such as, "Words and pictures by. . . ."
- *Insurance:* Arrange in the contract that the publisher, color separator and printer will insure photographs while in their respective possession. The latter two usually have their own liability insurance, and the publisher should be urged to arrange insurance if it's not automatic. Negotiate to set the value of prints and original or dupe transparencies.
- *Artistic control:* Ask for consultation rights on the choice of photographs and layout of a book. Some publishers submit layout diagrams and eventually printed galleys to the photographer. Constructive suggestions for page layouts are usually welcomed.
- *Return of photographs:* The publisher should be required to return all photographs by a specific time period, such as thirty days after publication.
- *Free copies and book purchases:* Most contracts provide you with six to ten free copies of the book, and offer a discount of 40 to 50 percent on purchases of your own book.
- *Out-of-print provisions:* The definition of out of print should be clearly stated. The photographer's right to seek another publisher after the book is declared out of print should be defined. Only occasionally can you find a second publisher for a book that has gone out of print, but you should know your options.

In *ASMP Professional Business Practices in Photography* is a chapter on book publishing including a photographer's book agreement that covers many terms and areas. Use it along with the information here to navigate through

negotiations for your first book. In *Business and Legal Forms for Photographers* by Tad Crawford is another book publishing contract with opinions and information about its terms. Knowing what to expect in a contract early on can increase your confidence.

BOOK PACKAGERS

Individuals and companies are available to help a photographer create almost any aspect of a salable book. Packaging is usually done on a fee basis which means you need conviction about your book idea as well as money to pay for professional help. A book packager starts with your idea. You are directed and encouraged to shoot the photographs (or some of them), and they will help you write a proposal. The packager can help you find a writer-collaborator and will help you submit the proposal to the right editors—or they will submit it themselves. They should know the book business well and have previous contacts with editors. Review all the steps described earlier in this chapter for making your own proposal so you'll be better prepared to help a packager do it with you.

There is no standard fee a book packager might charge. It depends on how much work you've already done, what the packager needs to do to be effective and how well each of you do your part. You might pay on an hourly basis until you've worked together a while. Ask for a detailed proposal first, and later a careful accounting of the packager's time.

A book packager may also work on a share-the-income basis with a photographer whose work and ideas show promise. In a sense, this is like having a personal agent or representative sharing his or her expertise because future earnings seem promising. If you agree to share the advance and royalties, and the packager can help you expedite the work and make a sale, fifty-fifty may be a worthwhile deal. However, packagers are usually not in business to take risks, so you may have to pay a nonreturnable fee as well.

On the plus side, you get experienced assistance in preparing whatever is needed to sell a book to a publisher. On the negative side, if your ideas are really salable, you might do better financially to find an experienced photographer and ask him or her to tutor you on the basics, and be available for more consultation, for a fee which would be tax deductible just as payments to a packager would be. Excellent photography and creative ideas will appeal to publishers and readers, and may well get you a book contract on your own. Or you may need informed help on your first book, and then take off alone.

To find a book packager, look in the *Literary Market Place (LMP)* at your local library under book producers or contact The American Book Producers Association at (800) 209-4575.

VANITY PUBLISHERS AND SELF-PUBLISHING
Vanity Publishers

Vanity publishers package books and offer guidance to writers who want to see their work published and are willing to pay the costs of production. A

vanity publisher may help on a photographic book, too, but find one with experience to edit a book, have it designed, contract with a printer and deliver copies to you. Arrangements may also include distribution to book stores or wholesalers, but the latter are often not interested in vanity books, and you may end up with a room full of books to distribute yourself. I've heard stories from a few photographers who hired unconscionable vanity publishers and were disappointed and exploited because the companies claimed they understood organizing and distributing picture books when they did not.

Self-Publishing

The cost of producing a picture book, even using black-and-white images, can be high depending on length, quality of reproduction and paper, and number of copies. You stand to lose more on vanity publishing, however, than self-publishing, though neither approach is predictable. A very good photographer I know was a private commercial pilot with opportunities to fly all over the world. For years he shot excellent black-and-white photos and eventually he hired a design consultant. The result was a handsome, classy 120-page picture book. Three thousand copies were printed, and my friend then had to tackle the real bugaboo of self-publishing, distribution. Most books are distributed by huge wholesalers who have little interest in vanity or self-published books. A small wholesaler agreed to take a trial batch of my friend's book, and he also persuaded some book stores to handle the book. He did a lot of legwork and I believe that he broke even after about two years. My friend was happy with his book, but he's certain that do-it-yourself publishing is rarely profitable. Books have to be promoted and advertised and your funds may be too limited. Publishers usually save their promotional budgets for books they feel will sell big.

SUCCESS STORY

The most successful author-photographer I ever knew was the late Bradley Smith who began shooting for *Look* and *Life* in the late 1930s. His first book, *The Horse and the Blue Grass Country*, published by Doubleday in 1955, developed from a magazine story he shot, as did a second book, *Columbus in the New World*, from Doubleday in 1962. Among his books was one with and about Henry Miller. He packaged a series of twelve books for children with writer Ernest Raboff on famous artists and wrote an imaginative how-to on photography. Smith's most profitable books, subtitled "A History In Art," covered France, Japan, the U.S., Mexico and other countries. He packaged them, too, and arranged with large publishers (whose names were on the books) for distribution. When the most popular volumes were reprinted, the publishers had to order thousands of copies through Smith, who occasionally went to Japan to oversee reprinting. (Bradley Smith was a raconteur, promoter and took tap dancing lessons at age 82. I miss him.)

FORM 15 Query Letter For Children's Books

YOUR NAME OR BUSINESS NAME
Your address • Telephone number • Fax number • E-mail address • Web site address

Dear [*always send your query to a specific person*],

Over several months a writer friend and I have been photographing two six-year-old children learning to swim. The writer, Jon Madian, is also a swimming instructor. The title we propose is *Swimming Is Fun*, and the book is aimed at ages five to seven, to first be read to children by an adult. Previously Jon and I worked together on *Beautiful Junk* a story about the Watts Towers, which Little, Brown published in 1968, and *Two Is A Line,* published by Platt & Munk in 1971. I will enclose a separate list of my other books for young readers.

The photographs, five samples of which are enclosed, begin with a young boy and girl learning to exhale air from their noses underwater. The text is simple and the steps continue with:

[*A list of picture situations, such as floating face down, learning how to move arms and legs, etc. would be included at this point. Some photos were taken underwater.*]

The primary theme of this proposed thirty-two-page book, besides basic instruction, is helping children get over the fear of water barrier. Parents may choose to read their children the whole book first to familarize them with what's coming. After that, if a parent will be instructing, he or she can follow the easy steps suggested. The book could also prepare children who will receive instruction from a professional teacher.

Our research shows that no other book for young readers covers the theme as we have. The pictures and story are completed and we would like to send our book to you. Thanks for your interest.

Sincerely,

Enclosed: SASE
Five 4″ × 6″ color photographs

Q&A *with*
Morton Beebe

Morton Beebe is a photographer and author whose assignments have taken him to places as diverse as Miami and Borneo. His first book, *Deep Freeze* (published in 1958), describes his adventures as the forty-third person to reach the South Pole. Building a client base in advertising, editorial and annual report assignments, he traveled the world and developed a sizable stock library. He founded the first franchise of The Image Bank (T.I.B. West) stock photo agency. Currently he is a major contributor to Corbis Images. Beebe's pictures have been shown in museums including the International Center for Photography in New York and the M.H. de Young Museum in San Francisco. He has done assignments for many magazines including *National Geographic*, *Travel and Leisure* and *Smithsonian*.

Beebe's second book was *San Francisco* (first published in 1985 and revised in 1996), a favorite of visitors to Mort's home city. His latest book, published in 1996, is *Cascadia: A Tale of Two Cities*. It's a wonderful pictorial pageant of Seattle, Washington, Vancouver, British Columbia and the Cascade Mountain areas. Mort has been active in the ASMP for decades.

Q Did you go to the South Pole primarily to do a book, or did it materialize later? How difficult was it to interest a publisher in *Deep Freeze*? Who published it?

A Upon departure from the U.S. Naval Flight School I volunteered for duty in the South Pacific. Assigned to Operation Deepfreeze, I became the Public Information officer and was sent to Antarctica, our fifth largest continent, an island covered by an ice cap of 5.4 million square miles. As a writer, I reported, "The surface is wrinkled into mountains and smoothed by winds into flatland, a land of incredible beauty and irresistible mystery that endures only one sunrise and one sunset each year." With Noel Barber, a foreign correspondent from the *London Daily Mail*, I interviewed Sir Edmund Hillary and Sir Vivian Fuchs by radio as they approached us at the South Pole U.S. Naval Base. Dorville Press, now out of business, published the U.S. Navy Yearbook as a complementary record of the events of Operation Deepfreeze III in 1958. As its assigned editor I added my own photography and selected articles from all thirty-five visiting press reporters. Ten years later I visited the famous Explorers' Club in New York City. My host discovered my *Deep Freeze* book in the private archive of Sir Hubert Wilkins, and I was asked to become a fellow member.

Q Did *San Francisco* come about as a book because you had a large stock collection of the city? Were you able to contribute to the layout? If there's a story about struggle or triumph connected with the publication of *San Francisco,* please share it.

A As a third generation San Franciscan, I had built a photographic profile of the city over many years. Once I showed this resource to Abrams Publishing in New York City, they assigned me a terrific editor and designer and I began a two-year effort to reshoot some communities and build a balanced study of the city. Whereas the pictures are seen through one photographer's eyes, I retained the services of eight important writers to uniquely chronicle the major communities.

I worked closely with the designer in New York City and flew to Japan for a press check. Through seven reprints and two revisions I have made a 60 percent change in content. Of the sixty thousand books printed I personally was responsible for more than forty thousand corporate sales. Following the successful format of *San Francisco* was *Miami, the Sophisticated Tropics,* published by Chronicle Books in 1991. Though successful, and the subject of a television special, it never went beyond its first printing. Ironically, when the White House chose the book for a summit conference, Chronicle had already remaindered the last few copies.

Q What came along next?

A *Making Friends* published by Henry Holt, New York City, and copublished by Raduga Press of Moscow—the first U.S.-Russia copublishing event. My illustrations with two children's texts were published, one in Russian and one in English. I followed them on a journey around the world meeting heads of state with children as the peacemakers.

Q Have you also kept up an interest in books by offering guidance to other people.

A In 1998 I taught two classes at the Academy of Art in San Francisco. One covered the business of photography, and the other was a master's class to produce a published thesis for a master of fine arts degree. I turned it into a publishing course with guest speakers, a book agent, a designer and a publisher. Two students have succeeded in having their theses published as books. A few years ago for the ASMP I set up a one-day publishing conference in San Francisco that was a sellout.

Q Did *Cascadia* originate because of a stock file? How much additional shooting did you do, and how long did you devote to the project?

A *Cascadia, A Tale of Two Cities*, was released in 1996 after two years of commuting north to photograph the Seattle and Vancouver, British Columbia, areas. Even though I had an extensive file of material on the two regions from numerous trips and magazine stories, I shot another one thousand rolls of color. It is hard to know when to quit when you uncover more insight into the lifestyles of diverse subjects. The book is about the people, not wildlife and buildings. Sometimes it was difficult to give a fair and balanced commentary about issues that affect British Columbia and Washington due to conflict over fishing rights and timber. I retained four Seattle and four Vancouver essayists whose writing suggests a seamless border crossing.

Q Did you influence the layout of *Cascadia*? Did you work with the writers to choose their topics?

A Yes. I assigned the topics and I worked closely with the designer and a text editor. Under a tight deadline we made only two caption errors. The writers were paid a flat fee each, but I encouraged them to retain secondary publishing rights. In the case of *San Francisco*, six writers enlarged on their essays and each had a novel published.

Q Please continue the *Cascadia* publishing story. How many were originally printed and sold?

A I have sold out my five thousand hard covers, and half of the two thousand soft covers. I later bought out my publisher's forty-six hundred remaining copies and sold six hundred books in three sales in one week. Abrams chose not to reprint the book, perhaps because it should have been two city books. Sales were also affected by the Canadian dollar sinking from $1.05 to $.60, which priced the book out of the market. I didn't buy the printing plates from Abrams, I bought out the balance of inventory. I have gone forward with a reprint of *San Francisco* which became a $175,000 commitment for both books.

Q Has your experience with *Cascadia* inspired you to undertake another book of your own work that you might self-publish from the start and arrange distribution?

A Self-publishing may resemble the experience of a vanity press unless the project is sponsored. Copublish and you share the risk. If you tie in a big

company sponsor who contracts to buy thousands of copies, a self-published picture book can be profitable. In this regard, the Internet may save us or kill us. Small press runs (fewer than eight thousand copies) might be printed on demand or sold chapter by chapter as E-books with minimal illustrations. I've launched two Web sites to market my photography and some books. I don't have enough feedback yet to evaluate this approach.

Q What are your views about getting picture books published today? Do many of them pay off their advance? Do enough publishers care about doing picture books?

A Picture books are a high risk venture to most publishers without a sure sponsor subsidy. Book store shelf space is limited and large format sizes are difficult to display. A cover price over $40 scares publishers, and delayed deliveries undermine sales. Success can cause a problem because it takes three months to reprint a coffee-table book overseas. By that time the key marketing (Christmas) season may have passed and interest is diminished.

Be market savvy. Talk to book store buyers about their experiences with picture books in areas where your book might sell later. Keep in mind it can take one to three years to initiate, shoot, write and deliver a book, and another six months to a year until publication.

Picture books rarely pay off their advances, which may be the only income the author-photographer sees to cover his time, travel, film, overhead and maybe text expenses. In my case the exception was *San Francisco* which sold well and helped the publisher make up for losses on other books that season. That's not unlike what happens in the movie business.

You may be at less risk to invest time and money elsewhere, but there's no more pleasurable experience than seeing your book in print, especially when your peers hear you made the bestseller list.

CHAPTER ELEVEN

Dealing with Commercial Studio Clients

Studio product photography is separate from portrait and wedding photography (covered in chapter twelve), though I realize that readers with studios may shoot all of the above. The reason: Companies and businesses of all kinds are the clients for product photographs that will usually be published, while wedding and portrait photos are for individual and family use. Photographers can combine both categories smoothly, but the basis for pricing is different, as are questions about ownership rights and promotional techniques. If you want to do a larger variety of studio work to make more money, acquaint yourself with this and the next chapter.

THE BASICS

One can begin doing product photography at home on a card table with a suitable background and a couple of lights. If you shoot some new widgets for a neighbor, please him, and charge him $40 to cover materials and processing, you may wonder if you should charge him a creative fee. After you have done other semipro jobs with a camera, what next?

That depends on your age, education and other factors. Preferably, you should study photography or apprentice yourself to a local commercial studio where you can learn camera work and business practices, and get paid for it. In school you have opportunities to shoot many subjects and learn photographic techniques. Hopefully, you will also learn something about how to conduct a business, such as establishing sensible fees, becoming aware of your ownership rights, and a number of other things. As an apprentice or assistant in a studio, if your boss is understanding, you can shoot projects of your own in your free time. During your training, observe customer relations, as well as where to place the lights, and ask a lot of questions about how and what to charge.

STARTING A STUDIO

Until you can afford your own studio, consider renting one when you need it. Rentals are available and relatively expensive in large cities, but a local photographer may agree to rent his or her studio part-time. I've been shooting closeup work in a home studio for years because I'm mainly a location photographer and don't need any more space than I have. Ask advice from established photographers about investment in a studio and equipment, and

get a loan from a commercial bank with an interest in small business. That's what Nick Vedros did; read his Q&A in chapter seven.

For valuable free guidance about getting started, contact the Small Business Administration (SBA) which sponsors SCORE (Service Corps of Retired Executives). My brother worked many years with SCORE, a volunteer organization, and he advised many new and established businesses about successful methods of financing and other operations. His SCORE experiences lead me to suggest that you are more likely to succeed if you seek advice from business veterans, either from SBA and SCORE or friendly studio operators.

The average person starts slowly in a limited space with one or two cameras and lights, a few backgrounds and tables, some reflectors, a tripod, etc. The more money you make with that equipment, the more you can pour back into the business for additional gear. That includes a suitable computer setup. Basic computers are loaded with capability nowadays, and new models come along all the time. Allocate money for worthwhile programs to help manage your business and photo files. You need a separate setup if you intend to shoot digital photographs, so you can share the results with clients on a computer screen almost instantly. However, you don't need a digital camera in order to have scanned prints or negatives, because film and flatbed scanners do the job well. Whether you want to make and retouch prints with a computer program in your own studio is a decision to make in the future. At some point you may require an assistant to do computer lab work, if you intend to make a living behind the camera.

On your way to success in studio photography, consider specializing in products or subjects that you like to shoot. I know photographers who specialize in closeups of small objects like jewelry, and others who have built studios large enough to shoot cars and trucks. It may not be simple to become a specialist, but when your skills with specific subjects become known, more business will come to you.

An important part of success is having a system for pricing. The basics are thoroughly explained in chapter three. Figure out how much it costs you in labor and materials to do a job, and decide how much you need to charge to make a profit. I've digested some essential techniques below for commercial photography.

PRICING TECHNIQUES

There are several ways to price commercial photography. Some photographers use print costs as a basic unit to determine the total price of a job. I'm not sure if that would suit me. Instead, you may decide to base prices on an hourly rate or by the shot. As in media photography, a fee for usage can be added, which is discussed in the next section. These approaches should be interrelated. If you charge a certain amount of money an hour, you should be aware of the average number of shots included. Let's say you can do two salable photographs of a simple still life setup in an hour. If you charge $50 a shot, that's $100 an

hour. (These figures are to illustrate my examples, and are not meant to represent reality in your business.) A client may feel that $50 per shot is reasonable, but $100 an hour is high, so an hourly basis may not be indicated, especially if the client is there when you shoot.

If the client wants five shots, instead of pricing by the hour or shot, quote a job rate of $400, which may represent two to three hours work. This would be more profitable than $250 for five shots at $50 each. When the subject is more complicated than a simple still life, let's say you charge $100 a shot. The client realizes the shots are trickier and finds the price acceptable, and it's more profitable. Whether you charge by the hour, the shot, the print or alternate between methods, you will eventually establish a basis that fits your needs. But you may find that a job rate suits the work you do better. It allows you to set prices with more flexibility without having to be accountable for time, or the number of prints or transparencies.

JOB PRICING FOR RIGHTS

Here's another method of pricing product photography by the job, when other pricing methods are not suitable because reproduction rights are involved. For example, a client brings two different samples of a new stereo/radio combination to your studio. You show your price list based not on print costs, nor a per-shot or hourly fee, but on a job (or assignment) fee. In my example for this case, the fee includes a minimum of three views of each radio, together with limited reproduction rights for local advertising and publicity only. (Decide for yourself what you want the fee to cover.) Let's say that the basic price set to shoot each radio unit is $450. Finished color print or transparency prices, beyond proof prints, are also listed for the client. He is agreeable and leaves the two radios to photograph after telling you his concepts of the pictures.

You shoot more than three views of each unit to be sure you have caught their contours and features well. You show the client proof prints or transparencies and he's pleased. He understands that the photography thus far will cost $900, which covers your time for setting up and shooting, plus postproduction. The client chooses two or three views of each radio that are ideal for his needs.

Now you discuss with the client additional fees for usage in advertising, local publicity, as well as wider reproduction rights for state-wide or national advertising and publicity releases. For the sake of this example, you would double or triple the $900 for additional rights and add the expense of more prints or dupe transparencies. Prices would increase according to the ad medium. For example, *Time* magazine charges more per ad page than an electronic equipment magazine would. Discuss and explain these variations with the client beforehand. He should understand that the more value the pictures produce for his company because of publication circulation, the more they are worth. There are more complete pricing details in chapters three and seven.

Details of your agreement about the radio images could be covered in a

document such as the commercial photography licensing agreement at the end of this chapter. You and your attorney can create your own agreement based on my form to suit your needs. The client in my example has exclusive use of photographs for local advertising and publicity, and may negotiate additional rights, though the photographer owns the copyright, which also provides control in case the pictures are misused or not fully paid for. Copyright may be assigned to the client to cover advertising (because entire ads are copyrighted by advertisers) for an agreed-upon time limit.

There are several methods of pricing in Edward R. Lilley's book, *The Business of Studio Photography* . He says that many studios charge based on the prices of prints which are marked up according to size. He also says that studios may price on "what-the-competition-is-charging and what-the-market-will-bear techniques. . . . and this mixture is especially true on the price of larger prints." When you are starting in business, call and arrange to visit other commercial photographers in your region, but not in your vicinity. The farther away you are located, the more likely a competitor will give you factual figures on how and what he charges. The informal survey you make talking to other studio owners will help you sort out the options to establish suitable pricing techniques of your own.

Lilley also mentions joining a professional photography group such as Professional Photographers of America, which is mainly studio photographers. Association with other members can be helpful, particularly in the areas of pricing and exchange of technical information. Some of Lilley's book applies to other studio work such as marketing and selling, convention coverage, setting up a studio and paperwork.

LICENSING FOR PAPER PRODUCTS

If you shoot pictures for posters, place mats, gift wraps, checks, calendars, greeting cards, apparel or household items, price your work as a commercial job, then (as in the previous example) add a fee for the reproduction rights being licensed. If you sell stock photographs for use on paper products, I suggest you check the scale of photographic rates based on location, distribution and duration of rights in *Negotiating Stock Photo Prices* by Jim and Cheryl Pickerell, or the charts in *Pricing Photography* by Michal Heron and David MacTavish. Another source, fotoQuote, is a computer stock management and pricing program described in chapter eight. Call (800) 679-0202 for information. The licensing contract for images used on paper products form included in this chapter is for sales of photography for paper products as merchandise.

Licensing Agreements

Agreements to license commercial photography for advertising or other publication may be covered by a stock photography delivery memo or an assignment photography delivery memo. Be familiar with each of those in chapter five as well as the forms with this chapter. It lists terms and limits for use of photo-

graphs in advertising, publicity and other commercial applications, and should be used when product photographs are delivered. It can also be adapted as a prephotography memo to introduce the same conditions and limits that will reappear in the licensing agreement, so both you and the client understand what the assignment entails. It is not intended for use with pictures taken for publication in periodicals or books, though it could be revised for that purpose.

A New Business Program
In the fall of 1999, a new computer program was introduced and is described as "a tool for managing the office and administrative side of your photography business." It is called Exactly! for Photographers and is designed to set up and manage assignments, track stock photos, create estimates, and a lot more jobs that are concerned with good paper work. It was designed by a photographer. To request information and a CD-ROM, call (415) 625-2699. Their Web site is http://www.exactphoto.com.

GREETING CARDS AND POSTER PHOTOGRAPHS
The greeting card business is large and competitive, with more than one thousand publishers in the industry. Though they purchase photographic images from stock, the use of assignment photography has grown among card makers. Photographs used on cards include still lifes, images of children and babies, humorous sports shots, romantic scenics and a wide spectrum of others.

According to *Photographer's Market*, "The pay in this market can be quite lucrative if you provide the right image at the right time for a client in desperate need of it, or if you develop a working relationship with one or a few of the better paying markets." The introduction to the *Photographer's Market* chapter on Paper Products goes on to warn readers that higher rates of payment by some companies may indicate they want to buy extended rights to images. "Many companies are more willing now to negotiate sales which specify all rights for limited time periods or exclusive product rights rather than a complete surrender of copyright." The latter means that they may return your photographs after a year or two, depending on the agreement.

Keep in mind that many greeting card companies buy up to two years before a card is published, which means your work is out of circulation all that time. Even worse, *Photographer's Market* states, "It can be weeks, months or as much as a year before buyers contact photographers. Some companies will only pay on publication or on a royalty basis after publication." For these reasons you must consider the greeting card business very cautiously.

Study the *Photographer's Market* listings for greeting cards, calendars, posters, games ands gift items, and if any firms are local, arrange an interview to show a portfolio. Otherwise, before you send even lists of what you have, write to a company and ask permission to send sample work. Do not send anything but letters unsolicited. Don't give publishers the opportunity to hold anything of yours indefinitely and avoid payment on publication.

FORM 16 Commercial Photography Licensing Agreement

Commercial Photography Licensing Agreement

Date _____

Client's Company Name _____
Address _____

By request of [*If not the same as client*] _____
Description of images [*By quantity, format and subjects*]

[*For additional images, attach separate list*]

Total count of images _____
Photography Fee: [*Billed separately in invoice; included here to be binding*]
Licensed for [*List purposes of use and rights leased*] _____

Conditons of transaction:

1. Copyright to all images created and created for client remains the sole and executive property of the photographer unless specific other terms have been agreed upon in writing. There is no assignment of copyright, agreement to do work for hire, or intention of joint copyright or joint venture expressed or implied in this delivery. [*These terms can be negotiated and revised by agreement with client.*]

2. Reproduction rights for these images are limited to local advertising and publicity for the product(s) photographed. "Local" shall be defined as _____ [*as agreed to by client and photographer*]. Such rights do not have a time limit unless otherwise stated in this agreement.
 [*Clauses #2 and #3 can be amended to suit your needs.*]

3. Reproduction rights for these images for regional, state-wide or national use must be negotiated separately from this agreement, and such rights are neither included or implied. Photographer will not withhold additional usage for additional fee.

4. The photographer agrees that the photographs covered in this agreement are for exlcusive use of client, and will not be offered or assigned to any other client.

SUBJECT TO ALL TERMS AND CONDITIONS ABOVE

Acknowledged and accepted by client _____
Date _____
Acknowledged and accepted by photographer _____
Date _____

FORM 17 Licensing Contract for Images Used on Paper Products

YOUR NAME OR BUSINESS NAME
Your address • Telephone number • Fax number • E-mail address • Web site address

Licensing Contract for Images Used on Paper Products

Date _____ of Agreement between photographer named above and client _____ at Address _____

Purchase Order No. _____ Delivered to [*individual*] _____
Description of photographs [*include file number with each title or description*] ___

Intended use of photographs _____

Conditions of transaction:

1. Copyright to all images created and supplied in this shipment remains the sole and exclusive property of the photographer unless specific other terms have been agreed upon in writing. There is no assignment of copyright, agreement to do work for hire, or intention of joint copyright or joint venture expressed or implied in this delivery. The client is licensed the above usage according to specifications in Assignment Confirmation and Conditions form dated _____ and previously delivered to client.

2. Photographer shall be credited on the licensed products with copyright notice. Usage specified above and/or by previous agreement is licensed to client only upon receipt of advance.

3. Licensee agrees to pay photographer a nonrefundable advance in the amount of $_____ upon signing this agreement. Advance shall be repaid from first royalties. Licensee agrees to pay photographer a royalty of _____(_____%) percent of the net sales of the licensed products. "Net sales" shall mean sales to customers less prepaid freight, customary volume rebates, and actual returns. Royalties shall begin to accrue upon first sale, shipment and payment for licensed products.

4. Royalty payments shall be paid monthly on the first day of each month beginning _____. Licensee shall furnish photographers a monthly statement with payment. The photographer shall have the right to terminate this agreement upon 30 days notice if licensee fails to make any payment required, and does not make payments current within said 30 days. All rights granted shall revert to photgrapher.

5. Licensee shall give photographer _____ samples of licensed products for personal use, and photographer shall have the right to buy additional samples at licensee's production cost.

6. Photographer shall have the right to approve the quality of reproduction of images on the licensed products. The photographer agrees to do this expediently.

FORM 17 **Licensing Contract for Images** continued

7. Licensee shall use its best efforts to promote, advertise, distribute and sell the licensed products.

8. The licensee shall hold the photographer harmless from and against any loss, expense, or damage stemming from any claim or suit against the photographer arising out of the use of the images.

9. Photographer shall have the right to inspect licensee's books and records concerning sales of the licensed products, upon prior written request.

10. Neither the photographer nor the licensee shall assign rights or obligations under the agreement, except the photographer may assign the right to receive money due on royalties.

11. This agreement shall be considered in accordance with the laws of _____ and licensee consents to the jurisdiction of the courts of _____.

12. All communications of any sort shall be sent to the photographer at (address):

13. This is the entire agreement between the parties named and shall not be modified in any way except by a written agreement signed by both parties.

Acknowledged and accepted by [*licensee*] _____

For [*name of company*] _____

Photographer _____

Date _____

Place _____

Note: Agreement may be on blank stationery or on letterhead of the licensee if desired.

Q&A *with*
Rick Barnes

Rick Barnes is a studio photographer in Van Nuys, California, who specializes in product and glamour photography. He has experienced many aspects of professional photography during his thirty-year career. During one interval he assisted fine-art photographer Max Yavno, who, Barnes says, did very meticulous ads with a 4×5 view camera. He built several studios for himself in the Los Angeles area and shot architectural jobs on location. Barnes also teaches photography at the Chatsworth Campus of the Learning Tree University and served as the president of the Los Angeles chapter of the ASMP from 1998 to 2000.

Q How did you get started? Apprenticeship, self-taught, school?

A I've always been interested in photography and started very young when my parents gave me their Kodak Brownie camera. I would construct little sets using airplane models trying for creative close-ups. Unfortunately, the Brownie did not focus closely so the pictures were all fuzzy. I had to settle for snapshots until I was about twenty and was serving in the air force. A friend introduced me to the magic of the darkroom and I was hooked. I bought a Nikon and began to shoot everything from portraits to scenics. I decided that this was what I wanted to do with my life.

After my discharge, I came to Los Angeles to attend the Art Center College of Design. While still in school, I started working part time for an advertising photographer named Bruce Benton. He let me use his studio to shoot small jobs, but eventually, as I got busier, our schedules began to conflict. I opened my own studio and began to accept any job that came along. I've tried photographing about every type of subject there is, and finally began to specialize in small products, particularly reflective objects, and glamour.

Q I understand you've had several studios over the years and that you now have a very efficient place which is small but complete. Please describe your present studio.

A It's in a loft of an apartment building. The main disadvantage is that clients may not like to hear that you shoot in an apartment. They visualize a small room with low ceilings. Eventually, they see I use the living/dining room area

with a ceiling that's sixteen feet high. This gives me about two hundred square feet for cameras, lights and shooting space. The downstairs bedroom is my office and upstairs is a dressing room and storage for props and wardrobe storage. There are three big advantages to my arrangement.

1. The building office is open seven days a weeks so, if I am away, the manager can accept deliveries or hand over jobs to clients who come by.

2. My security is enhanced. If someone breaks in and sets off my alarm, neighbors converge from everywhere. This is particularly true at night or on weekends, the high-risk times.

3. I have an apartment in the same building so my commute time is reduced to about two minutes.

Q What kind of products do you photograph?

A I shoot lots of things but my main subjects are lamps and lighting accessories, womens' fingernails and nail or beauty supplies, computers and circuit boards, mechanical parts and video store accessories.

Q For what sort of clients? Local, regional, national?

A My clients are small manufacturers and distributors, graphic design firms and magazine publishers. Most of my clients are located within twenty-five miles of the studio.

Q I understand that some of your work is for catalogs. What other markets or media do you sell to?

A I shoot for catalogs, flyers, point-of-purchase displays, Internet Web sites, advertising for small magazines or newspapers, book covers and video disk packaging.

Q You told me you do some glamour work. What does that entail? For what kind of markets? For media or for individuals?

A Most of my glamour is done for media or stock. It ranges from bathing suit shots to adult images used mainly for 900-number ads, plastic surgery ads and video packaging.

Q Do you have agreement forms that you use with clients, similar to an assignment confirmation? If not, what kind of paperwork do you rely on before and after shooting?

A My use of forms depends on the client. New clients get copies of my price list, assignment requirements and usage limitations. Usage is also spelled out on my invoice. Stock photos are submitted with a delivery memo that lists the number of photos, stock number, description and value of each photo. I've customized all my forms from the samples supplied in *ASMP Professional Business Practices in Photography*.

Q How do you charge for studio product photography? By the day, the hour, the job, or according to usage? Or maybe a combination?

A Once again, it depends on the client and the job. My base rate is calculated using the number of hours plus the usage. Many clients want a total fee before the job is approved, so I find out the type of pictures they want and especially what kind of media they will be used in. I can then give them a figure based on what I believe will be the work time and the kind of usage. Naturally, larger circulation and wider distribution require higher photo fees. I ask questions and through experience I can estimate pretty accurately.

Q Do clients come to your studio to work with you?

A Usually they do. Sometimes a client who has worked with me before will send the product over with a general description of what is wanted, and leave the rest up to me. Clients with large products or a large number of pieces will often ask that I come to their location to shoot. I charge a specific fee for going on location to cover the time and often, an assistant.

Q What formats do you shoot? Which one more than others?

A Most of my product photography is done with a 4×5 Sinar view camera. That's partly because of the quality you get using a larger image, but primarily it's because of the corrections possible with swings and tilts.

Some of my product and glamour photographs are editorial illustrations, and are done with a Mamiya RZ67 medium format camera. All my remaining work is done using 35mm Nikons, which I prefer for most of my glamour photography and some product shots that are destined only for Web sites.

Q Do you have a darkroom or do you use a local lab? Do you deliver prints, slides or larger color, or all of the above?

A I still do a little print work (black and white, and color) but 95 percent of my images are chromes, developed at my local professional photo lab.

Q Having been in business for many years, do you advertise or promote your business? Or do you rely mainly on word of mouth for new business?

A Word of mouth has always been my best method of advertising. That's why it's so important to keep every client satisfied. I also use promo cards and my Web site. The Web site, however, is more of an online portfolio for those already interested in my work.

Q What would you advise newcomers to do in terms of getting new business?

A Cold calls are a necessary agony. I've received very few jobs directly from showing my portfolio, but some of my best clients came to me at the suggestion of someone I interviewed with. They didn't hire me, but they recommended me to others. It's hard to figure.

Q How competitive is the kind of photography you do? Are there new people coming along who try to compete via very low prices?

A Los Angeles is a very competitive town filled with talented people who have to pay their rent. All forms of photography are competitive here and unfortunately, there are plenty of people willing to lose money on a job in order to get experience. There are also plenty of clients who don't know a good picture from a bad one, and are happy to accept inferior work at a cheap price. One of my favorite games when working with a client is to shoot a Polaroid of the setup, find the flaws, but show the Polaroid to the client without comment. The client usually says it looks great, then I point out the problem areas and fix them. I do it in a friendly manner but it tells the client that I can see and will fix things that they would have let pass. An inferior photo represents a company as an inferior business. They would have had to pay more to fix the problem later or, worse, might have published it as it was. I believe my being meticulous is one of the greatest reasons for my repeat business.

CHAPTER TWELVE

Selling Portrait and Wedding Photography

Most people photograph their first wedding for friends or relatives. For the dozen weddings I've done over the decades (some as gifts, some for good fees) I remember writing a shooting script listing the situations I needed to cover. The upbeat atmosphere of weddings is fun, the bride and groom are grateful if coverage is a gift, and usually they pay for materials and processing. Hundreds of photographers who start like this graduate to professional wedding photography, which offers a lucrative career based on excellent photo techniques, an empathetic personality and good business sense.

THE NATURE OF THE BUSINESS

Photographers who shoot weddings, and often portraits as well, face their own sort of business issues because individuals are their clients, rather than media outlets or companies. Their studios become professional headquarters, and they may offer special deals and advertise in local papers. Wedding and portrait photography combines photographic timing, psychology, business acumen and an ability to work under pressure. In addition to income, your reward is pleased couples and portrait sitters, and their word-of-mouth promotion is essential.

Plenty of good material has been written about techniques for shooting weddings and portraits. I edited a book by Greg Lewis titled *Wedding Photography for Today* (published by Amphoto in 1980) and many new books have been published since. One of the better ones by Edward R. Lilley, *The Business of Studio Photography* (Allworth Press), extensively covers wedding packages, booking, pricing, equipment, planning photography, dealing with clients and more. Magazines like *Rangefinder* and *Studio Photography & Design* offer monthly articles about wedding photography and business techniques.

Starting a Studio

You may start a business in a home studio space, photographing individuals and small groups. You'll need lights, cameras and other equipment, some of which is expensive—particularly medium-format cameras and lenses—but they have lasting value. Arrange to visit professionals in nearby areas where you may not compete directly, and ask about outfitting a studio as well as other business subjects. Consider assisting a local wedding photographer for

basic photography training and information about professional practices. Professional Photographers of America (PPA) is a large organization of studio photographers, offering an annual convention and courses. Their number is (404) 522-8600. The PPA also has state associations with offices in many towns. Another association, Wedding and Portrait Photographers International (WPPI), offers information and a collection of instructional videos. They sponsor speakers at a yearly convention. Inquire at (310) 451-0090 or check WPPI online at www.wppi-online.com.

When you feel ready, you might investigate an Internet site for soon-to-be-married couples called The Knot. It's a wedding planning site with a link to the Wedding Photographers Network. For a monthly fee, The Knot will list your business. Prospective brides and grooms may visit The Knot and learn about your studio. Find out more by E-mail at wpn@wedphotonet.com, by phone at (404) 873-8060, or online at http://www.wedphotonet.com or http://www.TheKnot.com.

THE BUSINESS OF WEDDINGS
Wedding Packages

Weddings are one-of-a-kind occasions when the couple and their families may spend lavishly on the reception and photography. When you first start in business, make extra effort to create a good reputation to generate recommendations. To help sales you'll need a portfolio of wedding pictures to emphasize your creativity, reputation and personality rather than how much you charge. Realizing this is usually not a time when couples economize, be prepared with a brochure or, in the beginning, a price list describing the various packages you offer. For flexibility, write in a price on an order form at the time of the interview.

Craig Larsen, guest Q&A photographer in this chapter, says he offers two types of packages, one that includes negatives. "While many photographers continue to retain negatives," he told me, "others are looking at the large expense of storing them for an indefinite period. So some of us are selling the negatives on a shared copyright basis which restricts buyers from having the pictures published without notifying the photographer. But 99 percent of clients who purchase negatives simply have prints made for family and friends, and then store them as keepsakes. On one plan I sell negatives about a year after the wedding for $150 to $350 based on the original order, which assures a more professional looking wedding album."

Many photographers offer various types of wedding packages ranging from straight coverage plus proofs and prints, payment for time plus proofs and prints to no proofs with the photographer making the choices. Albums are sold as part of packages or separately. You will discover the variations by talking with other professionals or through books and seminars. It could be profitable for you to work with one lab, and perhaps one or two album suppliers. Not only can these experienced sources give you advice about pricing

and other business operations, but they may offer special discounts for volume orders. While the spontaneous quality of your pictures and your personality are primary business advantages, you can also compete pricewise by making deals that reduce your expenses for supplies and services.

WEDDING CONTRACTS

Veteran Ed Lilley says, "Anything that causes a wedding to turn into a disaster will release anger seen nowhere else in our culture, and this anger is usually followed by legal action. If there is something you did wrong, you will pay for it dearly." He maintains that there are errors of omission, such as, "You didn't show up, or your lab destroyed the film, and errors of commission that are more subtle, which entail promises a couple says you made and didn't keep."

In other words, you can get into deep trouble without a contract or agreement to photograph a wedding. Here are the main areas that should be covered:

- State the amount of time you'll be at the wedding and when you'll leave.
- Include numbers and sizes of prints as well as albums that are part of the price. The price of the package could reflect an average number of prints at a suitable figure.
- Stipulate the dates, times and locations where the events of the wedding are to take place, and who is to be in the photographs, including any special requests the couple or family may have.
- Detail the price of the coverage the couple orders, and give a payment schedule which states the amount of deposit, the amount of balance, and when the latter is to be paid—usually upon delivery of the final photographs.
- Include your cancellation policy in terms of how much will be charged if a wedding is canceled, and the time periods involved. If you have a month's notice, for instance, you can book another job and charge less for cancellation than if you know only two weeks before the nuptial date. The down payment you received should cover the cancellation fee, and any excess can be refunded.
- Define a limitation of liability in case there is a problem and the film is destroyed, either through negligence or by accident. If the catastrophe results in no pictures, the contract can stipulate a full refund, but no damages for negligence. You may consider offering the latter if you carry insurance that covers it.

Additional Contract Requirements

The longer you are in business, and as your reputation grows, the larger the weddings you may expect to shoot, and the more money and responsibilities will be involved. Whatever you are charging, such as a sum to cover an assistant, you must protect yourself and your client. Ed Lilley puts it this way, "Don't assume that you can do weddings with a handshake. First, it's

unprofessional, and second, it's dangerous. For instance, I include a contract clause to cover third party consequences, which means if the desires of the couple are different than those of the parents, who may have booked the photography, it is the couple's requests I follow, and I make this point quite clear." Contracts for a wedding must be inclusive and precise since considerable investment is being made by both parties. Think of all the things that might go wrong, and take pains to cover yourself.

For thorough guidance refer to a helpful wedding photography contract in Tad Crawford's book, *Business and Legal Forms for Photographers* (published by Allworth Press). It includes four pages of explanation. A contract for portrait photography follows it with detailed explanatory notes. Study these notes and contracts which you may revise as needed.

USEFUL BUSINESS PRACTICES
Proofs
Your business policy about proofs will help build a professional foundation that sets you off from the competition.

- Selected proofs can be included as part of a package.
- Proofs may be given to the couple for a limited time, and must be returned. The couple may buy selected proofs at a price set in the contract if they wish.
- A contract should include a clause stating that negatives (or original transparencies) remain the property of the photographer unless specific agreement to the contrary is made. Make it clear that proofs may not be copied or reproduced by any method whether owned or loaned. Use a copyright mark on the backs of proofs and prints, though it may not inhibit copying, since you can't effectively monitor individuals who rephotograph or scan a print.

Deposits
Get a deposit for a wedding or a portrait sitting for these reasons:

- When someone makes a financial investment in a service, it helps guarantee a commitment that the person will not impetuously change their mind days or minutes before the event. For portrait or wedding appointments they will also make an effort to be there on time.
- When the time comes to order prints and services, paying the remainder of a bill seems less formidable to the client because it is partly paid.
- It should be made clear that deposits are nonreturnable, unless a verified illness or suitable notice is given if the wedding is canceled. You may offer a schedule of partial refunds based on the time of notice.
- If inclement weather causes postponement of a wedding or an outdoor portrait sitting you can reschedule. Explain that portrait photography may be postponed by phone a day (or any time frame you stipulate) before the appointment. Weddings are usually scheduled months in

advance. Clients need to realize that you can't take the risk of turning another wedding down on the same day because you are booked with theirs. With enough notification you may reschedule a wedding or portrait sitting, and time will not be wasted. The deposit is your assurance that the time you've set aside will not be wasted.

Orientation and Fees

Some photographers like to invite portrait sitters to visit the studio so they will later feel more comfortable during the sitting. Clothing and other details for the shoot can be discussed, as well as pricing details. You can collect a deposit during this interview. The amount depends on your clientele, and this is your opportunity to explain that it is only returnable under specific circumstances noted above.

From other photographers and in my own experience, it is clear that one should charge fees that are appropriate for the area and clients you serve. For portraits, fees will be higher depending on the studio location. If you live in a major metropolitan area, the cost of doing business is higher than in smaller towns. Ask advice from other photographers, from Internet discussion groups, professional associations, or refer to books and magazine articles. In chapter three, it is suggested that you determine how much it costs you to do business, so try to set prices accordingly. Consider using this method of pricing wedding and portrait photographs, and compare the results with other approaches. Set fees to match the affluence of your clientele and your sensible assessment of the costs of doing business.

PORTRAIT PHOTOGRAPHY

Personal relations with clients are instrumental to success in all areas of professional photography, and especially in portraiture. Though you may have met the sitter or sitters previously at orientation time, it's a good idea to get acquainted again before the shooting session. Ask questions that will help people loosen up, and give you insights into their interests and character. If you're working with a family, try to involve everyone in the conversation, including the children. Remember that good business practice in photography also includes human relations. The sincerity and depth of your connection with sitters will pay off in added relaxation, more agreeable expressions and a larger print order. Everyone uses a camera these days, but few people know how to direct friends and relatives to make memorable images. You have this talent, and after a period of conversation, especially while you are setting lights and camera, continue disarming your sitters. It may take ten minutes to arrange your equipment and all the while you can be making people comfortable. My experience confirms that consistent conversation with subjects gains their attention, pleasantly distracts them and helps them avoid being self-conscious.

BUSINESS ACCESSORIES

Most portrait and wedding photographers offer frames and albums as part of their services to clients. There are many varieties of each, both ready made and custom-made. There are also suppliers of frames and albums to guide you. If you know the taste range of your clients, you can help advise them. I'm partial to simple frames and albums with a minimum of embellishment, but I would be ready for those who prefer fancier ones.

Many photographers arrange wedding photographs selected by the couple in an album. Present your photographs attractively by designing the album presentation, and if you are hesitant, take a basic course in design or be tutored by a professional. With some artistic skill you can sequence the pictures to work with each other, or work in harmonious contrast from one side or spread to another. Keep in mind that the time and effort of album layout should be factored into the photography fee you charge. If someone asks "Why so much?" when you quote a total price, remind them of this and other professional services they are getting for their money.

I have not discussed negotiating fees with wedding and portrait clients because my sources say it's not a suitable way of doing business. If someone wants to pay less, you can reduce the price by including less in the package. If that's still not suitable, suggest that they look again at your sample photographs before they leave. You might say, "I understand your need to economize, but try not to settle for anything less than quality photography. You will be living with it for many years."

Wish them luck. If you and your photography are engaging, they may be back.

FORM 18 Portrait Photography Contract

YOUR NAME OR BUSINESS NAME
Your address • Telephone number • Fax number • E-mail address • Web site address

Portrait Photography Contract

Client _____ Date _____
Address _____ Telephone _____
_____ Order No. _____

Photographic Services Covered

Portrait of [*As many names as required*] _____
Location of photography _____
Date _____
Time _____
Minimum number of proofs to be shown to client _____
Special services if needed _____

Charges

Portrait photographs are priced for a group of services performed according to the photographer's standard fees based on time involved and number of photographs desired by client. The fees may be based instead on photographic sessions for which all photographic situations are billed individually according to standard fees. In addition may be extra charges agreed to by the client, not otherwise included.

Package fee (number of photographs) _____$_____
Fees individually .$_____

Additional Charges

Additional prints _____ @ .$_____
Digitizing and prints .$_____
Additional sittings .$_____
Special retouching .$_____
Rush service .$_____
Travel .$_____
Miscellany .$_____

Subtotal $_____
Sales tax $_____
Deposit $_____
Balance due less deposit $_____

Client(s) and photographer agree to all terms on both sides of this agreement. All parties have signed this agreement and have received a complete copy.

Client(s) _____ Date _____
Photographer _____ Date _____

FORM 19 Wedding Photography Contract

YOUR NAME OR BUSINESS NAME
Your address • Telephone number • Fax number • E-mail address • Web site address

Wedding Photography Contract

Client _____ Date _____

Address _____ Telephone _____

_____ Order No. _____

Bride's Name _____ Groom's Name _____

Address _____ Address _____

Couple's Future Address _____

Photographic Services and Locations

Studio photography _____ Date _____ Time _____

Home address _____ Date _____ Time _____

Rehearsal address _____ Date _____ Time _____

Ceremony address _____ Date _____ Time _____

Reception address _____ Date _____ Time _____

Special services if required _____

[If desired, attach a description of: Formal portraits of bride, groom, wedding party and location of same; if appropriate, minimum number of proof prints to be shown to client; specifications for prints to be sent to newspapers or other publications.]

Charges

Wedding photographs are priced by the package for services performed according to the photographer's standard fees based on time involved and number of photographs desired by client. The fees may be based instead on photographic sessions for which all situations are billed individually according to standard fees. Extra charges may be agreed to by the client that are not otherwise provided in a package or individual fees.

Package fee. .$_____

Fees individually .$_____

Additional Charges

Rush service .$_____

Extra sitting(s) .$_____

Special retouching .$_____

Extra prints .$_____

Travel .$_____

Subtotal $_____

Sales tax $_____

Deposit $_____

Balance due less deposit $_____

Client(s) and photographer agree to all terms on both sides of this agreement. All parties have signed this agreement and received a complete copy. Anyone signing as Client shall be fully responsible for full payment according to terms of this agreement.

Client(s) _____ Date _____

Photographer _____ Date _____

Q&A *with*
Craig Larsen

Craig Larsen of Redmond, Washington, has been photographing weddings and portraits for fourteen years. He has a degree in commercial/technical photography, but prefers photographing animate subjects. In his words, "I feel weddings are an important type of photography because it's a time when there can't be any mistakes. Every year I try to provide my clients with something new. In the past couple years I have added black-and-white imagery, sepia toning, high speed black and white (6400 ASA +), and infrared images in addition to shooting color. It's a constant challenge, but one that has sent me to many foreign and American cities. I photograph between fifty and sixty weddings per year, and turn away hundreds more because I am booked. I run a one man shop (with one office worker) because I have a difficult time trusting anyone else to capture what I am looking for. I've received more than ten international awards from Wedding and Portrait Photographers International."

Q Please tell me about the kind of contract you offer to wedding clients. Do you offer wedding coverage in various packages? What do they include?

A I offer full service coverage and full ownership coverage. They don't differ much in the price. In the full service plan, I oversee having photos enlarged and mounted in albums. The price covers extra time spent cropping negatives, separating orders, assembling albums, etc. The couple is glad to know they can purchase their negatives in a year. I charge $150 to $350 per set depending on the size of reorders. If someone only orders prints offered in the package, the price of the negatives is higher. Full service clients realize that doing everything themselves will be undertaking too much.

Full ownership coverage is usually done for clients that have their hearts set on doing everything themselves. Basically they rent my photography service for a certain price per hour and a certain price per roll. When I get the negatives and proofs, I send them everything, though they may order prints at a reduced rate. They often have a certain vision of cropping in special albums that I cannot do at the level on which my professional album company and lab operate. Full ownership constitutes about 10 percent of my business.

Q I assume that you ask for a down payment on the wedding photography package arrangement? Is your charge based on an hourly rate, a day rate or a job rate?

A A 50 percent deposit seems to be standard. For a five-hour coverage at $1,850, the deposit is $925. This holds the date and the time for me. There are only so many Saturdays in the year, and if someone cancels, at least the photographer has something to show for the day. I have probably had to turn away potential clients and the deposit is some insurance against losing work. Only about 10 percent of my weddings are on Sundays.

Part of my package is applied directly to photography. I like the fact that clients can choose any size image they want. Putting the same size prints into an album is quite boring. I like an album that tells the great story of a wedding day in a variety of sizes and layouts.

Q Do you offer portrait clients an agreement also? If so, what are its features? Do these clients also make a down payment?

A Portrait clients are charged a reasonable sitting fee for location work. I do not use a studio because portrait lighting on location is more challenging. I like going to various places such as the mountains, the seashore, downtown, parks and clients' homes. Studio work is rather generic, and most of my clients know this since I often photograph former bridal couples as their families are growing.

The portrait sitting fee is paid on the day of photography using a standard invoice form. I bill the remainder when I deliver. I think they like the ease of this arrangement.

Q Marketing, I assume, is a vital part of success in your business. Besides word of mouth, do you promote or advertise your services?

A I operate on 95 percent referrals. I have not done a wedding show for six years. Where as I really enjoy prospective brides' enthusiasm, and I enjoy talking to them, I've found most are looking for price lists, and when they get home, it's hard to remember who they talked to. It's difficult to speak privately to brides at a show because others are waiting. I don't send out direct mailings, and last year I found out that my name has not been in the local yellow pages for two years, although it is now.

New photographers should spend as much time as needed with brides at a show, to build a solid foundation in a few years. My marketing expense is $50 per month to host my Web site. I feel that if you listen to your clients and show true enthusiasm for what you do, then they will take care of you.

Q Are the business arrangements different when you shoot on location than when you shoot in the studio?

A I charge a sitting fee, but the same price for enlargements as I do for a wedding. I feel that if I make the transaction easy at any level, then I will have clients continue to come back. I am always aware that if someone feels I've sold them something they do not need, I have lost a client.

Q Are albums and frames part of your business?

A Albums are a big part of my business. I am constantly looking for new and unique albums to help give some distinction to wedding picture presentation. This is the most important day of a bride's life to this point, and it should stand out. Everything from the style of photography to the albums should have the photographer's personality on it.

Q Do you use some kind of portrait preview system, like one I saw advertised, which evidently stacks a digital camera atop a medium format camera? A Denny brochure offered three price ranges: Cameras only, cameras plus computer sales station, or the deluxe package for $17,695 that has everything plus a dye sublimation printer. How prevalent are digital systems with portrait photographers? Being able to show proofs immediately must be popular. Can clients take home proofs made from the disks?

A I still send out prints for clients to show their friends and families. I do know that many photographers are using slide shows to sell their images at a one-time presentation a few weeks after the wedding. But I've heard there's a lot of "buyer's remorse" when people choose and purchase their images using the digital preview method. I believe logical and honest decisions can be made about portrait images with proof prints, and for a wedding album, too.

I have seen the same advertising for digital cameras and setups that you mention, and I'm worried about photographers who jump into this large expense load. Maybe they don't realize that Sears studios and other large entities have been doing this for years. Being able to see images quickly is good for portraits, but unnecessary for weddings. The couple is usually away on a honeymoon for a few weeks.

But I'm also a big fan of new technology, and I currently get back all my images on CD-ROMs as well as paper prints. I am putting together Web sites for clients to visit and choose images. This service works well for relatives and

friends of the bride and groom who don't have to pass their proofs around. I usually pass out cards at a wedding that note the location of the Web site and the password to get in. Some sites that offer this service are http://www.lookupphotos.com, http://www.eprints.com, and http://www.clubphoto.com.

CHAPTER THIRTEEN

Selling Photography as Fine Art

WHAT FINE ART IMAGERY IS

It's not easy to precisely define fine art photography, which includes a range of styles and interpretations from objective documentary to the subjective blending or blurring of people, places and things. Photojournalistic images can be fine art. Conventional subjects and formal design portraying familiar and offbeat themes may or may not be. Realistic scenics by Ansel Adams or Edward Weston are pioneering fine art, but postcard scenics are not. Also sold or exhibited as fine art are painterly soft-focus photographs, imitation snapshots, erotic and bizarre images, contrived techniques (such as scratched negatives), incongruous combinations, darkroom or computer manipulations and hand-colored prints.

Despite the fact that relatively few people can support themselves by selling fine art pictures to individuals, collectors, museums, business clients and magazine or book publishers, this area of photography offers a prestige that breeds its own mystique. Gallery and museum exhibitions of paintings and other media often include photography. Auction houses get record prices for vintage prints. Visit museums and galleries to observe the variety of fine art photography available. Look there and in art magazines. Note the wide spectrum of subjects and styles.

Color vs. Black and White

Because just about every notable photographer for a hundred years after 1839 worked in black and white, it is the premiere fine art medium. Color prints have an enthusiastic audience, but black-and-white prints last far longer and are most desired by collectors. Black-and-white prints can be archivally processed, often by the photographer, which gives them added status. Color prints made in professional labs cannot boast of being the hands-on creations of the photographer who, however, may have supervised the printing.

If you choose to have color prints made of your work, choose a paper that will last. Tests on high quality papers indicate they will not fade or discolor for up to fifty years when stored in dim light with low humidity. Carefully processed black-and-white prints may last one hundred years if stored properly. Both color and black and white do sell, so the choice depends on what you prefer to shoot. Decorators and interior designers usually prefer color prints

since longevity isn't a problem for them. Prints on home and office walls may be replaced by newer images after a few years.

PRICING PRINTS

Pricing fine artwork is partly practical and partly arbitrary. Similar to the situation in editorial and advertising, the greater your reputation, the more you may charge for prints. However, in the fine art field, print prices often defy logic because *vintage* prints, made within a year or so after pictures were taken are more valuable than more contemporary prints from the same negatives. For instance, a well-known photographer's vintage 11″ × 14″ prints may sell for $1,500 to $5,000 each, while prices of his contemporary prints may be only half as much. Rarity is also a large factor. You've read about Edward Weston's prints selling for $50,000 or more, and even higher prices are not uncommon on images from nineteenth-century photographers.

So where does that put you in the pricing spectrum? Along with the influence of your reputation from exhibitions and in print, the more popular the subject matter you shoot, such as celebrities or imaginative landscapes, the higher the prices will be. Color prints often sell for more than black and white.

Average prices for sales to individuals, depending on who did the images and on the subject matter:

- Black-and-white prints, 8″ × 10″, matted: Beginner: $100 to $250; Intermediate: $150 to $350; Advanced: $230 to $1,000. For color prints in this size and these categories, ask $50 to $200 more each.
- Black-and-white prints, 11″ × 14″, matted: Beginner: $200 to $450; Intermediate: $250 to $750; Advanced: $400 to $1,000. For color prints in this size and these categories, ask $100 to $300 more each.
- Larger prints, such as 16″ × 20″, raise 11″ × 14″ prices by 30 to 50 percent.
- For sales to business and industry, raise all prices 15 to 40 percent.

Galleries show and sell black and whites for prices ranging from a few hundred dollars for an unknown photographer to $2,500 and up for prints by better known artists. Collectors prefer black and white for its longevity and perhaps because much of the greatest photography has been black and white. The average gallery commission is about 35 percent, a factor you must keep in mind when galleries price fine art images.

Discuss pricing with colleagues, interior designers and fine art galleries. Additional pricing information is included in sections that follow.

FINE ART MARKETS
Individuals

Friends and strangers may wish to buy specific pictures from you, though they are not collectors. Show a portfolio of prints, and discuss size, matting and framing. Some people may be astonished at figures higher than $50 to $75 per print because they think in terms of $5 snapshot enlargements. A framed

and matted 8″ × 10″ print should be priced from $100 to $500 in general. Ask the same for black and white as color because black and white lasts twice as long. Wealthier people may accept higher print prices because they're used to them. Some people feel the more they pay for something, the better it is. Make clear to people that your pictures are copyrighted and cannot be reproduced in any way without your permission.

Collectors

A modest number of collectors, usually in larger cities, buy pictures from photographers, whether they are unknown or gaining stature. They discover work on display in galleries, museums or magazines, or they arrange to meet photographers. A collector who finds a photographer in an early stage of his or her career often enjoys encouraging new talent, and may welcome prices lower than a gallery would charge. As your reputation grows, raise your prices. In the role of patron, a collector will recommend you to individuals, gallery owners and museum curators. Understand these circumstances and negotiate prices with collectors, though they may be convinced they know more about a photo's value than you do. An experienced collector may suggest prices that take into account that you have no commission to pay. In time you will develop a realistic idea of what your photographs are worth. Try not to undercut yourself. Cultivate collectors who like your work, and show them new photographs regularly.

Galleries

Few art galleries specialize in photography. Those that do are usually run by connoisseurs who may be partial to particular types of photography or certain photographers. They can be choosy about the types and styles of work they agree to sell on consignment. They are also discriminating about whose work they hang in their shows. Aesthetic quality, often contemporary style, top-notch craftsmanship and personal preferences influence the choice of work displayed. Your confidence in the validity of your own work is also a factor. Gallery owners are offered a lot more work than they can show or handle, and they must select images that seem salable as well as aesthetically distinguished. In many galleries, to be accepted means competing with established masters, current and past. But galleries like to make discoveries, hoping that a newcomer's work will have popular and critical appeal and become profitable. If you are offered a gallery show, you may be asked to share some of the expenses of announcements and opening reception. Negotiate and arrange to pay your percentage from pictures sold.

Research the whereabouts of galleries, call to ask if they handle photographs, visit them if possible and talk to the owner, who makes the decisions. Take some samples and ask for an appointment to show more work. Even if there's no room for you, it's a learning experience. When galleries are not nearby, shoot copy slides of your images and prepare a presentation by mail. Ask

permission before you send slides, and be sure to include a self-addressed stamped envelope for their return. Friends in other cities can check on galleries for you. Magazines like *Art News* and *Art in America* run ads from galleries that sell fine art photography.

Museums

When you begin building a reputation through gallery exhibits, sales to collectors, publication in magazines and maybe books, museums may become interested in you. Museum exhibitions are more elaborate, costly and more prestigious than those mounted in most galleries because museums have subscribers and larger budgets. Large museums have endowments and stage fund-raisers regularly. They often mount exhibits of historical value, and big-name photographers get wall space for one-person shows. If anyone expresses interest in your exhibited photographs, a museum will refer them to you, and may ask for a small commission.

Other Locations

There is a market for photographs of landscapes, other scenes, flowers and marine subjects for the walls of large offices, and the contact is usually a decorator or interior designer. Decor photographs are more likely to be popular subjects than fine art. These markets can be lucrative, so check with local decorators. For such a project, ask what kind of budget they have, and if it's feasible, price your prints accordingly. Matting and framing may be priced and budgeted separately. Prices also depend on the area you're in and the venue where the pictures hang. If you sell a quantity of images, individual prices may be lowered for volume.

SAFEGUARDS

- Try to find out about the reputation of galleries and their owners before you show your work. You could be leaving photographs with near strangers, so guidance from other photographers can be valuable. Later if you have a show, you need to trust the gallery to pay your share on time. Galleries take on the role of personal representatives in the fine art field. Try not to be overcome with gratitude if someone agrees to sell your work. It's the time to realize your images have aesthetic and financial value.
- When you leave a selection of photographs with a gallery, a curator, a collector or whoever, you should receive a receipt. In addition, list your images, leave a copy and have your copy signed by a responsible receiver. The list should state that the undersigned will protect your work with reasonable care, and be responsible for loss or damage while in its possession. (Refer to wording in the sample contract in this chapter.) For each photograph, a title and perhaps a file number plus a value should be stated. Note that none of the photographs may be sold, lent

or used in any way without your permission. Give the receipt a time limit in weeks, after which the undersigned will return the images to you unless they ask for an extension or invite you to be on their regular roster.

- If it fits your work and temperament, consider renting display space to exhibit at weekend fairs or shopping centers, where prices may be lower than in galleries, but lots of people see your work. Ask advice from local photographers with experience. Secure your pictures to prevent theft or damage. Think about buying an insurance rider to cover risks. Be sure each print has a copyright notice with a date on the back, plus a rubber stamped, "Not for Reproduction."

A SAMPLE GALLERY Agreement

Agreements or contracts with galleries and other outlets that sell fine art photography vary somewhat. The sample agreement at the end of this chapter (Form 20, page 196) may be revised to suit your needs. There is a more detailed photographer-gallery contract in *Business and Legal Forms for Photographers*. With it is a contract for the sale of fine art photography to collectors or individuals.

SUMMARY

Fine art photographs result mainly from personal projects, during travels and explorations or from concentration on subjects that generate your interest and may seem to have sales potential. Dedication and self-confidence are necessary if you are going to make money in this specialized category. Learn from dealers, exhibiting photographers and collectors. Visit galleries everywhere. Resort towns such as Aspen, Sante Fe, Taos, Martha's Vineyard and many others are crowded with galleries, some of which feature photographs. If you're in New York visit the International Center of Photography and if you're in Riverside visit the California Museum of Photography. Both are museums dedicated only to photography, and there may be one nearer to you.

Don't give your work away except as gifts for special occasions. Be prepared to start pricing prints lower than you hope is necessary, and raise prices when the market for them improves. Try to make an arrangement with a dealer for consistent exposure. Don't assume that everyone in the fine art photography business is completely reliable. Do try to educate people who buy your work about the qualities that make it timeless.

FORM 20 Photography Dealer & Photographer Sales Agreement

YOUR NAME OR BUSINESS NAME

Your address • Telephone number • Fax number • E-mail address • Web site address

1. The Photographer _____ appoints the gallery or dealer _____ to act as exclusive _____ or non-exclusive _____ agent to sell fine art photographs unless agreed upon separately.

2. The gallery shall document the receipt of all works [*numbered*] consigned by signing and returning to photographer a Record of Consignment. Additional prints are to be furnished according to a mutually agreeable arrangement [*optional to be included elsewhere in this agreement*]. All photographs are to be signed, dated, titled [*optional*] and matted by the photographer.

3. The dealer will be wholly responsible for any loss or damage to any print while in the dealer's possession. This shall include occasions when prints are in another's possession with the dealer's permission. The photographer will be paid his or her share of current market price by the dealer, for any prints lost, and will pay the photographer for materials and $50 [*or whatever seems appropriate*] per hour labor to replace damaged prints.

4. Framing of prints will be done at the discretion and expense of the dealer. If prints are not framed, dealer is to protect them in an effective way, such as a plastic casing.

5. The dealer shall exhibit or have available for viewing all of the photographer's prints on hand, along with sales prices, and shall offer information about the photographer if asked.

6. The photographer shall make no direct sale of photographs in the dealer's inventory, and shall refer prospective buyers for same to the dealer. [*This could be added: Photographer and dealer shall determine whether or not photographer has the right to sell directly work not covered by this agreement.*]

7. The basic selling price for the photographer's 8″ × 10″ prints shall be _____, and 11″ × 14″ prints _____ each. [*Note: Set separate prices for color and black and white prints.*] Works commissioned by outside parties and done by the photographer shall _____ or shall not _____ be considered sales on which the gallery may be entitled to a commission.

8. The dealer's commission is to be _____ percentage of the selling price. [*Note: If possible inquire about gallery commissions elsewhere before signing.*] Any discount given by the dealer to buyers other than _____ [*describe exceptions*] shall be taken from the dealer's portion of the selling price.

9. All sales are to be accompanied by an invoice that states: The name of the buyer; the price, title and file number of the photograph(s); notice that all photographs are copyrighted by the photographer; and a restriction that photographs may not be reproduced or exhibited in any way without the permission of the photographer. The dealer agrees to raise prices of prints after request and sixty days notice by the photographer.

10. The dealer shall have available for inspection an accounting of all sales of the photographer's works if requested. An accounting shall be provided in the event of the termination of this agreement.

FORM 20 **Photography Sales Agreement** continued

11. The dealer agrees and shall inform buyers that no copies, prints or slides may be made of any prints for any purpose without the knowledge and consent of the photographer.
12. The photographer agrees to provide the dealer with additional prints at times and in quantity agreed upon between them.
13. The dealer agrees that no prints may be sold to any other dealer except for said dealer's personal use.
14. The gallery shall pay the photographer all proceeds due to the photographer within 30 days of sale. No sales that are not completely paid for on delivery shall be made without the photographer's written consent, and in such cases, the first proceeds received by the gallery shall be paid to the photographer until he or she has been paid his share of sale in full.
15. This agreement shall remain in effect of at least one year from the date of signing. This agreement may be renewed, revised or canceled by either party on each yearly anniversary date, or on the normal business day before or after that date.
16. In case of cancellation all prints shall be returned to the photographer carefully packed and insured, and delivery charge shall be paid by the dealer.

Dealer _____

Photographer _____

Witness _____

Date _____

Place _____

Q&A *with*
Stephen Cohen

Stephen Cohen has had his own fine art photography gallery in Los Angeles since 1992. He studied art and theater at Brooklyn College, and went on to get a master of fine arts degree in filmmaking from University of Southern California. He began his career as a private dealer in fine art photography in 1977. Since 1992 Cohen has organized PHOTO LA, the largest photography art fair in the West. In 1993 he started Photo Santa Fe, and in 1998 he spearheaded the first Vernacular photography fair in New York City. Plans are also underway for Photo San Francisco. Some of the photographers represented by Cohen's gallery are Lauren Greenfield, Frederic Weber, Marc Riboud, Edmund Teske, Josef Sudek, Weegee and Arthur Siegel.

Q How do you define fine art photography? Many styles of work are included in the category, some very subjective. What sort of limits does the category have?

A Defining "art" has always been difficult. Complicating the matter is that much of what one would consider to be art was not originally intended to be art. It wasn't studied or produced to be viewed separate and apart from a function to describe or represent. This can be seen in tribal artifacts that are called African art; advertising images; propaganda photographs; vernacular art (primitive, folk, etc.). I guess I would say art is something that moves the viewer emotionally. The best art does that in many ways—through beauty, design, form and drama. That someone sets up an "easel" (or camera) and produces something to be viewed doesn't make it art.

Q As I understand it, there are specific markets for fine art photographs: collectors, museums, private dealers, book publishers and perhaps corporate display. Assuming someone has pictures that qualify as fine art, where should he or she begin looking for sales?

A Do you mean someone has a stash of Man Rays in an old trunk? Give them my number! If you mean, where does an artist go to sell, there are lots of areas. If one creates for the sake of creating and wants to share his vision with the world, the best way is through the Web. More people will see

your work online than in any gallery. One must realize that galleries have to sell to stay open, and a large part of their inventory needs to bring in money. What sells today are names. Some names are better artists than others. Rarity sells—daguerreotypes are the hottest things today. Quality sells and it may be from a new person on the block. A new artist should look around at what's being shown; join a cooperative; enter competitions and get your work to the various magazines that publish images such as *Photo Metro*, *B & W* or *American Photo*.

Q What approaches do you advise photographers to take to interest gallery owners, collectors, and others in viewing their work? Is it worthwhile to contact a more distant gallery by phone and, with permission, send slide copies of work to show? How do photographers get exhibited in museums, in group shows, or one-person shows? Does one have a better chance for the latter posthumously?

A Death does not ensure exhibitions. One has to realize that galleries and museums, even when lumped together, cannot exhibit all the work that's being produced. They also have different audiences, so museum curators have interests and reasons for exhibiting that are different from those of gallery owners. One can always send slides to museums and galleries since they probably want to see what's out there. Don't expect a verbal response and don't expect your slides back unless there's a self-addressed stamped envelope. Some museums and galleries may want to hold materials for future reference for group shows, theme shows and maybe even an exhibit. My best advice is to call first and ask about policy; edit your work; put it away for a few months and look at it again. Edit it again.

Q Do you have an agreement or contract form that you offer to photographers you represent? Is there a standard commission expected by galleries and dealers? What advice do you give people who contemplate selling through a gallery or private dealer?

A I suggest that those interested ask other artists who work with or who have worked with a gallery that sells photography about their contracts and terms, if possible. Look at the work of a gallery's artists and visit their exhibits to see if your work seems to fit that gallery. Gallery commissions are usually fifty-fifty.

Q Do some photographers have representatives arranging shows and negotiating with potential buyers? Or do most fine art photographers represent themselves?

A Most photographers work directly with the gallery and represent them-selves. It can be a conflict for galleries to have an artist working with a collector museum in the same area. Hopefully, a photographer who makes contact with a collector will let the dealer know about it, and allow them to make the sale, which is required if the sale is in the geographical area of representation. If a dealer and artist have an agreement of exclusive representa-tion for a certain area, it should cover sales and inquiries that come to the photographer directly, even from other dealers. Communication is most important. If a gallery is working with a museum, it wouldn't be good to have the artist contact the museum as well. It could upset possible sales.

Q Are portfolios of photographs you see usually prints? Are slides of prints also shown? Do you see more black and white than color, or the reverse? Do you try to acquaint new people with the difficulty of financial success in fine art photography?

A I am never encouraging regarding gallery sales and representation. Artists have to decide for themselves if they are defined by gallery sales and representation or does their art represent them. The work may not pay the phone bill, but a true artist will produce regardless of sales. As for slides, black and white, color—submit what you feel will represent your work, but call first before sending prints.

Q Have you any advice for photographers who ask, "What styles of photography are most likely to sell?" Realistic? Fantasy? Computer manipulations? Obscure themes and presentation? All of the above?

A If I knew what sold I would be selling it all the time. I want to believe quality sells. It often does. But a lot of lesser material also sells. This is a subjective matter. A lot of work that sells surprises me since there's so much good work out there that doesn't, both vintage and contemporary.

Q How do gallery owners and dealers decide what prices to ask for fine art photo-graphs? Does the process sometimes seem a bit arbitrary and unpredictable?

A My answer to your first question is "beats me," and to the second one, "yes." Responses depend on the material. Are we talking vintage material? If so, we need to know the net price for the gallery. There are issues of quality of image, quality of print and rarity. I usually suggest a price to the artist. Sometimes they are asking too little, sometimes too much. Some images require special mounting and printing, so those costs have to be included as well.

Stephen Cohen Gallery, 7358 Beverly Blvd., Los Angeles, California 90036. Tel: (323) 937-5525.

CHAPTER FOURTEEN

Opportunities in the Electronic Age

YOU MUST HAVE A COMPUTER

Photographers own computers to keep business records, write letters, file stock photo lists, check other photographers' Web sites and communicate via E-mail. Many people also manipulate photographs for practical and fanciful reasons. Most functions of a computer make life easier and multiply business opportunities. You're able to improve relations with clients, get more assignments, sell more stock, and increase your income. The potential of computers is enormous.

Compared to J.W. Burkey, who shares his views and knowledge in the accompanying Q&A, I am in the beginning stage of computers. The already outmoded system I own, only three years old, is great for writing and E-mail communication. I just bought a new computer with a faster processor to allow my new scanner, graphics programs and the Internet to operate more quickly. I'll learn photo manipulation and I also want to be able to upload pictures to clients. My system includes a CD-RW drive, also known as a "CD burner." Someday I may have a Web site, though I'm not certain if "Photographer-Author for Rent" will get much response.

BASIC COMPUTER APPLICATIONS

Writing: The instructional material that comes with computers and the way word processing programs work have been greatly improved since the mid-1980s when I swore at my first computer. Anyone who wishes to shoot and sell photography to improve his prospects and income needs word processing. Everything you write, fax or E-mail should be word processed, a basic proficiency expected of you by clients. I hope this paragraph is unnecessary for most readers.

E-mail: Communicating online is satisfying and relatively inexpensive. Locate an Internet Service Provider (ISP) by asking advice from friends. I've found America Online (AOL) quite satisfactory. An ISP provides E-mail service which is a fine bridge to clients along with a fax machine. A few ISPs are free, but most charge a fee. When you receive information, articles, letters, forms or caption data via E-mail, you can copy it and paste it into your word processing program to save and edit easily. E-mail is a fast and efficient way to "talk" with clients everywhere. I use it to query editors, exchange messages

with a stock agency in Tokyo, and to collaborate on a children's book with an author in San Francisco.

Web site: Photographers' Web sites are almost as common today as business cards, and often more effective. Web sites help sell your work, can mean more business and are inexpensive advertising. Later in this chapter you'll find details about Web site displays.

Photo manipulation: Possibilities with programs such as Photoshop are staggering. A friend of mine has spent two years digitizing her large repertoire of color and black-and-white images to print and exhibit in various galleries. When we have lunch together, she reads to me from her latest Photoshop manuals. I enviously watch her tweak color and sharpness on a slide she has converted to pixels. There's more about this below, too.

Digital cameras: Professional status cameras are becoming more affordable and now there are digital models under $1,000 with which you can do professional work. I grew up shooting film, but perhaps now that I own a scanner and other equipment, I will buy a digital camera to explore its money-making promise. I won't talk specifications and camera models here because new equipment is introduced regularly, for less money with greater image fidelity. *Popular Photography*, *Rangefinder Magazine*, *PDN*, *PC photo* and computer magazines all review new digital cameras regularly, and *Consumer Reports* occasionally tests digital models suitable for professionals.

DIGITAL SERVICES

Service bureaus: These are the "photo labs" of the twenty-first century. Services include:

- Digitizing images from slides and prints, usually to a CD-ROM, for storage and use on your computer. Digitized photographs can be transmitted over the Internet and viewed on screen or printed
- Scanning to enlarge prints and make slide dupes which may then be manipulated in many ways
- Making transparencies from negatives or prints
- Making color prints in quantity including fine art reproductions
- Some bureaus may also have technicians to help you create a Web site

Service bureaus also do digital retouching and offer design services, plus mounting and laminating. Check the yellow pages, or ask at a camera store for recommendations. You can provide clients with the advantages of the digital age without owning more equipment or learning complex processes. Work done at a service bureau is a legitimate expense on a photo assignment or otherwise as a tax deduction if it's business-oriented.

Digital rental studios: In numerous cities, rental studios offer many digital services such as photo imaging equipment, cameras, powerful computers and programs, and postproduction work. More clients are asking photographers to supply digital files (i.e., digitized images on disks or delivered over the

Internet). A digital studio would be a good place to get imaging experience, where a trained staff can help you, and when a client requests it, you'll be better prepared. In the twenty-first century you can expect your competition will be selling digital photography. It's worth investigating as part of your business.

Digital portfolio: CD-ROM disks showing your best work are inexpensive and much easier to carry or ship than portfolios of prints or slides. Ask for advice from friends or from a service bureau.

Stock via CD-ROM: Stock agencies gather a large selection of photographs (in many categories) on CD-ROMs to send clients who view the pictures on a computer, and order them to be delivered via Internet or as slides. Individual photographers are able to burn images to disks via a CD-RW drive and display their stock in the same way. Inquire at a digital service bureau for details about how to have copies of a CD-ROM stock selection made to attract new business. As for having your pictures stolen when they are downloaded to a computer, digital image resolution can be limited to small, impractical enlargements. Copyright watermarks can also be overlayed on the images to prevent theft. Register your pictures with the copyright office in case misinformed people risk paying far more in damages for infringement than it would cost to lease the images.

Digital archives: Black-and-white film and printing papers may last fifty years and longer, depending on processing and storage conditions. Color films may last thirty to forty-five years. Each type of film and paper is subject to aging. If you get involved with computerized prints that you want to last, inquire about the archival quality of color images printed on computer paper. For your own files, an alternative is storing photographs on CD-ROMs.

WEB SITE DISPLAYS

The World Wide Web is loaded with an enormous number of photographs by professionals and amateurs. You can design and display your own Web site, but expert J.W. Berkey and others, such as stock mavens Seth Resnick and Jon Feingersh, feel it's wiser to have the site designed by a specialist. However, there is software available to guide you in Web site design. If you don't have the time or motivation, look for designer recommendations from friends who have had Web sites designed, or contact the Graphic Artists Guild at (800) 500-2672. When there is no convenient bureau in your area, contact one in a larger city. After an initial person-to-person meeting, you should be able to work together via the Internet.

Web sites display photography to attract buyers to professionals and for amateurs to show off. Many sites are imaginatively designed with easy-to-read type and graphics. For examples, look at the sites of photographers who have Web addresses listed in professional directories or profiled in magazine articles. The ASMP has a site, http://www.asmp.org, that also lists its members. Or you may type "photographer" into a search engine like Yahoo or AltaVista

to find links to Web sites. Be resourceful and you'll find dozens of sites with excellent examples of photography, most of it for sale. Many Web sites offer E-mail links to the photographers, so you contact them to ask about specific pictures or other questions. You may get answers to logical business questions because sensible pros know the value of spreading the wisdom of good business practices widely.

Costs of having a Web site designed and showing your work on it are not exorbitant. Peter Kolonia, writing in *Popular Photography*, says, "A setup can run you less than the price of many camera lenses. Monthly maintenance charges to a commercial host computer, or server, are about what you pay for cable television," which according to Kolonia is "Not bad, when you consider the amount of [your] exposure." Eventually requests could come from art directors and editors for pictures you're showing or you'll get inquiries about subjects in your files. However, as Seth Resnick said at a photo seminar, "You have to market your Web site. People won't come just because you build it. Ask yourself who you want to target, ad agencies, stock buyers, corporate clients or what. Remember, people buy pictures, not companies."

For more information about building your own site, check out computer programs like Microsoft's FrontPage, Adobe's PageMill and Ulead System's PhotoImpact. Kolonia warned at the end of his informative article that you can expect to invest lots of time to create a worthwhile site that keeps visitors coming back. He said, "The effort requires a real commitment," which applies to almost everything you do to earn more income.

As a footnote, Rohn Engh, author of *Sell & Resell Your Photos*, runs a Web site called PhotoSourceFolio which posts many photographers' stock work. The address is http://www.photosource.com/folio. He also sends a weekly free stock-oriented newsletter to photographers. Engh's new book, *sellphotos.com* details how to set up a Web site to run a stock photography business on the Internet. The book also covers other topics mentioned in this chapter.

PHOTO MANIPULATION

Digital manipulation, using a program like Photoshop or others that may not be as complete but might be easier to run, is often a prime interest of photographers today. Computer magic allows you to distort pictures artfully, join them together seamlessly or originate painterly effects that artists with brushes struggle to accomplish. It is also possible to make small improvements to pictures like removing extraneous stuff or revising color to make them more appealing.

Start with simpler, inexpensive manipulation programs and graduate to the well-known more expensive and complicated ones. Be prepared to spend a lot of time learning and experimenting, while enjoying the creative and exciting effects you can achieve. I often wonder how Monet or Dali would have

manipulated photographs of gardens at Giverny or limp watches folded over surreal props.

If you became oriented to digital photography and its ramifications early in your career, you are in luck. You gain:

- The advantages of speedy transmission of words and pictures that don't have to depend on delivery by hand
- Almost instant contact with clients about jobs, while the work is being done (via laptop computer in many cases) and afterwards by coordinating with editors or art buyers
- Infinite variations of good pictures to improve them and often to suit them to special publishing needs such as adding more sky in a landscape to accommodate copy
- All the values of taking pictures, "developing" them yourself on a computer screen, transferring them to CD-ROM for sale or display, printing the images for wall art, and a lot more

Those of us inured to film for decades may have a little more difficulty becoming pixilated than contemporary generations who grow up with keyboards and scanners. In either case enjoy your opportunities to become computer sophisticated to increase your success in photography.

Q&A *with*
J.W. Burkey

J.W. Burkey graduated from the Art Center College of Design in 1971 and has owned a studio in Dallas for nineteen years. He describes it as "A seven-person photography and digital photo-illustration studio," with these objectives:

1. Service: Give the client more than he pays for.
2. Innovation: Find ways to do things better.
3. Fun: Enjoy our work and the people we work with.

He has been featured in stories in *Art Direction, Communication Arts, Studio Photography, Professional Photographer, Zoom Magazine* and *Photo District News* and his work has also been published in *Photographis, Studio Magazine, Photo/Design, USA* and more. He has won numerous art director's club awards including the New York Art Directors' Club, and has been named an *Adweek* creative all-star. Burkey has lectured in two dozen cities across the U.S. and Canada on digital imaging. There were fifty-three names on the client list he sent me, from which I have room for a short selection: Pepsi Cola, Exxon, American Express, Apple Computer, American Airlines, Bell Helicopter, Adobe Systems, Fina Oil, Hewlett-Packard, Holiday Inns, Dairy Queen, Ben Hogan, *Playboy* magazine and General Electric.

Q At what point should photographers seriously consider having a Web site? Is it primarily to attract prospective clients? Can one design a site alone or by using a book, or is it worth investing in professional help? How often should features within the site be changed?

A When we put up our site a couple of years ago, I didn't expect it to bring in any new jobs. I wanted to be able to steer art directors to it when they called for a portfolio from a sourcebook. That has worked out pretty well, though I'm not sure it was worth the expense. We have gotten a few calls from people who found our site on their own, but these have never been big jobs of the sort we desire. At first we put up something ourselves, and later replaced it with one designed by a professional graphic designer. Since photographers' sites will be viewed by art directors and graphic designers, I think it is a mistake for the photographer to design it unless he or she also has formal training as a graphic designer. Also remember that most people who bill themselves as

"Web designers" have no design training. Photographers' sites are not viewed by the same people each day, so adding new images every month or two and doing a total redesign every couple years seems enough.

Q I am familiar with the versatility of Photoshop. A friend has spent a lot of time, with the help of a guru, trying to master the techniques to improve her slides. Does it usually take quite a while to learn Photoshop, or can one use it in weeks with on-the-job training? Are there less complex programs that photographers should consider?

A If you're going to use an image manipulation program professionally, you might as well get Photoshop. There are far less expensive programs that will let you do retouching, but most don't use Apple's ColorSync color management to calibrate your system and thereby get the same color, contrast and other settings. on the output as you see on the screen. (You can also set up color management on Windows NT with greater difficulty, but it is not available on Windows 98.) You can be productive on Photoshop in days, not weeks. Doing retouching is pretty easy. You don't even need professional help if you're capable of reading the manual and going through the tutorials. Mastering Photoshop is another matter. I'm not sure it can ever be done. There's always something new to learn. Dozens of other companies are writing plug-ins and accessories for Photoshop all the time. I've been on the Mac since 1985 and I haven't caught up yet!

Q Is business management via computer programs, even on a small scale, fairly widespread now?

A Yes. Every advertising photographer I know keeps his or her records on computer. Some use programs, like InView, written for photographers. These are pretty amazing. Most of the rest of us just use things like Filemaker (database) and Quicken (accounting) right off the shelf. They are inexpensive and somewhat easy.

Q Digital camera quality seems to be increasing as prices drop. In addition to using a digital back on a view camera in a studio for the best image quality, do you anticipate that professionals will benefit by using handheld digital cameras more in the future?

A Certainly. Even Kodak will admit that digital capture will replace film someday. But no one knows how long it will be. While consumer-level cameras have gotten better and cheaper, they are unsuitable for most professional use. Professional cameras have gotten better, but at $20,000 and more,

and they come down in price slowly. Most of my advertising clients must have images they can reproduce larger than 8″×10″. The test is to have the shot output onto a piece of transparency film, and look for any difference on a light box with a good loupe. Color separators can afford the very expensive cameras. I think that every color separator in my town now offers photography services to clients. Sometimes they offer the photography for free in order to get the separation work. Try to compete with that!

Q A photojournalist friend covers the effects of natural catastrophes for a client and a photo agency. He shoots 35mm negative color, has it developed at a one-hour lab, edits his negatives, scans the best ones into a laptop and transmits them to distant editors within a couple of hours. Do you feel these techniques will be widely used as time passes? For more than just fast-breaking news?

A In some applications, including photojournalism, speed is more important than quality, but your friend probably uses a professional scanner. In the work I do, quality is the only consideration. Digital capture can be every bit as good as film (in the final printing) but is not better. The speed factor is usually a distant third to quality and cost. But everything changes in this business.

Q Is digital delivery to clients used very often by photographers in studios? I'm also wondering if stock agencies transmit work for reproduction or mainly rely on sending slides?

A In my opinion, the transmission of images is the biggest effect of the digital revolution. All the major stock agencies are moving toward the ability to deliver final image resolution digitally. They all now do digital delivery of low-resolution images for selection via their Web sites. My typical assignment involves working with an art director from another city whom I've never met. I send him low-resolution versions of what I'm doing daily (as an attachment to an E-mail). He phones or E-mails me with suggestions. I still send the final images on a CD-ROM via Federal Express. The same for my stock images. I E-mail them to the editor for approval, then send the final selection on disk.

Q Are there certain periodicals you could recommend for readers to learn more about digital techniques? I'm not asking about books because I know there are so many, but if you know of any basic ones for readers, they'd appreciate it.

A I get a lot out of *Photo-Electronic Imaging* most months, http://www.peim ag.com, I think. Yes, there are many Photoshop books out there, but only

one that I recommend when I give talks: *Professional Photoshop*, by Dan Margulis, is filled with practical information on how to get it right. Margulis is gifted in his ability to make complex technical concepts understandable and often fun to read.

Q Is it pretty much standard procedure for advertising and illustrative photographers to enhance their work digitally?

A No. I estimate that a bit over half of the commercial guys and gals I know have Photoshop and use it on some of their jobs. But the normal job flow is probably still to give the art director film and he pays the color separator to enhance the work digitally. It's probably very rare that a consumer sees an ad photo that hasn't been at least cleaned up on the computer. But I think that in the majority of cases, the photographer is not doing the work.

Q Do photographers you know of have much trouble with unauthorized usage of images downloaded from a Web site?

A I haven't heard much about this, but that may be partly because we don't hear about most thefts. About the only thing that an image on my Web site can be used for is another Web site. The quality is only good enough for printing about postage-stamp-size.

Q Are some photographers now transferring an assortment of their own images to CD-ROM and duping the disk for distribution to clients, catalog style, like stock agencies do?

A I'm sure it's a common practice among photographers who sell their own stock. Burning (duplicating) a CD-ROM is easy and blank disks are down to $1 each. A couple of years ago, a fair number of people were doing CD-ROM portfolios. That seems to have died off, and must not have worked that well once the novelty wore off.

Sources of Help and Information

Books

ASMP Professional Business Practices in Photography, 5th ed., Allworth Press, 1997

Business and Legal Forms for Photographers, Tad Crawford, Allworth Press, 1997

The Business of Studio Photography, Edward R. Lilley, Allworth Press, 1997

Digital Photography Handbook, Tim Daly, Writer's Digest Books, 1999

How to Shoot Stock Photos That Sell, Michal Heron, Allworth Press, 1996

The Law (in Plain English) for Photographers, Leonard D. DuBoff, Allworth Press, 1995

Legal Guide for the Visual Artist, 3rd ed., Tad Crawford, Allworth Press, 1995

Negotiating Stock Photo Prices, 4th ed., Jim and Cheryl Pickerell, Jim Pickerell, 1997

The Photographer's Business and Legal Handbook, Leonard D. DuBoff, Images Press, 1989

The Photographer's Guide to Marketing and Self-Promotion, 2nd ed., Maria Piscopo, Allworth Press, 1995

The Photographer's Internet Handbook, Joe Farace, Allworth Press, 1997

Photographer's Market, Writer's Digest Books, annual

The Photographer's Market Guide to Photo Submission and Portfolio Formats, Michael Willins, Writer's Digest Books, 1997

Pricing Photography, 2nd ed., Michal Heron and David MacTavish, Allworth Press, 1997

The Professional Photographer's Guide to Shooting & Selling Nature & Wildlife Photos, Jim Zuckerman, Writer's Digest Books, 1991

sellphotos.com, Rohn Engh, Writer's Digest Books, 2000

Sell & Re-Sell Your Photos, 4th ed., Rohn Engh, Writer's Digest Books, 1997

Stock Photography Business Forms, Michal Heron, Allworth Press, 1997

Stock Photography, The Complete Guide, Ann and Carl Purcell, Writer's Digest Books, 1993

Successful Fine Art Photography: How to Market Your Art Photography, Harold Davis, Images Press, 1992

Wedding Photography, Paul F. Frew, P&P Publishing Co. (from *Rangefinder*), 1998

Writer's and Photographer's Guide to Global Markets, Michael Sedge, Allworth Press, 1998

Magazines
Adweek (East), New York City, (212) 764-7300
Adweek (West), Los Angeles, CA, (213) 525-2270
Art Direction, monthly, Glenbrook, CT, (203) 353-1441
Art in America, monthly, New York City, (800) 925-8059
Art News, monthly, New York City, (800) 284-4625
Communication Arts Magazine, monthly, Palo Alto, CA, (415) 326-6040
Outdoor Photographer, monthly, Los Angeles, (800) 283-4410
PDN, Photo District News, monthly, New York City, (800) 745-8922
Popular Photography, monthly, New York City, (303) 604-1464
Rangefinder, monthly, Santa Monica, CA, (310) 451-8506
Studio Photography & Design, monthly, (800) 547-7377

Promotional Publications, Newsletters and Services
Adbase USA, Denver, (877) 500-0057, online creative contact mailing lists
The Blue Book, Directory of Geographic, Travel and Destination Stock Photography, AG Editions, New York City, (212) 929-0959
Clark Cards, Willmar, MN, E-mail: clarkco@usa.net, promotional postcards
Direct Stock, a catalog in which you buy space to show stock photography, New York City, (212) 979-6560
http://www.editorialphoto.com, a Web site for editorial photographers. Click on magazine section for day rates paid by magazines; also information on copyright and legal matters
The Green Book, Directory of Natural History Photographers, AG Editions, New York City, (212) 929-0959
The Knot, Wedding Photographers Network, Atlanta, (404) 873-8060, Web site: http://www.the Knot.com
Photographers Index, free photo pricing service at Web site: http://www.photo graphersindex.com/stockprice.htm
PhotoStockNotes, a monthly by Rohn Engh, Osceola, WI, (800) 624-0266
Postcard Productions, Rockport, ME, (207) 691-0000, promotional postcards
Selling Stock, a monthly newsletter by Jim and Cheryl Pickerell, Rockville, MD, (301) 251-0720
Stock Photo Report, a monthly newsletter by Brian Seed, Skokie, IL, (847) 677-7887

Computer Program
fotoQuote, for Windows and Macintosh, (800) 679-0202 for pricing photo sales

Organizations

Advertising Photographers of America (New York City), (800) 272-6364

American Society of Media Photographers (Philadelphia, PA), (215) 451-2767, forty chapters in the U.S.

Editorial Photographers Group, E-mail: info@photographygroup.com, Web address: http://editorialphoto.com

Gilbert-Magill Co. (Kansas City, MO), (800) 522-2460, insurance for photographers

National Press Photographers Association (Durham, NC), (800) 289-6772, various chapters in U.S.

Picture Agency Council of America (PACA), (New York City), (800) 457-7222, stock agency trade group

Professional Photographers of America (Atlanta, GA), (404) 522-8600, numerous state associations of commercial and wedding photographers

Taylor & Taylor Associates (New York and Los Angeles), (212) 490-8511, insurance for photographers

Wedding and Portrait Photographers International (Santa Monica, CA), (310) 451-0090

Index